DANCING ON MY OWN

DANCING ON MY OWN

Essays on Art, Collectivity, and Joy

SIMON WU

HARPER

An Imprint of HarperCollins*Publishers*

DANCING ON MY OWN. Copyright © 2024 by Simon Wu. All rights reserved. Printed in the United States of America. No part of this book may be used or reproduced in any manner whatsoever without written permission except in the case of brief quotations embodied in critical articles and reviews. For information, address HarperCollins Publishers, 195 Broadway, New York, NY 10007.

HarperCollins books may be purchased for educational, business, or sales promotional use. For information, please email the Special Markets Department at SPsales@harpercollins.com.

FIRST EDITION

Library of Congress Cataloging-in-Publication Data has been applied for.

ISBN 978-0-06-331620-1

24 25 26 27 28 LBC 5 4 3 2 1

For my family(s)

JADE

wrist bathed in vaseline
 moonlight, thrift
amulet embedded
 as "family heirloom" my
mom bought at the airport,
i told the story and everyone laughed,

cuteness is the beauty i can afford which is the
beauty i deserve. thank you mommy for naming me

ross: dress for less, every
day i check craigslist for
those i could replace.

at the estate sale, i meet dorothy and her puka shell
necklace, her grandson i request on linkedin, pacsun &
tule lake, what we don't have in common. my knowledge
of landfills ends at simcity. your necklace i can't hug into

softness. in shanghai and paris, stars
on the ceiling, no i haven't tried religion.
it wasn't the airport i just said it for the story

 —Julie Chen

CONTENTS

A MODEL CHILDHOOD 1

FOR EVERYONE 28

VAGUELY ASIAN 51

PARTY POLITICS 83

A TERRIBLE SENSE OF WHEN HE WAS WANTED AND WHEN HE WAS NOT 109

WITHOUT ROOTS BUT FLOWERS 146

AFTER, LIFE 177

ACKNOWLEDGMENTS 207

NOTES 209

A MODEL CHILDHOOD

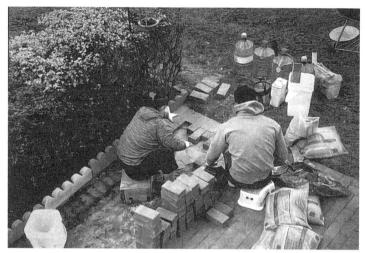

My mom and I re-laying bricks in our patio in 2019.

You. don't. have. to. hug. the. house. . . . You don't have to hug the house.
—*Maggie Lee,* Mommy *(2015)*

I don't feel that I assume a role or that I become someone else on the stage. . . . I become a rawer form of myself.
—*Robyn, SVT documentary, 2010*

My mom calls me. She has found a house on Zillow. It has all the extravagant, absolutely necessary fixtures of suburbia: a three-car garage, central air, four bedrooms, two bathrooms, and twenty-foot ceilings. If my brothers and I used our money for a mortgage instead of rent, she says, we could live there together.

She wants to move to a bigger house. I think that we have too much stuff, but she would rather expand the container than shear down the contents. She moved us from our small town house in Philadelphia to the three-bedroom split-level in the suburbs we lived in for the bulk of my childhood. The current house sits on a steep hill, sheathed in vinyl siding the color of butter. It has box-cutter hedges and blue shutters, and a patio—a middle-class mirage my parents saved up for.

"You have to climb the rungs when you can," my mom continues over the phone.

I imagine the rungs she describes as a ladder submerged in a grain silo filled with water. As she monitors the water's rise from her raft, our current house, she eyes the next rung: higher, drier, safer. This rung would have a house with high ceilings and two staircases, rooms for all of us even if we are old enough to live elsewhere now.

"We want to set you all up for when we're gone," she says. "But maybe I won't get to live in a house with high ceilings until my next life."

Somehow, with talk of houses, we always come back to the subject of death.

When the pandemic began in 2020, I moved back in with my parents, and we started sorting through the things they had collected in their garage. There were boxes of children's toys, piles of IKEA furniture from several college move-ins and move-outs, heaps of

yard machines, and miscellaneous materials from the sushi kiosk my mom used to run at a college food court—things accumulated in the twenty-six years since they had moved to the U.S. from Myanmar. I considered most of this stuff useless, but my parents disagreed; they were things lying in wait to be used again. I avoided the garage because I felt at different times suffocated by, responsible for, and protective of everything in it. Most of the time, though, I just wanted to throw everything out.

That March, as the world closed down, I burrowed into this unwanted inheritance. I changed into workout clothes and set up a speaker. I worked my way through Katy Perry's *Teenage Dream*, then Lorde's *Pure Heroine*, then Robyn's *Body Talk*, morale inflated on the engineered euphoria of pop music. I sat on a low stool in front of two open garbage bags—one for donation, the other for true death: trash.

I sang as I worked. And the singing let my brain disco while my body stayed in the garage. A makeshift karaoke booth in the lawn mower sea of suburbia. My hands moved on their own. My mom hovered warily as I slashed, with particular glee, through convention paraphernalia that we would soon be rid of: bottle openers, stress balls, and collapsible sunglasses. Children's clothes, kitchen supplies, side tables, and TV cabinets. These made it to the donation pile, and the fact that someone, somewhere, would put them to good use nominally eased my mom's melancholy.

I am often stymied by the persistence of my mom's desires, desires that are not difficult to understand but difficult for me to inhabit. When we took a break from cleaning the garage to repaint the living room, she repeated the name of the paint color she had selected like a mantra—Benjamin Moore, Chantilly Lace, Benjamin Moore, Chantilly Lace. It was the color the internet had confirmed would

be the most elegant white. She vacillated between outsourcing her taste to the blonde YouTube renovation women and sticking resolutely to her instincts. Sometimes I was impatient with her as she searched for approval online. I saw her outsourcing as weak and her intuition as stubborn. And then I judged myself for being cruel.

I was jealous of my friend's houses, where there never seemed to be any clutter. Objects there could live simple, frivolous lives. A cereal box was to be used and discarded. A broken lamp was removed from sight immediately. A sofa could work part-time, collecting dust in a room full of furniture that lazed about in slovenly repose.

At our house, aesthetics were produced through resourcefulness; beauty was to be found in an object's resuscitation from the edge of disuse. After the circuit broke on a floor lamp my mom found on the street, she brought it out to her garden, extracting the wire like a vein and staking the hollow rod into the soil, curling a waylaid pea-shoot tendril around it. Plastic water bottles were snipped in half to store pennies and paper clips; torn shirts used as mops; detergent boxes fostered Tiger Balm. Objects were made to live multiple lives, so that our life—this life, not the next one—would be perfect.

Take all our bookshelves. My mom used to enroll me and my brothers in reading competitions at the public library near our house in Philadelphia. The prize was an IKEA Billy—a sturdy, albeit plain, wooden bookshelf that came flat-packed in a dense rectangle. My mom collected us after school, and we'd check out entire shelves indiscriminately, reading everything between BET and COR, and the next week COR–DEK. This systematic method, combined with an actual appetite for reading, meant that

we had a steady stream of bookshelves. We have six IKEA Billys, and they're filled with board games and McDonald's toys.

Consider the aesthetic theory behind this kind of decoration: incentivize your child to read books and, in the process, furnish your home. What the bookshelves look like matters less than how they were acquired; they are conceptual artworks where the process of procurement is the art, a material manifestation of scholastic achievement. This was the dumb amazingness of America, where bookshelves could be grown by reading.

The urge to collect crystallizes most clearly in my parents' love for containers. They wash takeout Tupperware, store Starbucks paper bags, and keep Danish butter cookie tins. One time, I came home to find a neatly arranged stack of paper sleeves from Popeyes. They had once held chicken sandwiches, and my mom saved them because she said they would be great to store seeds and other snacks.

Containers are not possessions in themselves but rather a promise of the ability to store more things. They expand one's *capability* to stockpile, and this is what is so entrancing about them. Collecting containers feels like winning. It feels like drinking from the bountiful rain of capitalism when others seem to be ignoring it.

"What a waste it would be to waste," my mom once said.

When my father asks why we need to clear this stuff out, I tell him it's because we don't *need* any of it. "It feels like the stuff lives here instead of us," I told him. I was righteous, and I was right. They needed fewer belongings; they needed to shed this survivalist mentality. All of this was fat to pad the vital organs from the impact of migration. And what better life vest to the turmoil of immigration than a fortress of containers.

Houses are the perennial favorite of Asian American writers as the preferred form of metaphorical and material repayment for the sacrifice of one's parents. Houses and what they contain (a stray calendar, a stuffed animal, the promise of a son, etc.) are the stage, the repository, and the laboratory for experiments in the aesthetics of the diaspora. I don't find myself exempt from this yearning, but I do find myself critical of it. Who, and what, do we leave behind in all this middle-class striving?

But also, I get it. Without this upward drive, how else could my parents have gotten me to where I am? There will be corners of this house that will always be dark to me.

In 1941, immediately after the bombing of Pearl Harbor, the artist Ken Okiishi's grandfather, Kenneth T., received a frantic call from his brother, whose house had just been searched by the Honolulu police. They were looking for anything that might bear some trace of "Asianness" or "Japaneseness." The police were searching for reasons to charge Kenneth T. and his family with Japanese sympathy, even if Kenneth was second-generation Japanese Hawaiian (nisei). On the West Coast of the U.S., some 120,000 Japanese Americans were forced, often at gunpoint, into euphemistically named "relocation" camps. More than two-thirds of these evacuees were American citizens who had lived on the land for two generations. In Hawai'i, the entire territory was put under martial law for three years. Ken's grandfather, to protect himself from suspicion, threw out all traces of the family's Japanese possessions, including miniature figurines, clothing, toys, and dishware, dumping them into the Māmala Bay.

In 2018, reflecting on his family history, Ken loaded a minivan with all his childhood possessions and drove them from his parents' home in Ames, Iowa, across the country to a gallery in downtown

Los Angeles, where they were presented in his exhibition *A Model Childhood*. The archive included possessions from a twenty-three-year span, 1978–2001, that had been carefully stored by his parents.

Described as an "epic poem in objects," *A Model Childhood* unfolds in several interlocking parts.[1] The first consists of cardboard and plastic storage boxes, full of Ken's possessions, arranged across the gallery floor. Old clothes and high school paintings and action toys brim over the top of the containers, the lids removed for viewing. The long, vertical shape of the gallery resembles a suburban garage. The deliberate spacing between the objects lets a viewer wander between the boxes. The installation feels like Ken is mapping memoir into physical space, each object an invitation.

A video, projected on and through these boxes, shows Ken walking around the ruins of the Topaz War Relocation Center, a concentration camp in Delta, Utah. Another video shows a forensic scan—typically used for crime scenes—of the basement of the Okiishi family home. The rendering is set onto a desert landscape and documents the family's archive before Ken took his possessions out of it. Sections of the basement are cursorily sketched or distorted, the scan approximating round things like stuffed animals and basketballs into pixelated boxes.

As I sit in my parent's garage, I imagine *A Model Childhood* installed across the rooms of my parents' house. Maybe I can trick myself into doing what my mom wants. Instead of throwing away her belongings, I can transform them. Place Keanu Reeves DVDs and Shaboom! magic kits next to my Happy Meal toys and sushi bins, Ken's Doc Martens box and a piano recital program beside my own shoes and recital programs.

I was drawn to Ken's project because it is not so sanguine about these childhood memories. At the center of *A Model Childhood* is a statue of an angel in prayer. I imagine it might have resided in his

parents' garden. But elsewhere in the exhibition, a 3-D printed replica of that same angel, rendered in a ghostly white, is installed horizontally, as if it were emerging from the wall. In an adjacent room, its wings are replicated again in a corner upside down. I thought of these various copies as glitches in his memory, reminders that the memories of his childhood home are a blend of synthetic and real fibers.

In the third video, Ken follows his mom as she documents every object in the Okiishi household for insurance purposes. The handheld camera is shaky and intimate as it follows her from room to room, tracing her gaze across the house's features. We see that their house is meticulously well cared for—clothes in plastic boxes, clean couches, and neatly arranged knickknacks; they seem to live a very comfortable middle-class life in Iowa.

Yet, in making the video, the orderliness is undermined by a threat: these familial objects might all be taken away. The video accumulates, but it also preserves. It extends the life of these objects beyond their physical life span. Ken's work paws at re-creating something that can't really be found—ancestry? inheritance? This distance is only exacerbated by the documentary nature of his practices—forensic scanning, insurance video, travelogue. What he's hoping to document isn't there, no matter how hard he looks. Weighted by his grandfather's central trauma to expunge anything Asian from his house, Ken confronts absence through inventory, as if drinking all the water in Māmala Bay could bring back what was drowned so many years ago.

When I was in middle school, I begged my parents to buy me *The Sims*. We had just moved to the suburbs, and I wanted to act out the gay urge to interior design. I wanted to build houses, but I think I was also into the idea of making my Sims have sex.

"Your Sims can even have relationships," I told my mom. "I could learn a lot about them."

We were in the parking lot of Costco, loading things into the trunk of our Toyota Sienna. She paused to consider this, holding a carton of enormous, GMO-grown muffins in her hands.

"They can even have sex," I blurted out. "It's called 'WooHoo.'"

She placed the muffins down. "Is that why you want this game?"

"No no no," I backpedaled. "I want to build houses. I want to build houses."

I used to watch a lot of HGTV. One of my favorite shows featured Candice Olson, a precursor to the blond YouTube renovation women that my mom would find later. Olson was a sparkly white lady who hosted *Divine Design*, a half-hour-long home renovation show where she filled every room with chandeliers and puffy white chairs. I was not yet out to my parents, so I remember frantically switching the channel whenever anyone walked in. Even then, I knew that an excess of sympathy toward aesthetic refinement somehow portended sexual deviancy.

The pleasure of shows like *Divine Design*, and other total home renovation shows, like *Extreme Makeover: Home Edition*, was its gift of instantaneous and immediate class ascension. A bigger house meant a bigger life, which also meant a better one.

When my parents finally conceded and got me *The Sims*, I was allowed to play for exactly one hour after diligently doing my homework. A silver, graying desktop wheezed mournfully every time I booted up the game. I liked making my avatars toil through endless job ladders. I never played with cheat codes; I savored the climb.

I made one a doctor and saved up money to renovate his poor house into an eventual McMansion. He started as "Medical Intern," making $18 an hour, until days or weeks later (about

thirty to forty minutes in the game) he'd become "Surgeon" or "Chief of Staff," making nearly $300 an hour. Every Sims cent went toward renos. In the few times my Sim doctor was home (he worked a lot), I made sure his environment meter was full and that he had plenty of opportunities to Work on Skills and Enthuse About Video Games.

I loved how the game made very amorphous things concrete, the way it quantified things like "hygiene," "hunger," and the seemingly amorphous "fun" through easily measured colored bars and symbols.

Eventually, I used *The Sims* to model out the small renovation in my family's home that my mom and I undertook when I was in middle school. We moved the kitchen from upstairs to downstairs and in the process, freed up two more bedrooms for my brother and me. I mapped out the idea in *The Sims* first. I watched my doctor Sit Down on the edge of my new bed, and then Sit Down on the edge of my brother's new bed, and then Make Ambrosia in the kitchen downstairs to test out the flow. The fantasy of the game was that there was no clutter; every object was accounted for in its own little square.

Later, after moving back to New York, my roommates and I started playing a video game called *Katamari Damacy* (literally, "Clump Spirit") designed by Japanese designer Keita Takahashi and first released in the U.S. in 2004. In the game, you are a five-centimeter-tall green man known as the Prince. Your father, an enormous, conspicuously muscled entity called the King of All Cosmos, wears revealing tights and has accidentally destroyed all the stars, planets, and moons of the universe, except for Earth. As the Prince, your task is to go to Earth and re-create the universe

with a "katamari"—a magnetic, sticky ball that you grow by rolling around and accumulating progressively larger objects.

You swallow everything in your path, starting with things like ants and thumbtacks and rocks, then working your way up to chairs and tables, then humans and animals, and then entire houses and cars. By the end of the game, you've amassed a ball so big that it is bigger than the Earth, and it pulls away from the planet's gravitational pull. Congratulations, you have made your own star. From your katamari, the Earth looks no bigger than a baseball.

Imagine the Prince arriving with his katamari in my parents' garage, of the stars that would be born from all this accumulation.

It is not that Asian people do not exist in the Sims Universe, but rather that the tools to edit eyes do not contain enough nuance to successfully build a face without the result reading more "cat" or "alien" than Asian.

So, when I revisit the game during the pandemic, the Sims version I create of myself comes out a little wonky. I name him S and give him "genius," "gloomy," and "romantic" traits. S is going to be famous. I give S's mom/my mom "ambitious," "hotheaded," and "creative" traits. I lobotomize them both, turning their Free Will meters all the way down. Now I can ventriloquize my own desires into them.

On their first night in their Sims home, S and his mom Make Dinner and Ask Each Other About Day. S has just returned from his work as a Medical Intern, and a few hundred dollars have appeared in the account. They both seem apathetic to their newfound fortune; S's mom runs outside of the house to Chase Butterfly.

When S's mom returns, she walks over to the sofa and Sits Down. She turns to S, who is doing the dishes. She then does

Criticize Food, Have Deep Conversation, and then walks to the computer to Read About Business. S is confused by the slurry of commands and Stops Washing Dishes. In an idle moment, he decides to Set TV on Fire.

We take yet another break from cleaning, piling into the Toyota Sienna for our weekly Costco outing. My parents align their internal clocks to the rhythms of Costco's sales schedules. They know if we are at the beginning or at the end of a coupon cycle. This will dictate whether it is acceptable to buy that bag of Himalayan salt potato chips or not. We eat what is on sale—Bagel Bites or frozen Alfredo pasta or Japanese yakisoba—our stomachs are subject to the whims of the Costco marketing execs.

After flashing my dad's membership card, we disperse into our respective warehouse corners. My father goes to look at flashlights and tires, my mom, the cutlery and clothing. My brother Nick heads to frozen food while my other brother Duke and I drift over to the book section. Unlike most bookstores, Costco stacks their books flat on an oversized table, a map of titles and colors that makes it logistically difficult to reach anything near the center. (There is something vaguely democratic about this presentation: to present books as you might bulk packages of muffins and giant strawberries.) To read a book in a Costco is to go on the ultimate Side Quest, to diverge from your valiant path and opt, instead, to feel alone in a very public place, the sound of other people fading into the Simlish of NPCs.

It feels warm and comfortable to be surrounded by so much plenty. In Costco, I become my parents, I am relieved of the burden of finding the best deal. In Costco, it's not a question of whether to acquire because everything is so *worth it*.

My parents hate cheese, but they'll have it if it is presented in

the form of a free sample. Why? Because free things taste better. Do we crave Pizza Bagel Bites? No, but we'll wait patiently at the sample table for the elderly worker in a hairnet to microwave them, watching eagerly as she scissors the small discs in half and lays them on their crinkly cupcake liners. We'll practice our best pleases and thank-yous, gracious yet insistent about our place in line next to Russian, Indian, and other Chinese immigrant families. There is a Rule About Samples: even if you didn't want it, you get it for your brother.

My mom hates restaurants. She hates tipping and proclaims that she could make everything better at home. So, when Costco starts introducing restaurants' frozen foods like TGIF's Bloomin' Onions or Panda Express Orange Chicken, the little impetus we might have to eat out evaporates. We can get a bulk-size package of heavily branded frozen food and defrost it at home. We can eat our chicken tenders in peace, where we don't have to pay extra for rice. Costco is enlisted by my mom, and maybe immigrant moms everywhere, to lend weight to the rebuttal: "You want that? We have that at home." There was nothing we did not have at home.

We head to the paint store. My mom tells the impatient white man at the paint counter the color as rehearsed—*Benjamin Moore, Chantilly Lace*—and he asks: "Matte, eggshell, or semigloss?" Here, my mom becomes meek, and I become protective. She asks which one he recommends, which one people use the most. Through a raised eyebrow, he says that matte is best if we do not have children. And adds that it would also look the most *expensive*, which turns out to be the secret word. "Chantilly Lace in matte, please," she says.

When we get home, we start painting immediately. The paint goes on flat and luxurious, the texture like butter. But my mom

is disappointed. She says it doesn't look expensive at all; it's just white. "We . . . ," she says, pointing at herself, looking at the walls, "we are village people." She is only half-joking. "And we village people like shiny, colorful paint. I don't know what to do with this."

I try to assure her that it will lighten up during the daytime. She accepts this with some resignation. We watch the paint dry. By the third coat, she seems to have accepted the subtlety of the color. "There's the shine," she says. "I can almost see myself in it."

Back in New York, I go to dinner with my boyfriend, Ekin, and my friend Julie. We sit at Nourish Thai and watch versions of ourselves amble down Vanderbilt Avenue, which has been turned into a pedestrian walkway for the weekend.

Earlier in the week I had gone to see *Everything Everywhere All at Once* and we're catching up about it now. We are generally unnerved by the saturation of multiverse movies these days (Ekin: "Escapist fantasies where we don't have to reckon with the consequences of neoliberal capitalist destruction." Julie: "lol there are so many avengers . . ."), but I'm thinking that the movie—about a Chinese American laundromat owner (Michelle Yeoh) who travels through multiverses to pay her taxes and eventually accept her queer daughter (Stephanie Hsu)—suits the format really well. There is something like a multiverse paradox already built into immigrant narratives. Is there anything more sci-fi, whacked out, and fantastical than uprooting your life to live in another country? Anything more multiversal than facing the counterfactual every day—what if I/they had stayed—or, what if I/they had been born there instead of here? Is not speaking Mandarin, Cantonese, and English, as the characters do in the film, already a kind of multiverse experience?

"Yeah, but I'm not sure every mom would pick to stay in this reality if they had the choice," Ekin adds. I wonder if this is less a factor of moms and more a question for anyone presented with the choice of their life or another's.

The food arrives. We talk about other, mundane things. A play-reading Michelle is organizing this weekend. Rachel's opening. Plans to trip in Green-Wood soon.

As we eat, I am struck by the thought that this moment—to be able to make enough money working in art to go to a weekday dinner with a friend and *boy*friend—is part of the life that my parents had moved here for me to live. Well, not exactly this, but probably some of its main tenets: our freedom of movement, our ability to pursue passions, to be gay. Even if they could not have imagined it, or perhaps even encouraged it, they were still the architects of this mobility.

Ekin is heartened by this thought. He imagines a version of his life where he had never left Turkey. His parents sacrificed for him to be able to come to the U.S. We sit in this grateful image for a beat, smiling.

"Wow," I say.

I eat my pad see ew. Julie cuts through her mock duck curry.

"I don't know. The Confucian stuff can get a little debilitating sometimes," Julie says.

"Yeah, and I mean, we didn't ask to be born," Ekin adds. "In Turkish actually there's a phrase we have for children or people who are ungrateful to those to whom they should be indebted. We call them *vefasız*."

"Lol," Julie says. "Sounds intense."

"*Vefasız*," I say aloud, letting the flat "sız" sit on my tongue. *Vefa* means fidelity, and *sız* is the suffix for without. "We're all probably a little *vefasız*," I say.

Our waiter clears the food off the table. She is young, and

Asian, and not so different in age from us. When she leaves, Julie looks up and asks us, "Do you think your mom is living the life she had always wanted to by moving to the U.S.?"

It's hard to say. I worry I tend to project my desires into her desires. When I write about my mom, I fear she becomes a caricature, or in the very least *a character*. How much could I really know? How much did I really *want* to know?
We could just ask.
Yea.
But with knowledge comes responsibility, and which of my desires was I willing to sacrifice?
The urge to know our mothers is not unique, and sometimes I found evidence of it in other people's art. In 2015, the artist Maggie Lee released *Mommy*, a frenetic, devastating film about processing her mom's passing. The film is organized into sixteen chapters, each with its own kind of DIY-meets-'90s-internet vibe. It begins with an epigraph: "My mom was always telling me she would write a book about her life," Maggie narrates over a picture of her mom, smiling. "Before she retired, she finally began working on her autobiography. She would meet in the town library once a week with a ghostwriter to work on it. When she died, my sister found the book unfinished and gave it to me. This is my mom's story, as well as my own."
The film moves through various milestones in Maggie's life: her childhood with her magician father, who leaves the family; her mother's move to the U.S.; Maggie's decision to go to art school. When Maggie moves to Bushwick, she falls in with the rave and DJ scene, much to the dismay of her mother. "I want to dance," Maggie narrates over party pictures and the muffled sounds of a rave. "Parties are fun, yeah? Parties are important. Jamie's DJing.

Daniel's DJing. Kiss me, squeeze me, blush pink love." In the background, the buzz of a phone becomes more and more insistent. The music continues but now Maggie's mom's is yelling over the phone, intoning her to get a more traditional job: "You have to stop!" she says, the sounds of the party still rattling in the background. "You have to do something really good too."

I revisit the film a lot. I showed it to Ekin and Julie and barely withheld tears. I've shown it to friends and colleagues as if it were my own, and each time I am struck anew by its disarmingly honest nature, how directly Maggie processes her emotions, how well she captures being an artist and a daughter. On my fifth viewing, chapter 11 (simply titled "The House") sticks out to me. In it, Maggie is tasked, after her mom passes, with cleaning out the suburban New Jersey house she grew up in. It follows "RIP Mommy," the section of the film where Maggie learns of her mom's death. The chapter is tinged with shock and grief and anger, the indignancy of the fact that her mom died but left all this *stuff*.

"My mom never threw away anything, even if it was used up. So resourceful. Yet, on the brink of hoarding. I wish I could keep this," Maggie narrates. By the end, everything in the house is waiting outside, a truck from the Salvation Army coming to collect it. I watch the film and feel that I am looking into a set of emotions that I have been preparing for my whole life. I recognized how this perceived indebtedness to her mother—and I would emphasize *perceived* because it is not always the case that our parents want this—leaked unconsciously into the artistic productions of Maggie, a *vefasiz* child of immigrants.

In another scene, Maggie expresses the tension between loving her mom and also wanting to create her own life: "In 2010, my mom found my blog, so I stopped blogging because now it was tainted, not meant for her to read. So I deleted it and started using the name Suede87. She only found my blog because her friend

taught her how to use the computer. Then I created a new blog to please my mom. The posts were mostly about the music she would like, like Bach. I made this blog just for my mom to find, and she found it and left me a voicemail about it: 'Oh, I love this so much,' she said. I wish I had a recording of that voicemail."[2]

We are burning money. Paper money to celebrate my grandfather's death anniversary. We are in the cemetery next to the highway, and my mom is pretty sure that what we burn—paper houses, paper gold, paper iPhone 13s—will be sent to the afterlife. We're never quite sure of this fact—of what precisely this act specifies—because my mom didn't pay attention to her mom, and my grandma didn't pay attention to hers, so now we're ventriloquizing rituals, poking around the darkness of tradition. At one point, we flip a coin to ask if Grandpa has finished eating the fried snapper and three-layer pork that we brought. He has. We split it between ourselves.

We no longer live in Xiamen, China, where my great-grandparents are from, no longer live in Yangon, Burma, where my mom was born, but today we enact this Chinese ritual as if puppeteered by the past. The papers are seven by seven inches and feature a small swath of gold leaf inset into a larger square, like in a Josef Albers print. Placing a knuckle in the middle of the paper pile, I twist vigorously, which causes the square papers to fan out into a bloom. "We have to make sure that the papers do not fall into the fire facedown," my mom says hesitantly. "Or else they will not be sent to the afterlife."

Is art a burning of some kind? Another esoteric ritual, passed down? Is it a form of time travel, an epistolary fire where the substrate survives? I think of my Sim Setting a TV on Fire.

Between 1997 and 2001, Ken Okiishi made a photographic

series called *Wish I Were Here*. In it, he collages images of himself onto photographs of other young men. In one he seems to cower by a wall, looking out to see if anyone else is coming. Behind him, a black-and-white Bruce Weber photograph of two young sailors kissing is cropped almost entirely. *Wish I Were Here* references a famous series by the photographer Cindy Sherman, who inserted herself into iconic images of actresses from Hollywood films to critique their stereotypical portrayal of women.

"Dear Cindy Sherman, I am lost," Ken scrawls on the back of the postcard below the collage, writing to Cindy. "Not physically, but emotionally. I am on a cruise ship to Greece with my straight best friend, who I am in love with. Acting like 'The Girl' is getting me nowhere with him. Did it get you anywhere? Sincerely, Ken."

To Bruce Weber, the gay photographer: "Does taking photographs of straight boys lying around without their shirts on make them gay in real life?"

To Jack Pierson, another artist, he asks: "Do you fuck all those pretty boys you photograph? Do you find me attractive?" And then, referring back to the photo collage of his unrequited love, he continues, "What if I took off my shirt and were really out of focus? Then would he sleep with me?"

The work tracks Ken projecting his life into art history and into other people's art. I imagine him looking into their faces, searching for something of his own in them. From his own life, he looks into another's for answers.

Dear Ken, did you ever fall out of love with your best friend? Do you still want to feel attractive? Did any of the fires you made keep you warm?

When I finally get around to meeting Ken in lower Manhattan, a few years later after the garage cleanout, I tell him how much

A Model Childhood means to me. He blushes in response to the direct praise, instead telling me more details about the show: how the installation is traveling to Hawaiʻi, where his parents grew up; how his parents were nonchalant about the whole project. As we walk, I ask if he can show me the clubs he went to in the '90s.

Ken has long black hair that falls just above his cheekbones. He wears round black glasses and simple, loose-fitting clothing that is intentional and practical. He does not have an Instagram but does take video vignettes on his phone all the time. When I walk up to him to say hi and give him a hug, he is focused on filming a particularly scenic corner of Tribeca. It's the first clear afternoon after a four-day rain has scrubbed the sky of any cloud cover, and New York feels carbonated by an early fall sun.

"This is where you would line up," Ken says, standing in front of 6 Hubert Street, the location of the former club Vinyl. We stand before a nondescript, redbrick building and lean against the black metal stoop. Vinyl was a mixed club—as in gays and straights. "With a wooden floor that was easy on the knees," he tells me winkingly.

I orient my body to sniff out something of the energy that had once been. I peer into the window and try to conjure up a dance floor obscured with smoke, the smell of poppers. I try to hear the echo of house music fighting for dominance against excited chatter. But there is nothing.

"It's just a building," Ken says.

"It's just a house," Maggie might have said after putting her childhood home up for sale.

"Shpansa Shoo Flee," my Sim might say, standing outside his Sim House on Fire.

It's just a building. And, judging from the designer chandelier inside, it is likely a private residence now. We are looking for ghosts, we are looking for 1997, but all we get is the flat dial tone

of real estate changeovers. We walk around the building to a small alley.

"And this is where you went out to smoke?" I ask.

"Oh no, you could smoke inside," he says with a laugh. "It was a different New York."

When Ken first moved to the city from Iowa to go to school at Cooper Union, New Yorkers already bemoaned that the city was "over." "There were the cranky, eccentric East Village people," Ken tells me, "who rejected anything that had not been there when they first got off the bus in 1970 or whatever. People smoked and drank and never exercised. You went to places that had been there 'forever' and shunned the new."

He points to the sky bridge over the Holland Tunnel entrance. He used to try to catch the sunrise over the water after the club, he says.

Suddenly he turns to me. "Is this good? Is this interesting to you?" he asks.

I nod. We have nowhere in particular to be, and for that I am grateful. I want to be tugged along down whatever memory Ken will allow me to accompany him on.

Ken and I, at the outer ends of the millennial date range, compare notes on being gay in the city. He was born in 1978 and I was born in '95. Sometimes, I am struck by the feeling that I have known him for a while, even though we had only just gotten to know each other last year. We cross the West Side Highway into a shimmering view of the Hudson, and I think to ask about the piers, famous sites for gay cruising.

"When I got here, there was the very public mourning of the piers as a cruising site, by Douglas Crimp types," he says, by which he means primarily cis white gays. "But they continued to be something special for others, mostly queer and trans POC." And indeed, in the mirage of the poststorm sunlight, I did feel like I

was walking through some paradise on water, the lingering history of a former home energizing the possibility of a future one.

"Everyone suffers from this history that has never been properly worked through," Ken has said about *A Model Childhood*, "and it continues to be played out on the faces and bodies of all Asian Americans up to and including in the present."

As I walk east toward Chinatown, I pass tiny bodegas and fancy apartment lobbies, sterile galleries and maximalist boutiques. I pass Sweetgreen and bougie coffee shops and the store signs change their babble from English to Chinese. I pass a karaoke bar I went to with Julie, Michelle, and Ekin last year.

In Japanese, the word *karaoke* breaks down into two words: *kara* for "empty" and *orkesutora* for "orchestra." What a great phrase to describe the feeling of stepping in and out of identity. It captured, too, the rifts between my mom and myself, between Ken and me.

Asian American identity was something so vast and broad that it could not possibly have any kind of coherence across class and ethnic lines—what did we really have in common? Yet, I still felt a lush pull toward this illusion of a shared history. Empty orchestras described this impulse to try to stay together, despite class and ethnic differences; it held both the potential, and the failure, of a place like Asian America.

The pea shoots in my parents' garden eventually scramble up the recycled lamppost and around the gutter, nearly choking the chrysanthemums. They sprout frilly, paperlike flowers. There is nothing edible before the season lets out, but we are proud nonetheless.

My parents and I settle on an unspoken truce. We will throw out the lamppost (when the weather gets colder), stop using cereal boxes and T-shirt mops, and donate the CNN-branded notepads and lanyards instead of tossing them. We agree that some objects have life spans.

Yet we leave the garage messier than we found it. I feel remorse. Didn't my parents deserve a bit of nostalgia?

We are still often opaque to each other. My mom refuses to use the dishwasher because she believes it wastes water. In the winter, when it gets cold, I rub lotion on her hands because they get cracked and dry from handwashing with hot water in the cold air. But even when I buy her gloves she doesn't use them, or when I enjoin her to use the dishwasher instead of handwashing. All of this I think of as trying to ease her labor. She doesn't care. She says she doesn't want to learn how to waste like an American.

When she calls me and I'm working or writing and tells me about these things, about how tired she is or about the cracks on her hands, the frustration that bubbles up within me is plumed in anger. I find myself yelling, shouting over the phone. "Stop washing the dishes! Use the dishwasher! Use the gloves!" Or when she got knee surgery, "Don't cook! Don't stand! You need to heal!"

She does not listen to me; I fear I am speaking in Simlish. I fear that her learned deflection to *not* take care of herself is somehow taking her away from me, that my mom is taking my mom away from me.

Over Zoom, I describe to my therapist that, lately, my mom's efforts to purchase a house have made me feel more and more vulnerable and emotional. My therapist asks why I feel so responsible. I tell her that my parents had immigrated to the U.S. and given

up their support system to let me live the stupid little gay life I wanted to, so doing anything less than trying to help them would be a kind of abandonment.

My therapist asks if my mom has ever said this to me directly, or if this is what I am assuming. I take a minute to think about this.

"Sometimes," my therapist said, "we have to disentangle the relationship between indebtedness and agency. You can help them, but you don't need to infantilize them. They made all this happen, so give them their credit."

In the gray space "after" the pandemic, I put together an exhibition in New York reflecting on my garage cleanout.

I take stuff from my parents' house to make the exhibition, in homage to Ken's *A Model Childhood*. I grab things in the garage by intuition. I made a cursory checklist on the Notes app on my phone:

> *my Telfar bag*
> *my mom's Victoria's Secret bag*
> *a jade plant in a Chia planter*
> *a video by Maggie on an iPhone*

Ekin has the idea to design a cardboard structure to hold everything. I use leftover frames that I got in a MoMA staff giveaway to frame my parents' plane tickets to the U.S.

On the show's last day, my parents drive up to see it.

Actually, they drive up for a dentist appointment in the city, but the exhibition is close by, so it is good timing. I go early to the gallery to make sure all the knickknacks are in place. I nudge the Old Navy piggy bank; I water the jade plant. I make sure the iPhone playing Maggie's video is charged.

wooden croaking frogs from Burma

a Pier 1 Imports pinecone potpourri

a stuffed hamster that sings "Macarena"

I meet them at the dentist nearby. I am not nervous, but I feel sensitive to what is about to happen: Will it mean anything, to see the stuff from our house in a gallery?

I help them drive over. When we arrive we can't find parking on the street, so we decide to go up in shifts. My dad idles the car out front while I bring my mom up the stairs.

I walk into the gallery after her. She does a quick lap. She picks up the hamster and presses the button for it to dance, but it is out of battery. She puts it down. She sticks her thumb into the soil of the jade plant and rubs it between her fingers. She gives me a smile, but I can tell she is distracted because the car is out front.

"It's nice," she says. "It looks nice. Save the cardboard boxes."

When my dad comes up he does a similar lap, even more distracted. He gives me two thumbs-up.

a pineapple-shaped Victoria's Secret sippy cup

two of my dad's watches from Target (unopened, in original container)

a gray elephant piggy bank with a flower bouquet on its head from Old Navy

"Good job," he says, and he means it.

I realize I could have set up a better time for them to see the show, and figured out something with parking, so they would be less rushed. Or I could have invited them to the opening, but those are so chaotic that it wouldn't have made sense either. And a part of me felt squeamish to be so vulnerable with them, and so

I am happy with this oblique anticlimax; I want the guardrails of time and distraction, I don't know that I could bear a dissection.

two McDonald's Mulan spinny tops

a ceramic bunny sculpture

a panda plushie

Afterward, I help them back to their car and I come back to sit in the exhibition, taking one last look at my show before it closes. Instead of admiring the works, I sit in front of the gallery's large front window that looks onto Bowery in Chinatown, and I think back to the opening, when the place was filled with people, and I could look down at a sea of friends.

I see Julie and Ekin standing in a circle, discussing where to get food before the afterparty. Ken and his partner talk to my brothers, Nick and Duke.

I think of a party I'd like to throw. It would be a chic one, but DIY, at some kind of wood-paneled cabin in the woods. Or maybe I could throw it in my parents' garage, friends and lovers weaving between piles of stuff. Or maybe at a Costco, where there are Pizza Bites for everyone. Ken's there. And we're in *The Sims*, and Free Will is turned all the way up. There are people I know, but most of them are friends of friends, and the conversation is buoyed by the potential of new love.

I'm thinking of an intimate fête, a blowout gala, or a weekend rager.

We'll use disco balls like medicine balls and do sets of 3-x-20 ab rollouts.

Our sweat will make the disco light smudge and shoegazey, but we'll still shine.

It'll be medieval-themed. Venue: Halloween garage sale Gay

Prom/Spirit Halloween. We won't eat; there's no need to; we'll eat the moonrise the Prince built; it'll be crunchy. But also McDonald's, because the party's over. It's always starting and always ending, the fashionably late are awkwardly early, and no one's on the list except for you—you're definitely on it, don't worry.

And when everyone leaves the garage, I'll close the light for a minute and sit in the warm, womblike glow of the sun coming through the little panes of glass and the Earth will look like a round blue circle set in the black jewelry box of space.

My speaker will run out of battery, but Robyn will continue playing, tinny and compressed, through my phone. I'll turn up the volume so that here—in this most compromised of euphorias—it will become so dark that I can let my guilt off of its leash, and I'll begin to see what wholeness might mean. I'll place a hand on the mountains of plastic boxes, stubborn and unmoving, and I'll imagine the hum of a thousand lawn mowers, twenty rocket ships, and nineteen space arks. Gods, in tights, falling in and out of love. And inside this garage the size of a katamari Costco, there will be the highest ceilings and room for my mom and all her things will have a place.

FOR EVERYONE

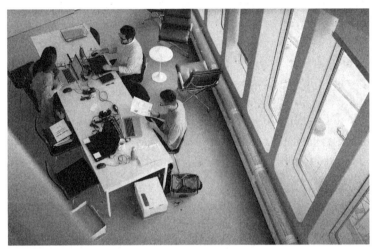

Still from the Whitney Museum internship program video, 2018 with Simon, Rosa, and Alberto sitting in the museum's library. Video by Oresti Tsonopoulos.

It's not a question of being against the institution: We are the institution. It's a question of what kind of institution we are, what kind of values we institutionalize, what forms of practice we reward, and what kinds of rewards we aspire to.

—*Andrea Fraser, Triple Canopy benefit speech, 2023*

For me, dancing is not something I always do in a club environment with other people, but it is something I do to check myself. Like taking the temperature or checking my own pulse.

—*Robyn,* Bon *magazine, 2010*

Somebody said you got a new friend. In her 2010 single "Dancing on My Own," Robyn is on the dance floor, in the wake of a messy breakup, unable to let go of a lover who has moved on. She watches them from afar. She swings between anger, indignation, and even desperation in seconds, a testament to the precision of her lyrics, lyrics she and her collaborator Klas Åhlund spent the better part of two years workshopping. By the time the chorus comes, however, Robyn's bitterness has molted into resolution. Yea, she knows it's stupid. But she just has to see it for herself.

It's a tragic image, and a relatable one—a scorned lover, unable to let go, cast aside, dancing on her own. She funnels her loneliness back into herself and the movement of her body and it dissipates into the potential of the dance floor, where it is admitted into the pop sublime.

But if you *really* listen to the emotion within the song, you might be able to detect, or at least to graft, a feeling of community. Listen to the melody and the beat instead of the lyrics. Listen to it with friends. Listen to it alone, crying, on the Q train from Chinatown to Brooklyn; in a bathroom, as it echoes in the tub; or standing on your bed, sniffing poppers, turning your room into a nightclub with Julie, Michelle, and Rachel amid the pandemic. You may start to get the sense that it is about something more than just dancing.

On my first day as an intern at the Whitney Museum, I met Rosa, who has round brown eyes and a sharp wit and whose parents were from Korea, and I met Alberto, who was soon revealed to be a teddy bear of a friend, the kind who cackles at your jokes and remembers the snacks you like. His parents were from Mexico, and I was surprised that most of the intern group was like us, children of immigrants or people of color, because we were used

to the opposite in art; we worked in lily-white rooms with lily-white people.

We sat at a little table in a big glass atrium of the museum's library and diligently printed checklists and scanned catalogs and did other administrative work that fell under the loose verb of "curating." We commiserated over the fact that none of us could explain to our parents what we were doing. We weren't entirely sure what we were doing ourselves. Was this a real job? How did people make money doing this?

Sometimes, being at the museum felt like being reckless with our futures. This was not the stability that our parents had planned for us when moving to the U.S. Rather than interviewing for some secure corporate position like many of our classmates—high-paying jobs to buy houses with high ceilings—we had chosen to follow our passions into precarious creative professions where few others looked like us and our parents could offer little help. Children of immigrants who pursue creative careers often contend with the perceived opportunity cost of endangering the economic foothold their parents carved out for them.

But still, we felt fancy. We went on internship trips to other museums, artist studios, and galleries in Chelsea. We met with curators and artists and writers. At lunch, we took walks on the High Line to defrost from the museum's AC. We learned what sample sales were and waited too long in line for them. We bonded over our love for Costco.

More than anything, we shared a sensibility. We were children of Tumblr, raised on critical theory PDFs and leftist YouTube. We discussed SOPHIE song lyrics as seriously as we did museum retrospectives; we looked at Balenciaga runways as closely as Marx; queer theory as closely as Britney Spears's Instagram posts. It felt like an ethical stance to decenter our cultural consumption from the hierarchy of fine art that we worked within. Our critique

of capitalism was alloyed by a particular susceptibility to—and interest in—its seductions. Because sometimes understanding the desire strengthened, rather than abated, the want.

One night we stood in line at a truly debased kind of want: to get into the afterparty for the alt-fashion brand Vaquera. SOPHIE was playing. We could see Rickey Thompson, an Instagram influencer, up ahead. An hour passed, and we started to feel stupid. I was hungry, and Alberto and Rosa were, too; we hadn't had dinner, just drinks at an opening.

Another hour passed and we thought about calling it. Alberto, sunny as ever, suddenly felt bad for bringing us there. We assured him it was not his fault. Rosa looked up the nearest subway. I found a McDonald's nearby that we could bail to, and a coupon we could use if we downloaded the app. We had almost settled on our combo order when a metal door next to us suddenly opened, and a few people stumbled out of the party. In the gap, we looked at one another, and then looked at the door. We were still ten or fifteen people away from the proper entrance, where the bouncer was seated. The exit door was heavy, but it paused briefly before swinging shut, just long enough that Alberto could stick a sneaker in between, slowing its path. The moment is etched in my memory, glorified in sepia: the door wasn't ajar, but open long enough to slip through, long enough for the three of us to make our entry.

We scurried down the stairs. The McDonald's app had not yet closed on my phone, and the light from the screen, in whites and french fry yellows and Big Mac browns, lit our descent. Sound from the dance floor made the walls undulate, as if we were traversing some kind of reverse birth canal. The guards yelled after us, but we were so small and so tan and had inspired something— others from the line had come in with us, tired of waiting for no reason. At the landing, we slipped into the red and purple lights downstairs, and became invisible.

Of course, the party inside was underwhelming. No one was dancing, just sitting around taking pictures. There weren't even that many people inside. But we were there for the music, and for one another. We thrashed and spun on the empty dance floor. "We're bumrushing the art world," Alberto yelled, and we laughed, because he was right. We were finding our own way into the party.

I loved working at the Whitney. I was happy being around art all the time, even if I often went days without looking at any of it. Its mere presence outside my office was hydrating. I loved making stupid little maquettes in tiny exhibition models and placing colorful Post-its in exhibition catalogs. I loved the plushness of the carpets under my feet as I made full-color copies at the printer nestled near the curators' glass-walled offices. I felt like the seagulls I could see flying over the Hudson.

The internship fulfilled what I imagined working at a museum might be like, both the monotony of desk work but also the unpredictability and excitement of working around art and living artists. Once, I had to figure out how to dampen the smell of two hundred car fresheners that were being used in an installation so that they did not nauseate the guards and museumgoers. I went to Beasty Feast in the West Village at 3:00 p.m. on a Tuesday and charged three bags of cat litter to a Whitney credit card, and then sat in the loading dock of the museum carefully smothering each freshener in the gray powder, wondering if it could absorb the smell of Mint Green Forest as well as it could cat urine (it did not).

We had arrived at the museum at a tumultuous time. Just months earlier, the museum had descended from the celebration of its new building into protest and controversy. At the latest edition of its famous survey of American art, the Whitney Biennial,

a white painter named Dana Schutz exhibited a painting titled *Open Casket* (2016), based on the famous photograph of the funeral of Emmett Till, a fourteen-year-old Black boy who was lynched in Mississippi in 1955. In an open letter, the artist and critic Hannah Black called for the immediate removal and destruction of the painting, arguing that it perpetuated the violence that it had drawn inspiration from—a white woman using the life of a Black boy.

Black's letter was endlessly dissected in think pieces and op-eds. While there were some supporters, it largely drew sharp criticism; many came to Schutz's defense over the seemingly noble, romantic terms of the artist's right to empathy, or took issue with Black's call to remove and destroy the painting. Writers such as Zadie Smith and Coco Fusco argued that Black essentialized identity and argued that art should not be overdetermined by the races of its makers or subjects.

I agreed with those nonessentializing arguments, but I identified most strongly with Black's provocation. She staked out a critical cultural politics that felt vital and new. It questioned whom a museum was for and by whom its exhibitions were made. It insisted that art was not exempt from the racial dynamics of the rest of the world, no matter how beautiful or transcendental it might aim to be. Even if we could debate the letter's exact semantics, to me, Rosa, and Alberto, Black's argument was an emotional declaration of exhaustion. It vocalized a frustration with the art world's empty gestures of politics and identity rather than systemic, structural change—the administration of diversity rather than a rethinking of why diversity was needed to begin with.

It was at an opening at the Chinatown gallery 47 Canal, on an evening after a late day at the internship, that I saw my first Telfar bag. Rosa and Alberto were busy that day, so I went alone. I didn't

know anyone, but I recognized artists: people whose work I had seen in museums and galleries. Anicka Yi, dressed in a light-blue Fendi jumpsuit with matching gloves, stood out. She made sculptures out of unconventional materials like spit and bacteria. She was receiving long overdue attention for her work, with several large museum shows, and I was in awe. On the V of her elbow, I spotted a little square baggie with an unmistakable logo: a *T* inside of a *C*. It was shiny and mysterious, understated yet glaring. The fact that Anicka, a successful, critical artist, was wearing it made it even more alluring to me.

In 2018 New York, a Telfar bag—a boxy purse modeled after the proportions of a Bloomingdale's shopping bag—was to be immediately identified and desired, hard to get a hold of via the brand's elusive drops. Founded in 2005 by Telfar Clemens, a young Liberian American from Queens, Telfar is a unisex fashion brand that he describes as "genderless, democratic, and transformative," built around a community of creatives who have historically not been represented in fashion.

After that night I started to notice the bag around the city, at LES openings and magazine parties and galleries. Artists I admired posted stories with the bag on Instagram. I counted and recounted how much it would be to spend a month's grocery money on a handbag, on a piece of candied rebellion. Compared with other luxury handbags, which may go for thousands of dollars, Telfar's prices are relatively affordable: the bag comes in three sizes and ranges in price from $150 to $257, numbers based on how much he would make on a given night DJing. Since they were first released in 2014, Telfar bags had grown into a symbol of identity not only for many artists and creatives, but now also for a worldwide celebrity clientele including Beyoncé, Oprah Winfrey, and Alexandria Ocasio-Cortez. The bag's covetability and the fact that it sells out within minutes have earned it the name the "Bushwick

Burkin" after the luxury handbag from Hermès that goes for upwards of $30,000.

To Rosa, Alberto, and me, getting a Telfar bag was more than just an acquisition of a status symbol, it was an act of support for a figure who was unapologetically queer and Black. Telfar had found success in the fashion industry, which—like the culture surrounding the art world—had historically rejected people like him. Getting a Telfar bag would be a rejoinder to what was happening at the Whitney; a way to show allegiance to a future that was dedicated to the vanguard Hannah Black had outlined. We felt a kinship.

Telfar also seemed to symbolize a certain disregard for the mainstream. He rejected Met Gala invitations, ended his wholesale business to better control his sales, ignored the fashion calendar, and catered to the crowd that he valued most: his friends and family. For his first show in Italy, he rented a palace where his friends, including such famous Black luminaries as Solange Knowles, Kelela, and Kelsey Lu, could join him for a dinner and a sleepover, the aftermath of which was presented as the "show" to the public. "The master's tools and money were being used to destroy the master's house," said Terence Nance, a filmmaker who was there. "Or at least throw paint at it that he can't get off."[3]

Even if renting a palace is not quite destroying the master's house, there was something of this rebellious energy that we were still intrigued by. While we sought our way into the traditional art establishment, we were beginning to sense that what was happening outside of it was just as, if not more, vital.

The biennial closed just days before we arrived at the museum, but somedays we could still feel its aftershocks. It felt like no small coincidence that our intern class was the first to be paid a sizable stipend—five thousand dollars for the summer, the most of any

museum internship at the time, likely the result of years of internal work and external pressure.

We eyed our relationship to this diversity and inclusion warily, suspecting it might come with a price. Some of us were asked to feature in a promotional video for the internship. Alberto had been tapped for a longer interview, but Rosa and I had not, and we joked that our backgrounds were not sufficiently oppressed to make for good diversity video fodder. Watching the video later, we saw the other interns, our friends, as they walked down the High Line, smiling, laughing, likely talking about how odd the circumstance was, their colorful faces an adornment to a voice-over testimony. It was 2017, and Trump had recently been inaugurated, so our jobs were our jobs, but also, apparently, historical absolution for the institution, for all the people of color it had not hired. We were reluctant poster children for a future that had not yet materialized, and we were unclear what our entry into this system meant.

We waited diligently until the next online drop. I ordered a Telfar bag in green; Rosa, in black; and Alberto, in gray.

Born in 1985, Telfar Clemens had a childhood typical of many first-generation creatives—an escape from war, an encounter with American culture, and an origin moment with his art, in this case a sewing machine. Telfar's mom sent him and his brother away from Liberia, where a civil war was fomenting, to live with their aunt in Lefrak City, Queens, in 1991.

The first time Telfar came to his aunt's apartment he opened the fridge and it was full of Butterfingers, Twix, and other American candies. In Liberia, most of the music, videos, and pop culture he consumed was American, but now he was at the source. He watched MC Hammer dance on TV; he heard the lilts and runs of Tina Turner and Whitney Houston. Telfar and his aunt lived

down the street from a White Castle and a McDonald's, and because there was no fast food in Liberia, where Telfar had mostly eaten rice and chicken, he saw hamburgers and pizza for the first time—the food that the Teenage Mutant Ninja Turtles ate. He had his first Happy Meal.

Telfar was placed in an ESL class when he started school at New York's P.S. 206 because he had mostly been exposed only to Liberian English. He had a hard time settling in initially. But then something resonated: instead of writing each student's full name on the board, his teacher used a monogram with each student's initials. His mom had named him Steven, but his grandfather had looked at him and told her: "He needs a better name. He's not a Steven. He's a Telfar." People told him it meant "star," but he couldn't find that definition anywhere online, although there is a diamond mine in Australia named Telfar.[4] The teacher drew the letter T inside of the letter C, and this logo would come to adorn his notebooks and replace his signature. Steven Clemens, the child of immigrants, had remade himself as Telfar Clemens, the American artist.

In 1993, Telfar moved with his family to Gaithersburg, Maryland, where he would spend his adolescence. At around the age of fifteen he started deconstructing and constructing clothing, selling them to his friends, who were mostly in the local nightlife scenes. At the end of high school, he thought he needed a backup job so he enrolled in Pace University, where his father went, and he started studying accounting. It was mostly an excuse to move back to New York, and he'd spend most nights in clubs and fake his way through school in the morning. He sold clothing to his friends, and sometimes on the street. In 2004, he caught his first big break selling T-shirts through Vice Media's now-defunct retail store and in 2005, he launched a label under his own name.

One of the first things he decided was his slogan: "Not For You—For Everyone." It was important that the garments be unisex,

and genderless—a concept that was at the time almost nonexistent in the world of designer fashion. His first collection, in 2005, was mostly built on his background of deconstructing and reconstructing basics into modified T-shirts, sweatpants, hoodies.

From the brand's inception, Telfar has been coy about his relationship to "diversity." Although the press likes to use words like "inclusion" regarding Telfar, it's more appropriate to characterize his work as embodying a tension between inclusion and *exclusion*, rearranging those terms to suit the needs of his market. "I don't think our story is one of inclusivity," Clemens said in a 2021 interview. "Our aim isn't to be included in the fashion industry—but to exit it. We are selling to a different customer. When you talk about inclusivity you have to ask; included in what? Who owns the world?"[5]

This tension is embodied in Telfar's slogan: "Not For You—For Everyone." It is a slogan that suggests a rejection of individualism for a communism of style—so long as you have $150 to spend. "Not For You" suggests an exclusion of "you"—the reader, the consumer—but also maybe a rejection of the establishment. Meanwhile, "For Everyone" paradoxically suggests an inclusion of all people in fashion terms—all bodies, all shapes—perhaps even of the reader who was initially excluded. It is a slogan that my boyfriend Ekin says could be written above the door of the Communist Party headquarters in Moscow, but instead we find it here, in America, at the center of Bushwick's queer renaissance, not as politics but as consumerism.

I would go home periodically to the suburbs of Philadelphia to pick up food and hang out with my parents. I'd take the NJ Transit and my dad would pick me up at Trenton, asking how the last few weeks had been, if I'd eaten the food my mom had packed. At home, the energy of New York and its cultural debates seemed

to dissipate. My parents wanted to know if the internship would lead to a job; my mother reminded me it wasn't too late to go to medical school.

The first time I showed my mom a Telfar bag, she pulled at the seams. She rubbed the material between her fingers, pinching the embossed logo. Then she asked me how much it cost.

I told my mom that it was a fashionable bag in New York, particularly among artists and creatives, and that it was made of something called vegan leather.

She turned the bag inside out. "So it's fake leather?"

Her go-to handbag—a pink, ruched number—was from Victoria's Secret (*Victoria* to my mom, like a good friend). She had purchased it for $10, reduced from $90 after a deluge of coupons. When I told her I had paid $150 for my bag, she gasped. "For that?"

In 2013, Telfar and his newly minted creative director, Babak Radboy, had the idea to bring on an unexpected collaborator: the mass-market retail chain Kmart. At the time, Telfar was widely viewed as an avant-garde brand, mostly catering to art-world and fashion types. He was virtually ignored by most mainstream fashion press. But Radboy imagined that this "downmarket collaboration"—as these kinds of maneuvers are called in marketing—would be a tongue-in-cheek way to riff on the brand's ethos of inclusion/exclusion. On the top floor of the New Museum, in a spare, gallerylike setting, models walked down the runway in elongated T-shirts, past clothing racks inspired by Kmart's retail spaces. A seven-foot-tall statue of the designer loomed over miniature replicas of the models. On the way out, attendees were given small shopping bags with Telfar logos to take away. People took a liking to them, and they grew into the infamous bags of today.[6]

In addition to Kmart, Telfar has launched other downmarket collaborations with brands like Budweiser, Eastpak, UGG, and White Castle, drawing on the products of his childhood as an immigrant in the U.S. In January 2019, a collaboration with Gap was announced, although it was put on indefinite hold after the pandemic. Avena Gallagher, his stylist and collaborator, has described how Telfar has always been interested "in what everybody wears rather than what the rare person wears."[7] This fascination for the authenticity of the "real" or working-class people in fashion isn't particularly new (take Balenciaga's Spring/Summer 2017 IKEA bags, for example) but Telfar's appeal to the "everyone" feels different.

Telfar's brand plays with the iconic symbols of the working class—beer, hamburgers, retail clothing—but melds it with the shine of Black celebrity—Hennessy, fast cars, gold chains. The thrill associated with this kind of conspicuous consumption comes from how it plays against the norms of a creative class that often prefers *in*conspicuous consumption. Sociologist Elizabeth Currid-Halkett, in her 2017 book *The Sum of Small Things*, coined the term "aspirational class"—an NPR-tote-carrying, yoga-practicing, Whole Foods–shopping group of neo-yuppies who find it gauche to flaunt wealth through brands, preferring instead to spend their money on goods and services.[8]

At the Whitney, I was becoming a part of this aspirational class, around coworkers with their *New Yorker* tote bags and unbranded, expensive basics. I could feel those tastes leaking into me, and I wanted to resist. Telfar, in its revamped version of *conspicuous* consumption, felt radical in its rejection. It was an alternate version of aspiration based on Black and queer celebrity, that might open a world to a more progressive cultural class. Although this world still wasn't completely in reach, considering how little I made at my internship, I liked Telfar because it seemed to include people

like my mom, at least symbolically, through its "downmarket collaborations."

But although the bag might draw inspiration from people like my mom, who loves Victoria's Secret, Telfar's high-fashion transformation of the "every person" sensibility (on top of charging $150 a bag) paradoxically rendered it inscrutable to her. Or at least uninteresting. She much preferred her Victoria's Secret bags, and I was beginning to think they had more in common than I initially figured. The Telfar bag, and the renaissance of identity, art, and commodity associated with it, is as much a product of a certain class aspiration—a dream of American ubiquity—as the buying habits of my parents were.

These conflicts map the emotional and aesthetic landscape of class aspiration, the rifts that open by generational differences in education, immigration, or occupation, and the art that is made, and left behind, in the process.

Because even if I bought my mom a Telfar bag, I don't think she'd use it. It's not really her style.

On a lunch break from the Whitney, Rosa, Alberto, and I found ourselves in front of a wall of beads that had been strung up like a suspended waterfall. They rustled slightly when we walked by them, shimmering around our bodies. The beads reminded me of the curtains my mom put up to separate the smells of the kitchen from the living room, but also the curtains in the bodega backrooms on my new block in Brooklyn. Encountering these "home" aesthetics in the cold, unsparing space of the gallery filled me with an odd sentiment. Stripped of their warmth and context, I could appreciate them anew, but I also could barely recognize them for what they were.

Standing on one side of the work, squinting my eyes, I felt

that I could conjure the mirage of all these versions of home overlayed. *Untitled (Water)* was a 1995 work by the Cuban American artist Félix González-Torres, who was having a small survey of works at a gallery near the Whitney called David Zwirner. Born in Guáimaro, Cuba, on November 26, 1957, Félix became famous for works like that bead curtain, for the way that they proposed a radical openness of meaning. After studying art at the University of Puerto Rico in San Juan, at the age of twenty-two, Félix moved to New York to pursue a career in art making. He studied photography at Pratt, but his real awakening was the Whitney Independent Study Program, a yearlong reading seminar separate from the museum for artists to study the relationship between culture, artworks, and institutions with an anticapitalist bent. (I would attend the program two years after working at the internship.) Emboldened by more experimental practices, Félix started making spare, minimalist sculptures that he called "open works"—stacks of paper, strings of lights, billowing curtains.

In the 1990s, as his friends and his lover, Ross Laycock, contracted HIV and began to fall sick, his work turned increasingly to grief, although still within the terse visual language he had developed. He orchestrated displays that were spare and poetic, often with components that the audience was meant to take away. *Untitled (Water)* might reference the curtains his mom used in his own upbringing in the Caribbean, the language of minimal art that he developed as an artist in the 1990s, or the thin barrier between life and death he witnessed so often as a gay man during the HIV/AIDS epidemic in New York.

I recognized the same tension between inclusion and exclusion I saw in Telfar's work in Félix's. Félix sought to weave his identity into form in innovative, sometimes illegible ways. He famously never wanted his photo taken, and he rejected biographical readings of his work. In the '90s, the culture wars raged as Senator

Jesse Helms attempted to ban art that spoke explicitly about HIV/AIDS or homosexuality, so Félix's obfuscation was partly strategic. All of Félix's artworks, with a few exceptions, are titled *"Untitled"* in quotation marks, sometimes followed by a simple parenthetical title. His titling mirrors the openness of his work—a blank slate, a suggestion of something to fill it with. He called this kind of identity art "being a spy" or "guerilla warfare."

It was an obfuscation that had taken place on the battleground of his own name. While he was alive, Félix asked for the diacritics to be removed from English publications of his work. It is a wish that his estate carries on today, and a fact that others, including myself, initially misunderstood as a whitewashing of his legacy. The reality, of course, is more complicated—he might have done this in an effort for his work to be understood without handicap or guardrails; he wanted the specificities of his life to be universal, not relegated to the particular. His decision to remove the diacritics from his name speaks to the conditions that his work was presented in at the time, where perhaps he had to divorce his home self from his arty New York self to be taken seriously. I've returned those diacritics to Félix's name here, with all of the potential problems of the gesture, because I want to conjure the version of Félix that Rosa, Alberto, and I saw in ourselves, the one who came from Puerto Rico and went to a gallery for the first time and decided to make art that both obscured and transformed his identity. We needed both Felix and Félix, Steven and Telfar, to exist in print.

Although his work spoke to grand conceptual issues of form, such as the public-vs.-private divide, they were often dedicated to just one person: his lover, Ross. "When people ask me, 'Who is your public?'" he would say in a 1995 interview, "I say honestly, without skipping a beat, 'Ross.' The public was Ross. The rest of the people just come to the work."[9] It was for you, Ross, not for everyone.

Félix and Telfar are queer, diasporic artists—one working in art,

the other in fashion—who responded to the demands of institutional diversity, to the demands of being "for everyone," in different ways. Telfar inverts diversity; rather than being a token, he built a brand around the idea that he—a Black, queer immigrant—is already "everyone." Buying his products allows you to participate in this proposition. For Félix, anyone can participate in a work like his candy spills or curtains—you can pocket a sweet, or walk through the beads, or take a poster. But ultimately the work is neither about nor for you. It was for Ross. "Everyone" is an impossible construction; it will inevitably exclude. A project's character is ultimately defined by the character of that exclusion.

In 2019, the Whitney opened the next edition of its biennial. Curated by two women, one of whom is Black, the 2019 Biennial was by representational standards an absolute triumph, with record-high percentages of women and artists of color. But the show was soon clouded by its critique, yet again by Hannah Black and by writers Ciarán Finlayson and Tobi Haslett. In an *Artforum* op-ed titled "The Teargas Biennial," the writers demanded the resignation of Warren B. Kanders, a member of the museum's board who owned investments in Safariland, a company that produces tear gas canisters that had been used against protesters in Ferguson, Missouri, against Palestinians, against migrants at the U.S.-Mexico border, and at other sites of state violence. Black and her cowriters argued that the museum was "artwashing" this money through diversity and inclusion, while implicitly perpetuating the very conditions of control, violence, and exploitation that the artists in the biennial sought to combat.

My earliest years in the art world were defined by this "failure of identity politics," a phrase scholar Keeanga-Yamahtta Taylor develops in her 2012 book *How We Get Free*. In 1977, the Black

feminist socialist group the Combahee River Collective coined the term "identity politics" to describe an intersectional politics rooted in their personal experiences as Black women, experiences that had long been denied as human. Class, race, ethnicity, and sexuality were all shifting factors that could be used to build coalition across categories. Yet in the late 2010s, the primary way I encountered identity politics was through consumption—in a handbag, in the representational politics of the museum, and in the marketing tactics of large corporations. And arguably I saw the most successful, and pernicious, use of identity by conservative politicians in the wake of Trump, who leverage white supremacy and nationalism as the basis for a political party.

The malaise that I felt working at the Whitney, uplifting artists of color and queer artists and so on, was that much larger, deeper problems were underfoot. Even as curatorial and artistic endeavors became more diverse, museum boards—key decision makers in questions of museum finance and investments—were still primarily white and wealthy. Or, that even as the Whitney Biennial and other institutions became demographically more diverse, unionization negotiations for fairer wages and better health care at the Whitney, the New Museum, and the Philadelphia Museum, to name just a few, were ongoing and embattled. Somehow, working at my little cubicle to "uplift marginalized voices," I felt that I was participating in an artwashing process. It was hard to hold on to moments like my experience at Félix's show, where I was moved into a kind of artistic transcendence. I wondered how and in what circumstances an artwork could transcend its political context, and what the nature and utility of that transcendence would be.

Despite my disillusionment with the artworld, and the failures of its identity politics, Telfar had proven to survive those discourses. His

brand was quickly becoming a global phenomenon. On the heels of high-profile collaborations and the popularity of his eponymous bags, Telfar was selected as the recipient of the 2017 CFDA/Vogue Fashion Fund award. After his site crashed during one of his bag drops in 2020, Telfar announced a bag security program, where people can preorder bags within a specified twenty-four-hour period, with confirmed delivery. The first bag security program brought in more than $20 million, catapulting their small operation into a global brand.[10]

His project of being "for everyone" was looking less like inclusion and more like that old specter of success: the American dream. Telfar is something of a modern-day Warhol—another immigrant artist born to working-class parents who aspired to ubiquity. "I just want to be everywhere, truly global," Telfar said in 2020. "I want to dress everybody."[11] When he says "everybody," he's not only talking about everybody in Hollywood—he really means everybody. He further explained to *Dazed*, "I want to be mass-marketed in a way that's scary. It's like a Michael Kors bag. Everybody has one of those. But it's even dumber than that. I want to be Michael Kors, but on purpose."[12] He wants his brand to take its place among other American "lifestyle" brands that sell the basic clothes that "everyone" wears—Polo Ralph Lauren, DKNY, Calvin Klein. "I'm American," he has said. "There's no reason this can't work."[13]

I still wear my Telfar bag a lot. I own a few pieces of his clothing, and I follow his career like I would any artist. But sometimes I sling it crossbody with the logo facing my body, embarrassed about telegraphing a brand allegiance so blatantly. I wasn't sure exactly what I was subscribing to anymore, and if his project really was for me. More than that, I was beginning to think that I had attached more radicality to Telfar's project than he ever actually ascribed to it himself. Even if he danced around the language of

inclusion and diversity, at its core, Telfar is a brand, and a business. And I wondered if I should be more pragmatic about those policies; after all, it had gotten me to the museum.

Telfar spends nearly six months of the year in Hong Kong, working closely with a manufacturer named Joice Group Ltd. A full-service manufacturer established in 1990, it also produces clothes for luxury brands like Alexander Wang, Juicy Couture, Yeezy, Aimé Leon Dore, and Givenchy.[14] Most of Joice Group's products are made in Asia and then live their lives elsewhere, in a diaspora of objects that is so commonplace we don't think about it.

Telfar's engagement with Chinese manufacturers is about the bottom line, like any other fashion company. "The thing about producing in China," Babak Radboy said in an SSENSE interview, "is that it makes it possible to actually work on a garment. . . . Like, if you want to make a change in the late afternoon, you can see it that night. Whereas in New York you'd give it to someone, they'd come back in four days, and there would be a bill for $700 to change one seam." In the same interview he goes on to disparage the press's exaggeration of the working conditions of "Made in China," calling it pure propaganda. "Luckily the Chinese have never fucking cared," he says. "I think they're a model to the rest of us."[15]

All fashion sells belonging; Telfar is no different. But was it now "marginalized" people's turn in the Global North to exploit the Global South? Is this the queer vision we wanted, financing Brooklyn's art projects with Chinese laborers on the operating system of the American dream?

After school, Rosa started working at a gallery in Harlem. After it folded during the pandemic, she moved to L.A. to work for a larger gallery. Alberto moved back home to Nevada and studied to

become a psychotherapist, all the while running a local art space. Although we live in different cities, we find a way to see one another every year; we have bonded over various milestones—Rosa taking her mom to vacation in Paris, Alberto spending a summer in Japan.

At one point that summer after the intership, I decided to set up an apartment show with my roommates Sydney and Colleen. We cleared out the furniture, wrote up a press release, and made little labels for each of the artworks. We called the show *close quarters*, because we were all interested in intimacy, but also because we lived in tiny apartments. We invited everyone we knew and set up the opening as two consecutive nights of parties. The exhibition wasn't for everybody, maybe at least not yet, but it was for some of us, for our friends, and that became a microcosm for how we wanted to engage with the artworld. It was our way of building out our own circles, and it felt like the beginning of creating trajectories that didn't have to end with museum attention, or global brand domination. I imagined it might have been what the beginnings of Telfar's project must have felt like, the years where he worked and the fashion institution paid him no mind, when he made clothes for friends and family.

Later, in the midst of pandemic isolation, Julie, Michelle, Ekin, and I made nightclubs out of our apartment; we danced with Rachel, Julio, and Jarron in bedrooms and flicked light switches and yes, sniffed poppers, again, to simulate the dance floor. We played our own music. We worked our way through a list of hits—from SOPHIE to Toxic to Twice and, in the late hours, to "I Wanna Dance with Somebody" and "Dancing Queen."

And to "Dancing on My Own," of course. Robyn's spirit of independence and resilience soundtracked my time at the Whitney. I learned that she signed a record deal at fourteen, based on a song

she wrote about her parents' divorce at eleven. That she rejected a contract with a major U.S. label because the terms limited her creative freedom. (The alternative that Jive found was a fifteen-year-old American teen named Britney Spears, someone the label thought "could be an American Robyn—a Europop teen queen, with an added dash of girl-next-door."[16]) I learned that in 2005, after two albums in the pop machine, Robyn founded her own label, Konichiwa Records (a name so cringe it might even be vaguely Asian) to further preserve her artistic freedom. "I knew I could change the structure from the bottom up, but it wasn't something that I could fix within the system," Robyn told *NME* in 2020. "I spent so much time trying to do that, and it got to a point where I was like, this is not going to work. It was definitely disconnecting that helped me do what I wanted to do."[17] Robyn redefined her audience by building her own record label, and this redefinition—like the Black, queer immigrant of Telfar's "everyone," or Felix's Ross as "everyone"—is the radical act.

Robyn is a pop star's pop star, and her rebellious energy is imbued in the sorrow and joy of "Dancing on My Own." If the art world was an unrequited lover, or an ex, who it would be better if we moved on from, then "dancing on our own" meant making our own rooms rather than pursuing the hallowed halls of the institution. This didn't mean that we didn't still yearn for a toxic relationship, that it didn't bring us to making poor decisions (*I'm so messed up / I'm so out of line*). But in the face of crumbling institutions, we danced to survive, as Robyn herself hinted at in a 2010 interview:

> I dance a lot by myself. I dance at home, when I brush my teeth. It's not even real dancing to music every time, but it can be that I just do things with my body, or with my hands. For me, dancing is not something I always do in a club environment

with other people, but it is something I do to check myself. Like taking the temperature, or checking my own pulse.[18]

The emphasis she places on danc-ing, *dan-singgg*, seems to suggest that it might also be like persisting, loving, alive-ing, running, building, moving, despite the absence of attention from an entity you once thought you needed. It is a method of navigating desire and power.

To dance on our own is to move from critique into joy. It describes the feeling of Robyn's song—a bedrock of sadness with a vaulted cathedral ceiling of elation and possibility. I don't mean to suggest that we should leave critique behind, but that joy is a kind of existence that doesn't rely on being against anything, it just *is*. To approach identity with the utmost sympathy for the kinds of belonging it might promise, and to look beyond it—this is what it means to dance on your own. I want us to dance in spaces where we never had to fight to belong.

VAGUELY ASIAN

Storefront of the East Broadway Mall at 75 East Broadway in Manhattan's Chinatown. Taken November 3, 2023, by the author.

When you think about it, department stores are kind of like museums.

—*Andy Warhol*

Hitcha gaw gaw, breeza subuwah
Imma kwee kwah abah weena hah kah

—*Robyn, "Bonichita Kitcha" (the Simlish version of her 2007 single "Konichiwa Bitches" recorded for* The Sims 2 IKEA Home Stuff)

The Gallery Mall in downtown Philadelphia announces its presence in old-school marquee lightbulbs, all the letters hunched together like a family standing against the wind. Within its maroon-tiled halls one could find a food court, a train station, and a mixture of budget department stores like Old Navy, TJ Maxx, and JCPenney, the last of which routinely sent coupons to my family with the irresistible provocation to take $15 off your purchase of $25 or more. Like many born in the '90s, I divined my earliest ideas of design and style, of gender and conviviality, from the mall.

All of my life has been lived inside of capitalism, even all those places where I read about how to escape it, and so it was at JCPenney that I was weaned on my earliest lessons of the deal. We never bought things at full price because what you paid for in full price was time—the ability to wear a garment that was of a moment. It was a tax we didn't care to pay. And focusing on getting things cheap, we believed, literally made us more stylish by imposing an arbitrary set of limitations.

At JCPenney I hid in the canopies of dresses when I was still small enough to do so, imagining them to be soft cathedral architectures, and my mom would pull me to get my opinion on a blouse or a top. I lingered by the underwear models, pulled in now obvious, clichéd ways to their sex. There were kind cashiers who smudged the rule that we could only use one coupon, asking us with a wink to do a quick lap and come back as "Jack" or "Paul" instead. I liked pretending to be brand-new. The glamour of the deal produced its own style and lifestyle. The lore of a purchase imbued our garments with a lucky pallor, a charm derived from the adrenaline of coupon-aided theft.

The clothes we bought at JCPenney were "outside" clothes. They were clothing my parents bought for my brothers and me to wear to school and school assemblies—stiff polos, khakis, Levi's

blue jeans, Van Heusen shirts. But at home we wore "home" clothes. These were more comfortable, but they were also more Asian, because they were usually made from fabrics from China, by way of Burma. Soft flannels with small, dancing animals impossibly anthropomorphized; loose-fitting, bouncy, plaid shorts; the occasionally longyi. I never wore "home" clothes outside because they were pajamas but also because they seemed too delicate to survive the world. I got used to shedding my "outside" clothes once I passed the threshold of home, like an actor coming offstage with a relieved sigh.

My mom keeps suitcases full of fabrics that feel like neither "home" nor "outside" clothes—celadon-colored satins and shimmery plaids from Burma that she had saved to make clothing for special occasions. That stuff never really interested me as a kid. I wanted a skater hoodie to match my sideswept bangs. Or a shirt from Old Navy that looked like it was from Abercrombie. But sometimes I'd ask her to pull the suitcase out just to look at the fabrics. They smelled of mothballs, a smell that I like now, which added to the feeling that they were relics of styles and homes past. They rested in wait for a time when their use might present themselves again.

Julie and I are shopping. She had just started a job as a paralegal and I had started a fellowship at the Brooklyn Museum after my Whitney internship. Disaffected, both of us, at the pinnacle of our youth, by jobs that required long hours in front of a computer, we Facebook-Messengered each other about Jia Tolentino articles, weird Issey Miyake bags on SSENSE, and bizarre posters for raves happening on the weekends ("????"). A friend told us about this store that was also apparently an artwork, and we decide to go.

A mannequin made of tape, cardboard, and papier-mâché reclines on the floor, propped up on one elbow, looking down at a paper iPhone. Garments hang sparely on bamboo poles around the perimeter.

"This is cute," I say, picking up a cropped vest made of smiling cartoon bear plushies. "It's reversible," I add as I turn the garment inside out, revealing a shimmery inner surface.

Julie nods. I pick up the label, printed on stiff paper, and peek at the price—$250. I show it to her and we raise our eyebrows together.

"I think my mom got an entire sack of pajamas with patterns like that for twenty-five dollars," I say.

She thumbs quickly though the other garments. There are puffy, stiff jackets made of packing blankets; shimmery suits in flowery patterns; latticelike tops to be draped over plaid dress shirts.

"This reminds me of the pajamas I used to wear when I was growing up," I say, measuring the cropped jacket against my chest.

"Asia," she says, definitively, before she is interrupted by the wonder of a dress with a stuffed animal in its lining. "*Kawaii.*"

We are standing in *Cover Street Market*, an installation by the art-fashion collective CFGNY. It has been made to resemble the high-fashion boutique it borrowed its name from, Dover Street Market, but with more humble materials—plastic, cardboard, tape. Their name stands for Concept Foreign Garments New York, or Cute Fucking Gay New York, but also sometimes Crime Fracture Gross Nasty Yummy, or Cutting Fried Garlic Near You, or whatever other acronyms they can think of; CFGNY has multiple names to reflect the shifting nature of their collective.

Julie points to the floor. A small display of stuffed animals,

PlayStation controllers, and woven sheets of leather parody a shop display, but with a stuffed bunny splayed out on the floor like a tired shopper.

CFGNY coined the term "vaguely Asian" in 2016 to describe this aesthetic.[19] It's a term they prefer to keep intentionally ambiguous. But they generally use it to refer to a shifting set of symbols, experiences, and relationships shared by people with similar migration histories from Asia. In a 2021 interview, they describe it more simply as "Getting things cheap and loving deals," and a "feeling, or notion of Asianness, that isn't really Asian, that connects us."[20]

In CFGNY's first collection, *Subtitled*, which hung on wooden rods in the perimeter of the installation that Julie and I were standing inside, the "vaguely Asian" manifested in a mixture of nostalgic references and a patchwork aesthetic. There were simple button-down shirts that seemed to be "infected" with strips of plaid; minimalist jackets revealing cute animal cartoon prints; sheer panels and strategic cutouts that hide and reveal the wearer. Other materials pointed directly to Vietnam, where the clothes were made in collaboration with local tailors: leather from a motorbike seat factory on the outskirts of Ho Chi Minh City, trousers made from recycled woven plastics used to create plant canopies. In later collections, they would incorporate more idiosyncratic references, like Rei Kawakubo's lumpy dresses, the industrial grunge of Bushwick's queer scene, and the oversized suits and jelly slippers of elderly residents in New York's Chinatown.

We didn't end up buying anything that day. But I was struck by how the clothing made me feel. CFGNY had brought together "home" and "outside" clothes in a way that scrambled what either of those might mean. These were aesthetics that I had forgotten about since moving to New York. That I had willfully left behind

to ascend into an arty creative class, that I thought had no place in my new, adult, queer life.

On my Notes app, I start a running list of "vaguely Asian" things:

Paris Baguette
remote controls wrapped in cellophane
the sound of taking slippers off in front of a door
Louis Vuitton bags (real and fake)
Danish butter cookie tins
loving deals
stuffed animals
pasta

Earlier in the summer, Julie and I had gone to our first Soul-Cycle class together, somewhat ironically. We walked out of it, flushed, a little disoriented, and, despite ourselves, kind of liking it. Pretty earnestly. At SoulCycle, I felt that I was staring into the most perfect performance-art installation to encapsulate our current moment: a machine that wanted me to become a machine, to create a more aerodynamic version of myself through EDM, sweat, and vaguely Eastern spirituality. Intellectually: indefensible. In practice: really fun.

We explored this dichotomy in notes that we collected in a shared Google folder we called "capitalism is fun and convenient." When I look in it now, it has a picture of Amazon dash buttons (where you instantly order an item when you press a button), a *New York Times* article called "Why Are Young People

Pretending to Love Work?," and a note from Julie that reads: *That one time this dude on Tinder asked me if I had a linkedin, said I had a "linkedin vibe?"*

Julie has always had a shrewder outlook on cultural politics. Too often I was dazzled by exercise classes and fashion runways, the shiny baubles of capitalism. I romanticized the radical claims of contemporary art. Part of this was from being at the Whitney Independent Study Program (ISP), which was its own intersection of art and capitalism. Founded in 1968 as the first education department of the Whitney by a man named Ron Clark, it soon moved to a separate building so that its participants could more freely reflect on their relationship to institutions. It had produced generations of socially engaged artists who critiqued the museum and larger institutions everywhere; the artist and critic Hannah Black, who penned the letter of protest against Dana Schutz, was a graduate of the program. Yet it was not without its own contradictions, its own tendencies to get wrapped up in too much critical theory.

Out of the seminar room, Julie would always steer me, gently, back toward more material questions: What is this cultural thing claiming to do? Who is it actually for, and what is it doing for them?

After SoulCycle, we go to a Froyo place downtown and reflect on the class.

Did you cry? I cried. We sit underneath a wall of fake vines. Pink fluorescent lights cast a glow on our faces. The only other person at the counter, wearing a black cap, presumably also Asian, watches videos at full volume on their iPhone. A neon sign on the wall misinterprets the 2010s ism "It's Lit," saying instead:

"It Lit."

It is so close to the original, yet in its asymptotic difference, it is a world away.

"Very vaguely Asian," I say, and Julie nods.

Later that night, CFGNY throws a party. The installation's lights are dimmed to purple. Tin Nguyen and Daniel Chew, CFGNY's original members, are in attendance. They first met in 2013: Daniel worked for the artist Kerstin Brätsch, and Tin was studio mates with the artist Debo Eilers, who collaborates with Brätsch in a collective called KAYA.

I met Daniel and Tin for the first time that night. In my mind's eye, Daniel remains the way I met him then, kind and smiley. I was happy to meet another Burmese Chinese person. He wore a pair of dark blue pants whose legs flared out in a way that felt, at the time, inaccessibly stylish to me; something I didn't even have the proper context or set of eyes to appreciate. Tin had a more severe look, wearing a pair of plaid shorts and a sweater vest baring his arms. In the small kitchen in the back, a few open bottles of wine were laid out with plastic cups. There was a DJ, an Instagram star, and his boyfriend. Julie and I observed the sharp litheness of their modellike proportions from afar.

Tin and Daniel both moved to New York in 2006—Tin to study art, and Daniel to study film at NYU. At first, they noticed each other because they were both gay and Asian in a predominantly white scene, and felt that they might have to be competitive.

"I think that one thing that you internalize, or at least I did, is that you get competitive with this other person, because you're used to being special," Daniel said. "But that special is conditional."

"Because you're also tokenized within the wider circle," Tin added.

Instead, they made the deliberate decision to be friends. Their

friendship was cemented as fashion friendships so often are in New York: waiting for embarrassingly long amounts of time together outside sample sales. It was in one of these lines that they got the idea to start CFGNY.

"So basically we were at the sample sale, talking about being cheap," elaborates Daniel, "and then Tin was like, I wanna spend more time in Vietnam because I've only been there once or twice. My mom goes there to make clothes. We should just start making clothes. We could do it more like an art project. It wouldn't need to be a production line."[21]

Neither Tin nor Daniel is formally trained in sewing, so they decided to collaborate closely with local tailors in Vietnam, often deferring to the tailors' interpretation of their instructions. Sometimes, this meant that zippers end up in different places, materials are swapped, or garments are given a different fit. Soon this collaboration became an integral way that CFGNY would operate. "A lot of times they'll just kind of make decisions," says Tin, laughing. "Because they worked with us so many times, they feel like they understand our sensibilities," says Daniel. "So if they can't contact us and it's at the tailor, there's this sort of chain of sequence that goes down, and then decisions are made, not by us, and I feel like they know our aesthetic."[22] (In 2019, the artists Kirsten Kilponen and Ten Izu would join the collective, and introduce even more collaboration.)

Lingering at the perimeter of the party, I take a closer look at a patchwork shirt. I notice an oddly placed button. A collar that is slightly larger than normal. I try to discern if this is Daniel and Tin's taste or the tailor's call. I can't tell. Maybe that is part of the point.

I think about buying something. A vest made of teddy bear stamps. At prices ranging from $100 to $500, CFGNY's garments are comfortably within the range of other designer clothing,

probably even on the lower end for that. But it was more than I had ever spent on an article of clothing. This price tag was as alien to me as the prospect of owning it was seductive. I reasoned that I was investing in an artwork made by friends, and this made it easier to short-circuit the deal-busting mindset I had grown up with.

"Well, how do you like to dress?" Daniel asks, seeing me pull the vest close to myself. "You could wear the vest with a shirt if you want business-casual-anime. Or wear it without if you want to look slutty." He laughed.

"I think you can go anywhere you want in the *kawaii*-slutty spectrum," Julie encourages.

I buy the vest. Later, when I wear it, it feels like I have dredged up some substance within my identity and externalized it into something that others could see, all by paying money to someone else. Capitalism is fun and convenient. I liked how the vest was both cute and unnerving in its multiplicity, that there was something transgressive to the sexual pallor it was casting on pajamas that reminded me so strongly of home.

Tin and Daniel see fashion as a vessel, and an excuse, to bring people together and talk. Specifically, they hope to explore common Asian American experiences: reinforced racial and sexual stereotypes of gay Asian men on Grindr, the intraracial competition stoked by tokenism, and a more existential sense of alienation. "We all feel that alienation and we understand each other in a very specific way," Tin says. "That's a very big common bond, the alienation that we feel."[23]

I appreciated CFGNY because they were critical, and sympathetic to the idea of "belonging" in Asian American culture. "Belonging" seemed trite and overdone, and it pushed for an idea of America, and American citizenship, that I wasn't sure I wanted to

aspire to. In coming up with the term "vaguely Asian," CFGNY suggests that there are other, more ambivalent emotions to being Asian. Identity is constructed from an outside; it is something that is done to a subject. One result, they posit, of having to reconcile (or being unable to reconcile) the images you make of yourself and those that others make of you is a pervasive sense of alienation. A feeling that you don't belong where you should belong. CFGNY proposes this alienation as an integral aspect of identity formation.

"What does 'being Asian' even mean?" Daniel asked in a 2019 article. "We can't possibly define that. What we can define is the experience of being viewed as one huge group. The alienation that is a consequence of being judged for something you aren't, and what brings us together is understanding that relationship between ourselves and our identity. It's not about being Asian, it's about trying to expand what being Asian means."[24]

They have not yet given up on the idea of community, or Asian America, even if they are critical of both. Their work across fashion, art, performance, and writing seeks to use that alienation as the basis for a community.

The party starts to crowd. Angela Dimayuga, the chef of a popular downtown restaurant, comes in with aluminum trays of food covered in Saran Wrap. Riffing on the idea of "cute," she had made pandas and little bears out of rice and Spam and other food that she had grown up eating as Filipino American. She had gone into her mom's recipes, pulled out "home" aesthetics, and was letting them oxidize in the New York air.

I take a walk to the other end of the gallery. The music dims; no one is here, they're all by the food. A long table displays DIY versions of high-fashion accessories: designer briefs stretched over rectangles of shipping material, a cardboard remake of the popular

Bottega Veneta cassette handbag, a fabric tote with green fringe. I stop in front of one particular accessory—a pair of black briefs studded with rhinestones with CALLVIM KERNEL on the waistband. I pick them up, feeling the cardboard bend a little underneath my fingers. I notice the synthetic tautness over the brief's crotch. I notice a tag. "Slightly Worn by Franky," it reads in shiny silver letters. Who is Franky? Is he hot? I look up Franky on Instagram, and I can't find him, but I am an experienced gay social-media sleuth, so I search through CFGNY's followers to look for him. I see that he walked for CFGNY's last show. He is indeed hot. His pictures reference Asian culture but nothing too specific—Pokémon? Hello Kitty? Abs. Mostly abs. But also old Celine and Dries van Noten. Always selfies. Orange cowboy selfie. Round circle tattoo selfie. L.A. tattoo selfie.

I imagine buying the CALLVIM KERNEL briefs to enjoy the uncanny, erotic intimacy with this Instagram star they might afford; I imagine their musk and their residue, the sweat the elastic might have captured. The inner label of the briefs, meanwhile, says "Made in Vietnam." Even if Franky put them through the wash, might residue have been left by the seamstress who sewed them, or by the machine she used? Who else do these briefs put us in contact with? Who else was at this dimly lit party, hiding in the seams of our garments?

In 2019, Tin and Daniel flew to Vietnam to go shopping. In the District 1 area of Ho Chi Minh City, known for its many tailoring shops, they ran their hands along reams of fabrics. On the veranda, a child thumbed an iPad in the shade, and garments hung on mannequins sticky from the humidity. Tin and Daniel were there with a proposal, an experiment for a new collection they were developing called *Synthetic Blend V.*

Although they had been working together with various tailors—Nguyệt Huế Nguyệt, Bùi Thị Mỹ Linh, Bùi Thị Lan Anh, Da Trần Văn Tân, and Namsilk Tailor—since 2016, this time they had a new proposal for the tailors: to create an outfit based on *their* interpretation of what a CFGNY garment might look like.

But first, Tin and Daniel had to explain the concept of a diasporic identity, or even an "Asian American" identity, to the Vietnamese tailors.

"One way we put it simply was like, he's Chinese, I'm Vietnamese, and we hang out," Tin recounts, trying to explain the idea of Asian American community to the tailors. "So emphasizing this idea that there's overlap (and camaraderie?) in the ways in which we, as Asian diaspora, identify. They were often surprised by that, that a Chinese and Vietnamese might identify with one another in America."[25]

Working on this collection, Tin and Daniel became much more aware of the cultural, even U.S.-specificity of an "Asian American" or an "Asian diasporic" identity. They had taken this to be common knowledge, but of course, one only becomes Asian outside of Asia. The process of explaining this to the tailors asked them to articulate how living in the diaspora feels and looks like in blunt and unforgiving language, run through the blender of Tin's elementary Vietnamese.

"Community. Ummm. Friends. Ummm. Together. Asia."

I was excited by the idea that these exchanges might be a way of bridging transnational rifts in Asian experience. Or that they might be a model to alleviate the alienation that otherwise embeds itself in the economic exchanges of fashion production—designers in America making long calls to Asian factories. Tin has mentioned how the tailors treat him like family, and he calls them "aunties" and "uncles," what the cultural theorist Thuy Linh Nguyen Tu in her 2017 cultural history of Asian American designers, *The Beautiful Generation*, describes as an "architecture of intimacy."[26]

Those impulses are present. But the reality that they recount seems to be more complicated. Custom tailors in Vietnam are not the same as the factories at the fringes of the city where most fast fashion is produced. CFGNY does not posit that they work in a fast-fashion economy; rather they work more in the language of luxury fashion, even if they try to reject that language as well. (CFGNY does not participate in fashion week shows or sell to retailers, and they produce each of their garments via preorder. At least for now.)

Also, who is to say that the tailors they work with were all that alienated from their work to begin with? Or that they need them to become less alienated? Although CFGNY would like to count many of these tailors as collaborators, not all the tailors were necessarily receptive—or cared much, for that matter.

"Some tailors were like, 'we just cut and sew, you direct us, we don't provide creative services,'" Tin says. "They were unwilling to do it."[27] A shop run by Anh Quanh and Chi Loi refused the invitation, explaining that they are set up to take measurements and fill orders, and that to come up with ideas for garments would be too distant from their business approach and too disruptive to their daily work.

And although Tin and Daniel often defer to the tailors' suggestions and translations, they still curate which of these garments make it into their collections: "Sometimes, we'd get it back and be like, ugh this is so ugly, the fold is wrong, etc.," said Daniel. "And then sometimes we'd get things back where we hadn't asked for a certain thing, but they'd just done it." Another time, they asked their moms to produce a version of a diasporic garment, but they found the results so off-putting that they didn't want to display them. Mistranslation is a key part of their process, but it is ultimately mediated through Tin and Daniel's particular sensibilities.

Synthetic Blend V is, however, exceptional partly because they

worked with tailors who were enthusiastic to collaborate. Two sisters, Chi Lan (Bùi Thị Lan Anh) and Em Linh (Bùi Thị Mỹ Linh) are credited. In grade school, Lan dreamed of studying fashion, but ultimately pursued a career in economics until she left to open her shop. Lan was excited for the opportunity to exercise her creativity through her craft with CFGNY.[28]

In one of the outfits that CFGNY produced in collaboration with Lan, a model wears a wool skirt in which strips of leather had been woven into a checkerboard pattern. On top, she wears a mesh cardigan that sits like a transparent overlay.

To me, the garment is a little confused. It sits between "Hi-I'm-a-brown-leaf" and "Hi-I'm-a-crafty-demure-lady." The garment is the product of progressive cultural politics—collaborating with a far-flung tailor, scrambling designers and producers—but I find it, despite myself, kind of ugly. And that is perhaps part of the point. It's not for me, or for my taste; it's for Lan.

I used to take a bus from the Whitney ISP offices in Chinatown to Ramapo College in New Jersey once a week to help my mom at the sushi counter she ran in the cafeteria. In the 1980s everyone wanted sushi, but the Japanese didn't all want to make sushi, so the Burmese immigrants stepped in. They were Asian enough, and no one could really tell the difference. My mom had worked in sushi since I was a child, operating different counters at local supermarkets like Giant and Acme. Ironically, she doesn't even like sushi; when she brings back leftovers she microwaves the raw fish and recooks it in stews to eat with rice.

The counter at Ramapo College had just started selling sushi, the ones that everyone knew—California Rolls, Salmon Avocado, Spicy Tuna, etc.—before expanding to be an all-purpose pan-Asian food counter, with teriyaki chicken, popcorn shrimp, and lo mein.

Here I learned new meanings to the term "vaguely Asian." For one, we were Burmese Chinese people running a Japanese sushi counter named Mein Bowl. I wore an all-black uniform with a chef's hat, slacks, and a loose-fitting kimono top with a little chopstick and bowl logo stitched on it. In my uniform, I was frequently mistaken as female by customers, a misgendering I had no problem with but which added to my feelings of vagueness. When I mentioned this to my mom, she smiled and said it was because I had a pretty face, not because of the uniform—unhelpfully.

I was being flattened into an undifferentiated Asia, a pastiche of clichéd references. This is what CFGNY's clothing tries to both reflect and disrupt. Sometimes this fantasy produced a conflicted fun: it allowed me to lose a kind of nationalist identity; it made me lose my gender. But it also made me feel like a cog, like my Asianness was a commodity I could sell as pieces of battered, sweetened, fried chicken.

My mom employed mostly undocumented recent migrants from Burma to execute Chinese and Japanese dishes. They were distant friends of friends or acquaintances who had just immigrated and needed jobs. She was a one-stop immigration firm with her little Bluetooth earpiece: connecting them to lawyers to help grant asylum, housing them at the apartment she rented for work, finding them under-the-table work, all while rolling out fifty boxes of sushi at 6:00 a.m. I didn't even know she was doing this until I asked. It was such a nonchalant thing for her. She has always been ambitious and organized, and it wasn't until I was older that I could appreciate her practical expertise in what could only be an arcane world of immigration law. She would have made for a sharp lawyer.

I used to feel a kind of intellectual whiplash moving from the

ISP seminar room to the sushi counter. I would come directly from a presentation by a critically renowned artist like Hans Haacke, describing the radical gestures of his artwork and how they revealed the internal collusions of art and capitalism, and think about it while pressing avocados, imitation crab, and warm rice on seaweed into conical shapes. I'd think of Martha Rosler's *Semiotics of the Kitchen* (1975), a canonical video of feminist art, while hacking slabs of frozen chicken into fryable bits. I'd tetris boxes of broccoli in the cold storage room while my copy of David Harvey's *A Brief History of Neoliberalism* lay face down on a crate.

At the core of the ISP was cultural studies, a field of study originating in the U.K. in the 1970s. It believed that culture and art were not just reflections of how society—economically, politically, socially—was organized, but that it was the kind of fabric that could either support or upend it. I saw myself in the biographies of the field's originators, Welsh and English scholars like Richard Hoggart, Raymond Williams, and Stuart Hall, who had moved from their rural or immigrant backgrounds to attend schools like Cambridge and Oxford, only to find that the culture they grew up in had no place at the academy. Cultural studies, in my understanding, was a vein of study produced by people who were trying to reflect on their own experiences of class ascension. They were trying to make sense of the rifts that had come between them and their parents, friends, their hometowns—crafting theories that could fit both Milton and popular TV, Jamaican dance hall and high art.

"Good book," a beleaguered-professor-looking type mentioned once while I was slacking off behind the counter, reading Hoggart's *The Uses of Literacy*, a quasi-ethnographic survey of the working-class life in Leeds. I lifted up the cover to toast her. What image did she have of me—Japanese? working class? student? un-

documented worker? And there was what *actually* was—Chinese? Burmese? creative class?

"Good book," I repeated. "Shrimp or chicken?"

The idea of the vaguely Asian has a much longer history in the U.S., finding a cousin in the term "orientalism." Originally coined by the Palestinian scholar Edward Said in 1978 to refer to distorted depictions of Middle Eastern subjects by European imperialists, orientalism was quickly adopted in the field of Asian American studies to describe representations of fetishization, caricature, and demonization that Asian workers as early as the mid-eighteenth century experienced when they arrived in North America.

Orientalized aesthetics are an integral aspect of American culture—from George Washington's noted obsession with chinoiserie and fine china during the Revolutionary War to theatrical productions like *Madame Butterfly* and *The King and I* modeling a docile Asia for U.S. conquest (as the scholar Christina Klein writes in *Cold War Orientalism*), to the reframing of Japan from bloodthirsty soldiers to obedient co-conspirators in capitalism ("America's geisha ally," as the scholar Mari Yoshihara writes). Orientalism was used both to distance and to embrace the "East" and the "West," depending on the whims of American foreign policy. The "vaguely Asian," to me, includes both negative and positive images of Asia, by both Asian and non-Asian makers to refer to something intangible that exists between caricature and self-representation.

For our purposes, the multiculturalism of the 1990s is particularly interesting. During that decade, so-called Asian shapes, fabrics, iconography, and colors appeared everywhere, from the couture runways of Yves Saint Laurent and Gucci to the mass-market racks of Urban Outfitters and Target. Between 1990 and 2005, as Thuy Linh Nguyen Tu writes, there was not one year

in which Asian influences—or elements that could in retrospect be categorized as such—failed to find their way into a fashion spread, article, editorial, or advertisement. This moment would come to be known as "Asian chic," a time when the U.S. had once again become obsessed with images of an undifferentiated Asia.

Although Asian chic on the surface seemed to bring together the East and the West, it was better understood as an expression of *distance* produced from the anxiety of globalization, writes Tu. At a time when many Americans were resentful of immigrants and their effects on American culture (sometimes called the browning or the yellowing of American culture), Asian chic was a reassertion of distance, pushing back on the proximity created through the influx of goods "made in Asia" and the ineffable presence they took up in the West. It served to solidify the "East" as the land of raw, unfiltered tradition that needed to be translated in the "West" by the modern, innovative visions of European and American designers. This distancing also occurred by making these Asian designs anachronistic—literally out of time—by posing designs from ancient China as representative of present-day Asia.

Some, like the Chinese-born, Hong Kong–raised, American-based fashion designer Vivienne Tam, took the opportunity to capitalize on Asian chic, becoming self-selected authorities about East-meets-West relations. Tam moved to New York in 1982 to establish her own fashion line, which was then called East Wind Code, a Chinese proverb that indicates "good luck and prosperity," and her brand rose to prominence throughout the nineties. Tam became known for her slim qipaos and minidresses covered in Buddha statues and other recognizably Asian iconography.

Today, it's hard not to see her work as a form of self-orientalization—regurgitating the caricatures and stereotypes produced by the West of the East, now authorized by an Asian face. But it is not so easily dismissed as self-orientalization; in

other garments, Tam engages with heritage, craft, and biography rather earnestly. She is genuinely interested in this stuff, even if it's not in a comprehensive or scholarly way. This feels all the more interesting as we find ourselves in the midst of our own Asian chic moment, mostly propagated by a younger generation of Asian and Asian American creatives. If contemporary critiques of appropriation by identity politics led us to the idea that "only Asians can wear Asian culture," self-orientalization has been reclaimed as a fraught, but also freeing, reinterpretation of the constructed nature of any cultural birthright. Does our current moment share more in common with Asian chic than we'd like to admit?

In her famous "Mao Collection" from 1995, Tam collaborated with the Chinese conceptual artist Zhang Hongtu and printed Chairman Mao Zedong's face over dresses, T-shirts, and other garments, This caused outrage from Chinese media, but also considerable commercial success, in both the West and in her native Hong Kong. Her interest in Mao seems tied to the power of his image to incite rebellious, "revolutionary" impulses, even if they are abstracted from their actual historical circumstances. After the garments became quite controversial and some shops in Taiwan and Hong Kong refused to carry them, Tam was excited not by their political meaning, but by the way that they became youthful contraband ("Suddenly Mao was a symbol of rebellion again"), going so far to say that if she had stayed in China, she probably would have been a member of Mao's youth group, the Red Guards.[29] Maybe there was a strategic dimension to Tam's self-orientalization, a kind of scrambling of signs (a "running amok of signifiers," as Tu suggests) to give new meanings to images stereotypically associated with the East or the West.

If current diasporic aesthetics favor a more diffused, "vaguely Asian" relationship to one's origins—drawing freely from a pan-Asian panoply of references as disparate as *Sailor Moon*, the Hong

Kong hearthrob actor Tony Leung, Japanese anime, cosplay culture, and K-pop—what is the place of projects like Tam's that feel "overtly Asian"? Particularly in 2024, as U.S.-China relations seem to fray? I think there is something to be admired in Tam's commitment: a sustained engagement with one's heritage beyond a look for a night or a day. It might be a complement to "vaguely Asian" to also have "overtly Asian" aesthetics, borne of an unabashed specificity of a particular cultural heritage.

The mall at 75 East Broadway in Manhattan's Chinatown announces its presence with a jumble of letters and words in English and Chinese, huddled together like a motley crew of strangers waiting for the subway. A black rectangle serves as the mall's main sign, with the title "New York Mart" in Comic Sans, the *N*, *Y*, and *M* highlighted in the colors red, green, and blue. To this sign's left is the Chinese title, 中国城超市, which translates as "Chinatown Supermarket." Locally, the mall is known as Dong Fang Guang Chang, written in traditional characters as 東方廣場, or "Oriental Plaza," but two of its four Chinese characters are missing, so that it announces itself with a silent beginning: ＿＿ Plaza. The "oriental" part—*dong fang*, which translates to "Cathay" or just the "East"—has fallen off.

I was there, in 2019, to see a controversial exhibition. This area of Chinatown is just a short walk away from 47 Canal, where I looked at Franky's briefs, but it is much less trafficked by tourists and gallery types. The stores and street vendors here service a primarily immigrant clientele, historically from Fujian Province in China, where my great-grandparents are also from. It is a densely residential area boxed in on the northeast by the Manhattan Bridge and on the southwest by the Brooklyn Bridge, giving this neighborhood its name, Two Bridges. The neighborhood's proximity

to the water, and the fact that the nearest subway is about a ten-minute walk, makes this area feel secluded.

I wasn't sure I was in the right place. Under the fanfare of the mall's entrance, past the street vendors selling dried lychee and frozen buns, I walked into a fluorescent-lit hallway. Rows of black shoes, from utilitarian to fashion-forward, sat on shelves spilling out of glass-boxed shops. The vendors—almost entirely women—looked up from their iPhones. I presumed they gave me a once-over to see if I was there to see them or to go upstairs, and a look at my haircut, my glasses, my Telfar bag, told them all they needed to know. To my right, a directory listed the vendors in the mall, their names printed on green plastic, all in Chinese, except for a few in English—James Veloria, the queer-owned boutique, and Eckhaus Latta, a trendy brand favored by downtown art-world types. Their names stood out over the green placards of the other Chinese stores, many of which were probably shuttered at that point. The board haunts me to this day as a stark visualization of the cultural change that was occurring there.

I looked up the building on my phone. 75 East Broadway opened in 1994. Within its granite-tiled halls one used to find scores of mom-and-pop stores selling Chinese medicine, cosmetics, cheap clothing, and plastic hair accessories. But in the early 2000s, 75 East Broadway opened as a satellite to the larger, more popular 88 East Broadway mall across the street. As Wilfred Chan documents in an extensive essay for *Curbed*, 88 was packed with more than eighty small businesses, like employment agencies, barbershops, doctor's offices, and karaoke rooms on the two downstairs floors. The building was called Yi Dong Lou in Chinese, roughly "Eastern Harmony Building," partly because of its auspiciously numbered address. On Thanksgiving, Fujianese restaurant workers would hold rounds of weddings in its thousand-seat banquet hall on the second floor. Under the

cover of the Manhattan Bridge, a steady stream of intercity buses brought new immigrants and workers in and out. It was a place so famous that people back in Fujian Province knew about it.

But 9/11 marked a turn in the area's fortunes. Subway trains skipped Chinatown for months, and then the NYPD seized Park Row, keeping it in a state of militarized lockdown against imagined terrorist activity and cutting the neighborhood off from the Financial District and the Brooklyn Bridge. In 2012, Hurricane Sandy left Chinatown without power for weeks and aid was again not directed to this area. The beginning of the COVID-19 pandemic in March 2020 only exacerbated this isolation, and racism and xenophobia hit Chinatown businesses earlier and harsher than those elsewhere in Manhattan and in other boroughs, compounded with an ongoing wave of anti-Asian hate crimes.

By the mid-2010s, 88 East Broadway had only seventeen of its original eighty tenants left. A forlorn Christmas garland hung over its entrance and its façade was covered in graffiti. The popular thousand-seat banquet hall, which once held a Balenciaga afterparty, has been closed since 2020 and the escalator going up to it gated off haphazardly. When I visited in 2019, there wasn't even a security guard for 88—instead, the sentry from 75 East Broadway was being paid to take a quick walk over every hour.[30]

In contrast, 75 East Broadway went through an urban reinvention. The building's management company, Winking Group, launched a "recharacterization" of the mall in 2016. As a broker named Christopher Lam told *Bowery Boogie* that summer, it was "looking to re-create the identity of this mall and hopefully bring some galleries that are looking for small/large spaces or finding working office tenants." The first tenant to sign a lease on the second floor was 2 Bridges Music Arts, an avant-garde record shop that presented music "as an entry point for experimental modes of consciousness."

Shortly after that, Tramps, an offshoot of the uptown gallery

Michael Werner, leased ten of its units. Other small boutiques, like James Veloria and Eckhaus Latta followed shortly after. 75 East Broadway, looking at the bottom line, had rebranded itself as an art and fashion bazaar for cool kids. The portrait it leaves, of landlords, yuppies, and locals, is of rising rental rates and bottom-line developers putting legacy Chinatown spaces between a rock and a hard place: gentrify or die.

Who has license to the "vaguely Asian" aesthetic? Which fantasies are acceptable and which are offensive?

I take the stairs to the second floor of 75. I stand in the colorful doorway to James Veloria, peeking into the racks of clothing inside. The sound of hyperpop filters softly through the air from the speakers behind the colorfully dressed cashier. She smiles at me warmly, and I smile back. The units on the second floor have been described as "jewel boxes" because of their floor-to-ceiling windows. They allow you to look directly into the units without ever walking into one. I round the corner to an area of the mall that seems deserted, peering in as I walk by.

The exhibition I am here to see is by the German artist and musician Kai Althoff, organized by Tramps. Althoff, who has shown at MoMA, the Venice Biennale, and the Stedelijk Museum in Amsterdam, is known for making immersive installations that overlay personal and political histories. In a large corner unit, I spy various dimly colored paintings which seem to be heavily inspired by South and East Asian painting styles. They are hung salon-style on walls wrapped in purple cloth. I can see bits of white insulation peeking out from behind the cloth, and the fabric has deliberately been left unironed, leaving squares and pleats. There are no attendants around, so I walk into another open unit, onto a floor covered in cardboard. In the center of the room, the cardboard has

ripped, revealing the spongy insulation underneath. I feel like I am standing inside of a forlorn gift box.

Looking more closely at the paintings, rendered in lush and earthy tones, I see that although they referenced historical painting styles, the vignettes within them were more difficult to categorize, ranging from explicitly sexual to mythic or folkloric encounters between humans and animals. The painted, padded floor wheezes under my feet. Althoff left the walls of the previous Chinatown store tenants unpainted, leaving the sun-faded silhouettes from the former shelves on the walls like permanent shadows. I feel nostalgic, and a little mournful, aware of the bustle that used to move through this space.

In a fierce critique from the writers Leah Pires and Jamie Chan for *4Columns*, the show was charged with glamorizing the gentrification of the East Broadway mall into an "urban safari for art world voyeurs" that "rendered the complex lives around it into a backdrop for orientalist play." Drawing on the fact that Althoff is German, Pires and Chan connected the artist's gestures to a long history of European modernism. His appropriation of South Asian images effaced "entire cultural histories by aestheticizing them away from themselves," they wrote, and thus "reopened the wound of colonial erasure."[31]

The gallery's response, penned by its director Parinaz Mogadassi, refuted the claims of orientalism and cultural appropriation in favor of a cosmopolitan-style defraying of the constructs of both ownership and nationality. Invoking her own identity as an Iranian immigrant, she argued that it's hard to say where things come from and even harder to say where we come from, and we should avoid cultural essentialism. She emphasized the economic angle: in 2019, the landlord was having trouble renting out those stalls because of their expense and limited foot traffic; the gallery alleviated the landlord's financial burden.

Althoff produced an exhibition that some might even describe as "vaguely Asian" in its fantasia on various Asian references. But his presence highlighted uneven conditions of exchange. Art does not occur on a level playing field. Some players have greater mobility, visibility, and access, often at the expense of others. Galleries like Tramps, or downtown boutiques like Eckhaus Latta, benefit from the cachet of being situated within the "authenticity" of an immigrant enclave. In turn, they attract a particular type of cultural capital that benefits the landlords, who ultimately hold the capital and are key drivers in displacement of local shops. Although these cultural spaces may only be a frustrating symptom of a larger phenomenon and not the root cause, they contribute to this system in a way that is unsettling. Could we imagine a version of their existence that contributes more than just appropriation to the neighborhood?

Whenever I go to 75 East Broadway, I find myself torn. The building is a physical manifestation of the rifts that CFGNY tries to navigate in their own work. The first floor represents a world that caters more to the tastes of Asian immigrants—such as CFGNY's activity in Vietnam and their inspiration from Chinatown aunties and uncles—while the second floor with its high-fashion gloss echoes the intersection of art and fashion enjoyed by the creative class that interacts with its products. I'm tempted to try to think of the first floor as a space for "Asians" and the second floor as one more akin to "Asian Americans."

But this schematic is problematic for multiple reasons. The first being that the vendors on the first floor *are* Asian American—they are Asian people living in America, of course; they are like my parents. They benefit from the products of Asian factories that they are reselling in the U.S. And upstairs, in James Veloria, the clothes come from a variety of brands, but many of them from

designer Japanese brands like Issey Miyake, Commes des Garçons, and Yohji Yamamoto—a different kind of Asian presence. (One can imagine various kinds of Asian essences—Japanese design, Chinese producers, French tailoring—embedded in the garments, doing laps around the globe before ending up at James Veloria.) 75 East Broadway dramatizes the global class rifts within Asian American culture.

I went back to the mall in 2023 with Julie to try to interview the downstairs shop owners for this essay. I didn't trust my Chinese enough to go alone, and Julie offered to help. She didn't mind translating, she said, she enjoyed being useful, so we met up there one rainy spring day. The board with the listing of vendors had since been replaced with a TV screen. We lingered in the covered market nearby to try to figure out a game plan.
"I don't want it to be weird," I kept telling Julie. "I don't want to be weird." *I am open to whatever we can learn*, I told myself.
We walked back into the hallway and lingered awkwardly in the corridor. The women working were busy; one was steaming sets of clothing, another was engaging a few shoppers. We walked into a beauty store where the attendant seemed a little less busy, and Julie introduced us as journalists. She asked if they would be willing to be interviewed about their shop.
"Ah," she said. "No."
We thanked her profusely and then walked back out into the covered market to process our embarrassment. These women were *working*, of course. They had customers to deal with. Also who the fuck were we? Total strangers. I felt naïve; it takes time to build trust.
"It's nice to have another person to distribute the shame and embarrassment," Julie said as consolation, and I laughed.

"Maybe we should chill," I said, "and approach this more casually." We resolved to return and just look at the clothing in the stores, engaging as potential customers, rather than as outsiders with nothing to offer.

We stepped into a different store, where a woman was steaming clothing amid a fort of shoeboxes. Julie asked if it would be okay to look around, and she gestured us wordlessly inside.

There was so much clothing in the shop, it was hard to take in what was being sold. It was not very large. Maybe three or four people could fit comfortably inside, and the clothing rack, which hung relatively low, was dense with garments. I had the feeling of thumbing through a filing cabinet. Above, there were some highlighted outfits: variations on Chanel coats, Gucci sportswear, and other, unnamed silky garments.

Julie pulled out a black sweater with Tigger from *Winnie-the-Pooh*, emblazoned with the word ICCUG (GUCCI backward), and a sweater with the tag BUYDERRGY, a riff on Burberry. Julie went to try them on in the small fitting room in the back.

I found a pink zip-up with the words "niu u r," which I realized resembled the lowercase logo of another luxury brand, Miu Miu. These shirts were *shanzhai*, as the collective Shanzhai Lyric—consisting of artists Ming Lin and Alex Tatarsky—has highlighted. It's a difficult word to translate. Although the closest is something like "copy" or "counterfeit," *shanzhai* has less of the negative, subpar, or derivative connotations associated with those terms and a more poetic meaning coming from its etymology.

As Shanzhai Lyric outline in their 2022 artist's lecture at MIT, *shanzhai* translates literally to "mountain hamlet," a reference to a Song Dynasty story called "The Water Margin" (also known as "Outlaws of the Swamp"). In the story, a group of Robin Hood–like bandits steal goods from the empire and redistribute them among those living in the margins. Once the bandits reach a small ham-

let at the top of a mountain with the stolen goods, the sheer cliffs and rough geography protect them from government retribution. A *shanzhai* garment is a fake, but it also references "a sanctuary and a stronghold."

Shanzhai radicalizes the experience of alienation, as Shanzhai Lyric argue in the same lecture:

> And yet the counterfeit also offers us an experience of estrangement, costuming itself in the garb of the original so as to bring attention to the artifice at the heart of the whole endeavor, the slippage between copy and copied, the fakery of the concept of one single rightful owner. The experience of alienation brought on by the poetry of the bootleg sharpens our attention to the violence, the violent lies of branding, after all, a brand, in original meaning and usage, is a mark, made by a hot iron, in order to assert possession, or to designate disgrace, by burning a symbol of ownership into the flesh. Shanzhai lyrics then bend and break brands, pointing both to their violence and to their utter absurdity.[32]

They also reveal the material conditions of Chinatown, a place that artists have used for many generations to source and construct their avant-garde propositions. In another one of Shanzhai Lyric's projects, Canal Street Research Association, they investigated various rumors: that the French artist Marcel Duchamp found his famous urinal, with which he birthed the readymade, and thus much of contemporary gallery-based art, on Canal Street, that David Hammons purchased the molds for his snowball performance at a Canal Street plastics store, and that Félix González-Torres purchased the strings of lights he used in many of his light works on Canal. Chinatown and its producers are rarely credited in the works of art and the prestige that results from the use of its resources.

Julie emerged from behind the curtain, and we decided the shirt was indeed very cute. I tried the *shanzhai* Miu Miu top and it fit surprisingly well. A great "going out top," Julie remarked.

"How long has the shop been in business?" Julie asked the attendant casually, in Mandarin.

She did not look our way. "A long time," she replied.

"Are most of the clothes from China?" I asked, my own college Mandarin like pebbles in my mouth.

"Yea," she said.

We looked a bit longer through the clothes before settling on our two purchases, and asked how much it would be.

"Ninety dollars for the two."

It was hard for Julie and me to contain our shock. We had, again naïvely, perhaps with racism, assumed that things would be cheaper here. Yet we were also clearly "foreigners" in this space, and we were paying its surcharge. We managed to haggle down to eighty dollars and resolved that this was all part of the experience, anyway.

We took the elevator down to the basement and walked by an electronics store, a massage parlor, and several more closed-down shops. We took a different set of stairs back up to the first floor into another clothing store that was also crowded with dresses and shirts, the attendant crouched over a low table eating her lunch. Julie contemplated buying a set of very cute slippers, while outside of the store another woman, speaking Chinese, asked how much the dress in the window would be. A European family in ponchos came in and looked around.

I realized that while to Julie and me these clothing stores were fraught with meaning, the mall was still a place where some people just came to buy clothes. I had absorbed American tastes to the extent that these clothes didn't appeal to me other than in an arty or ironic way. They looked like "home" clothes but I no longer had

license to them; I was lost somewhere else. I was dumb to think that I had any license to this space just because I was Asian; I felt as much a foreigner as the Europeans, as *shanzhai* as my niu u r top.

After the pandemic, my mom retired from her sushi job, staying home to take care of my grandmom. I haven't worked a service job since. Julie left her job as a paralegal to work at a bail fund. She toiled in front of a laptop during the week and wrote poetry and volunteered in Sunset Park and Chinatown on the weekends, canvassing for candidates and teaching English to recent immigrants. Sometimes I would join her for protests, and I admired how her contributions to the community felt direct and material, compared to the diffuse effects of art or writing. The separation between her aesthetic and political activity was becoming increasingly appealing; I had always sought ways to bring them together, but the clarity seemed to alleviate the demands we asked of art, while clarifying the ambitions of our activism. It presented another model for being an engaged cultural citizen in our newfound Chinatown home.

I was in Richboro for the weekend, and my mom and I were looking through her old suitcases. I had some event to go to and wanted something fun to wear. We sat in the haze of a mothball cloud, squares of fabric falling out of the suitcase like entrails. She held up a shimmery green bolt of fabric.

"It looks a little weird," I told her. We had hoped to find a garment that she could use to sew a jacket for me.

"Yes," she agreed. "What about this one?" she said, holding up a dark blue, kimonolike garment dotted with large white cranes.

"Maybe too much," I said.

"I wanted to make a long Burmese-style dress out of that one," she reminisced.

We sifted through some more bolts of fabric from Japan, Burma, and Indonesia, different pieces she had collected for potential dresses.

"Are you sure you want to use these?" she asked. "It's all flowers. Won't people think it's girly?"

"And what, they'll think I'm gay?" I joked, and she shrugged. The garments no longer felt so foreign to me. CFGNY's experiments gave me a context to understand them.

Consumption—or what you buy and what you don't—is an impoverished form of politics, but it helped me limn the contours of the political and economic world. Fashion likes to appropriate. This is part of its DNA. To short-circuit this system I could preempt its appropriation into high fashion, or art, and just elevate it myself. In my mind, I composed an outfit. I picked a pair of Dickies pants—itself an appropriation of working-class aesthetics—with my Mein Bowl uniform polo, and a pair of Eckhaus boots.

I held up the dark blue fabric, the one covered with cranes. I reconsidered its weirdness. The pattern was garish, the cranes distended, almost alien. It pulled at the edges of my taste, making me a little uncomfortable for how Asian, how untrendy it seemed, what others would think of me in it.

"Let's try it," I resolved. My mom laughed, and rubbed the garment between her fingers to see what we could make of it.

PARTY POLITICS

Drawings by Julie Chen. Editing by Ekin Bilal.

let's go to the zoo dressed
like animals

—"Popstar/Summer's Ending" by Slime Queen

I think "Dancing on My Own" is totally from me just being in clubs and going out and dancing a lot, and seeing people and thinking, "what are they doing here?" All these people with their hopes and their dreams about their big nights out, "look at me I'm dressed up and dancing."

—Robyn, in Pop Justice *(2010)*

At Electronic Zoo (EZoo), the EDM festival established in 2009, the garden of unnatural, digital delights is made real. Randalls Island, which also often hosts music festivals like Governors Ball and Panorama Festival, has been set up as a series of pavilions with loose, geography-based names—Riverside, Sunday School Grove, Hilltop Arena, Treehouse, Main Stage—each adorned with unnaturally hued, steam-punk-inspired animal sculptures. Even before its disastrous 2023 year, the energy of thousands of people congregated there felt unruly, threatening to burst.

Julie and I and eighty-five thousand other guests are overwhelmed. Fall is the season that most resembles an MDMA high because every day is laced with the threat of its dissolution through winter, a shiver of joy is always tinged with the anticipation of its eventual comedown. The grass beneath my sensible sneakers has been pressed until it resembles the greasy scalp of some enormous green-haired giant.

A man named Kevin and his friend Jordan ask for our names. They are standing at the edge of the dubstep tent (Hilltop Arena) wearing plaid shorts with Vans and the kind of backpack that only holds water. Kevin is Asian and Jordan is skinny, and I can't imagine that I would have approached them on the street any other day.

"The sky is so big," Kevin says, in medias res of a conversation with himself.

"My name is Simon," I say. "This is Julie. We've never been here before."

Talking to people feels loose and easy, as if some ordinance has been lifted from bodies and mouths. People celebrate by bumping into one another. Kevin and Jordan look stunned. Behind them, a tall woman clad in furry boots and workout gear hands out kandi bracelets.

"This is our third," Jordan says, as if celebrating a wedding anniversary. "And this year is the tenth anniversary of EZoo."

Julie and I nod.

"Anyone you really wanna see?" Jordan asks, and before we can reply gives his own answer: "We love Excision. He's not here but we saw him a few years ago and it was crazyyy." I explain to Julie that the metallic wop wop sounds emanating from the tent in front of us are of the same ilk as Excision—blistering, wobbling dubstep. On the enormous LED screen behind the DJ, a digital crocodile snaps its teeth.

"What do you like about Excision?" Julie asks.

"Listen to it," Jordan says, and lifts his arms as if Excision were all around us, the music's value obvious and divine-given. As if on cue, the music from the tent nearby builds, a succession of rapid beats, increasing in speed until it crests into a "drop." More than a musical motif or form, the drop is also a particular logic: one of anticipation and release, with an emphasis on the latter. The sound of free fall. Kevin and Jordan exit the conversation to enter the drop.

They look possessed, their bodies throttled in the music. Their necks are relieved of the propriety of uprightness, becoming soft hinges for a head that no longer needs to do anything other than serve as an extension of the body's elation.

"The sky is so big!" Kevin repeats. "The sky is so big!"

Most terms associated with nightlife and dancing are so embarrassing. Words like "dance floor," "rave," and "club" seem to have been drained of any substantive meaning, instead existing as vacant signifiers in pop songs of performers trying to convince you that they are having a good time.

The original inspiration for Robyn's "Dancing on My Own" came from her observations of people "going out." In 2009, when development for the song began, Robyn had been on the road for almost three years in a row, touring. She had observed a great deal

of club culture, not only in Europe, but also in America, and she noticed that something was changing, and this served as the backdrop for the song's narrative. "People have so many expectations when they go out, so many wishes about what their night is going to be: if they're going to meet that person, have a fun time with their friends, have a good high, hear good music," Robyn said in a June 2010 interview. "People get drunk and turn into themselves in a way, and they go to experience some kind of emotion."[33]

As an adolescent, I gleaned what it meant to "go out" from pictures posted on Facebook. Limp grips around solo cups; drooping eyelids. They seemed to evince a body and a mind gone completely slack. Someone seemingly relieved of control over the unwieldy suit of their identity. Drugs and drinking were clearly an aspect of this liberation. But because I did neither, being raised Buddhist, I studied those pictures for cracks and counterfeits, shortcuts to accomplishing it otherwise, and found EDM.

We leave Jordan and Kevin and take a lap around the gardens. The normal codes of dress, even between gay and straight men, have blurred. Unanimously, it is acceptable to go shirtless and adorn oneself with sparkles, glitter, and face makeup, and this does not have to correlate necessarily with one's sexuality. The gay uniform of the 2010s—high white socks, short shorts, a cropped tee—engineered to reference a kind of platonic, V-shaped masculinity, has been returned to its original source. Gym bros wearing the same thing as the gays, next to women in rainbow fishnets, the usual Nike workout gear, and the occasional, unfortunate Indigenous headdress.

In truth, the festival began the minute Julie and I stepped onto the subway in Brooklyn. Randalls Island is a subway to a subway to a bus, and we have plenty of time to pick up other festival goers as

we swing through Manhattan, identifying them from their mode of dress not meant for the real world. Because so many people here have only seen one another at these events, it has the feeling of a time capsule; a year has passed, things have changed, but this event is the same and this Eden is sacred. You can return next year with another three-hundred-dollar wristband.

There are more outlandish outfits too. An entire friend group is dressed like cows in various states of gruesome undress, udders and hooves flayed back to reveal tanned, muscled torsos or fitness-shorn cleavage. A techno penguin with sunglasses slides past us off the bus. The only real constant is a feeling of anything-goes, that the more outlandish outfits allow the regular dressers to feel at ease.

We find our way to the main tent as the sky bruises to purple.

In 2012, a song by the scrawny, otterlike DJ Zedd cracked its way into American Top 40 radio. In "Spectrum," featuring the high, silvery voice of Matthew Koma, the chorus is buttressed by jet-fuel-powered synth blasts, building precipitously until the song seems to fall off a cliff, into a moment of suspension. The drop is what returns.

The hit was followed shortly after by "Clarity" featuring Foxes, a track that softened the blueprint of "Spectrum" into a sentimentality bordering on the anaphylactic. *'Cause you are the piece of me / I wish I didn't need,* Foxes croons in the pre-chorus. The titular lyric comes as the chorus crests: *If our love is tragedy why are you my remedy / If our love's insanity why are you my clarity.* And then the song opens into a roar of a drop, one that sounds like a chorus of a hundred men over a glittery, pounding drum.

In 2012, Zedd, the pyrotechnics of unrequited love, electronic music, and the drop began to idealize what it meant for me to "go out." To achieve the experience of identity loss. A feeling of

catharsis that borders on a kind of ego-death or self-annihilation that I chased through college all the way to New York.

Amid the crowd now, it is an easy five minutes before we can exit it. Rather than claustrophobic, however, we feel warm and enveloped.

"How are you feeling?" Julie asks, as I try to repress an involuntary smile. I squeeze her into a hug in response. To be two ping-pong balls, plastic and filled with air, paddled around by the crowd.

In the little thicket we have carved out for ourselves, we start to become familiar with our neighbors: a young friend group of mostly white and Latinx gay men, clad in bandanas and Lululemon short shorts, rattling excitedly in Spanish; a lone, muscled stranger in sunglasses and a white T-shirt; a chatty girl with long brown hair.

"How's it going!!!" I ask this girl, in accordance with the new ordinance of free-speak.

She closes her eyes briefly in pleasure, lets the lights from the stage wash over her face. Manic, wild-eyed raccoons. "Ah-may-zing," she savors, smiling graciously. She shouts something: her Instagram handle, @barefootjourney. We wrap ourselves around @barefootjourney in a big group hug. We are on a journey together.

The Asian woman in front of us introduces herself as Stephanie. "Having a good time? Need anything?" She offers a water bottle. "This is my husband, Chen," she says, pointing to the man next to her. We immediately latch on to her as mommy. Rave mommy. She's being so nice. Why is she being so nice? Other shirtless men who are Asian are there with their nonplatonic girlfriends. We are indistinguishable by sight, when we think about it. I notice the way their skin resembles mine and I feel both intrigued and alienated.

Why did it feel like so many Asian Americans were into EDM? Julie knew of EDM culture from high school; she had grown up in

the Bay Area, and it was a very Asian American thing to go to these EDM festivals. Revision: it was perhaps a "bad" Asian American thing to do, as the parties were cesspools of drugs and alcohol and other illicit activity that would take away from one's studiousness.

Asians find freedom from repressive households in the space of the rave—or, at least, this is what the sociologist Judy Soojin Park writes in a 2015 research paper, "Searching for a Cultural Home: Asian American Youth in the EDM Festival Scene." The article continues: many Asians like video games and EDM sounds like one. Asians in Southern California go to raves because they aspire to whiteness. Asian Americans, billed as perpetual foreigners in American society, find a "home" in the PLUR (Peace, Love, Unity, Respect) acceptance of historical rave culture.[34]

But none of the explanations seem to really land, partly because they feel like very scientific answers to a phenomenon that is not very scientific. Maybe Asian Americans do like EDM because it is a respite from a strict household, a space to lose their identities, because it sounds like video game music. But does this say anything about contemporary Asian America? Does it portend a kind of escapism, or is it just a party, after all?

I only started drinking right after college. It was for no reason, but I felt that having made it through school with my wits about me, I could walk into adulthood with less of them. First drink: peach soju. A few days later, at a friend's party, someone brought out two white powders, and I let myself inhale them. I tiptoed toward these altered states of consciousness, aware, in a way, that they were now part of the life I wanted to live, among artists and creatives, and that the schooling I had been fortunate enough to have received could insulate me from their harshest effects, to a degree. I had reached a sufficiently dry rung in the class silo, but looking back

down the ladder toward the dark water, knew that I could fall back down at any time.

Stephanie squeals. On stage, the DJ Martin Garrix teases the first few seconds of his hit "High on Life," which, like many 2010s hits, mixes folk and electronic in an effect that would be overly saccharine in any other setting than perhaps here, where optimism is brimming and one can indeed feel high on life.

Suddenly, the thought strikes that the fog of every dance floor—in every gay bar and every club, in every city and every town—is actually the same place, connected to one another in a vast network of rooms and inlets that one could visit simply by entering your local discotheque. You can find your past and future lovers there, and with them, enemies and moms, homes and vacations, lakes and mountains. It's a place you couldn't resist and the one you attempted to avoid at all costs. A place where you could try on different selves or be reminded of the stubbornness of your own being.

We turn to @barefootjourney so the three of us can lock eyes. She kisses Julie, Julie kisses me, I kiss her. Around us, people are being hoisted onto shoulders, and we are suddenly under the twilight shade of human trees. We prepare ourselves for the sublime that is to come.

The next weekend, after a full five days of recovery at work, Julie and I meet at a bar and recount the events of EZoo. How had we ended up there? It was "research." Research for life. How to live better, we resolved. Julie makes two drawings of the Asian American raver archteype: the Asian Baby Boy (ABB) and the Asian Baby Girl (ABG).

The ABB, clad in sunglasses, a tank, and Nike shoes, socks and

shorts, feigns an outsized masculinity, calling everyone and everything babe, preferring the harder music. The ABG comes clad with falsies (fake eyelashes), fishnets, star-embroidered jumpsuit, and the arms of her boyfriend permanently soldered to her waist.

Luke, a friend, texts me. "come to Bubble_T!!"

"ooh im down," I respond, and then Google it. It had only been a few weeks since EZoo and my serotonin was still recovering, but this felt relevant to my life, my research.

On its Instagram profile, Bubble_T's tagline reads, between emphatic rice-bowl emojis, "Where Asianz Rule but Everyone's Welcome." I am an Asian(z), and I am also everyone. I am excited to rule and be welcomed.

Earlier in the day, I had called my mom to ask if she had anything conspicuously Asian to wear, maybe something from her illustrious suitcase, but I changed my mind, timid about dressing up, and just ended up coming straight from the museum in a Uniqlo polo, pants, and Tevas. Luke is already at the bar when I arrive.

I watch people as they come in. Qipaos over jockstraps, a Sailor Moon with a necktie, and gym socks. The looks are self-orientalizing, but fun, like if Pearl River Mart made a clubwear line. There are other, less classifiable looks, too: a sexy-biker-turned-ballerina talks to an orange, bedazzled cowboy in silk shorts; zebra-striped tops with corsets and sprinkle-beards, small glasses, and mesh. I feel timid, as one does amid people who seem very sure of themselves.

Luke gets a drink. He is dressed as Sun Wukong, the monkey king of Chinese folklore, adjusting the connection between his prosthetic tail and his jockstrap. In the backyard, a Pokémon Trainer lights a cigarette for his collared Pikachu in leather.

"This is great," I say hollowly. "I've never been to something like this."

"What do you mean?" he says.

I consider saying that I've never been in a room of people who are both Asian and gay, both the identities sutured together, that I'd always felt that I had to pick. That I was kind of amazed that this existed. I had accustomed myself to whatever scraps I could get from the "straight" space of EZoo; it seemed extravagant to be able to be gay *and* listen to EDM.

"Just all this," I gesture instead, and he nods, understanding.

A figure takes the stage, berating the audience to shut the fuck up. A Britney remix fades away. Vivianne, a performance artist, donning an elaborate Chinese headdress and white shawl, holds a tangerine impaled by incense and walks onto the stage. Her eyes are lowered, demure. She sings a traditional Korean song. Whoops and hollers from the audience. She paces the stage, her eyes downcast and deeply in character, until the song breaks into a remix and she falls into a burlesque routine.

After, the mood tilts; the air glitters and people start dancing to R&B and hip-hop remixes, stopping to pose for the photographer. A designer and a makeup artist exchange information next to me. They titter about collaborating soon, soon. I spot Tin from CFGNY on the other side of the bar. A man wearing only a diaper, white body paint, and horns comes up to us. "This is E.T.," Luke says by way of introduction. "He's dressed as a 'white devil.'"

I don't know very many people here so I stick close to Luke, but he's suddenly pulled away by a friend in a Sailor Moon costume, leaving me by the bar. I open up the invite on my phone, which is a screenshot from Instagram, and stare at the screen intently to look busy, all the while aware of being that person at the party who is looking at his phone, clearly uncomfortable. I am sometimes shy. The poster is red with gold lettering, with the letters "COSPL_A_ZIA." Vivianne, dressed as Sailor Moon, dances across the ad, on a background of space and a glowing yellow

grid. Below, it reads, "COS_PLAY_COS_TUME_CON_TEST," the underscoring a nod to a kind of online culture that Bubble_T tries to translate into real space. I shut my phone off. A Teresa Teng remix comes on.

In 2017, Bubble_T joined a wave of what we might call race-forward or identity-forward forms of party organizing. It followed groups like Papi Juice, a collective formed in 2013 that hosts parties primarily for queer Black and brown people. A catalog of the parties we might have attended on a given weekend: on Friday, Hot 'N Spicy, featuring East and South Asian DJs at the Bushwick astrology-themed bar Mood Ring; on Saturday, Yalla!, the roving queer Middle-Eastern party; and later the same night, Onegaishimasu, the "Queer API dance party celebrating all QTPOC/melanin/marginalized bodies in a sex-positive space," as well as Bodyhack, GHE20G0THIK, Hot Rabbit, Homotown, and so on.

Bubble_T was initially hosted by Instagram influencers—mostly queer Asian men and other downtown art denizens in the orbit of the Chinatown gallery 47 Canal. But as time went on, the party's renown—and featured guests—grew beyond its Instagram origins. At a party at Secret Project Robot, in February 2018, Solange came. Actor Bowen Yang and writer Alexander Chee cohosted a Bubble_T in the fall of 2019. And although the party went dormant over the course of the pandemic, it returned in 2022 with a more mature outlook and a less frenetic schedule, slowing down to about one every three or four months in the city. In the meantime, it had come to be associated with a more international network of parties centered around queer and Asian identity, like GGI in London, Worship Queer Collective in Australia, and many others.

The next time I go to Bubble_T, it is the Lunar New Year

celebration at MoMA PS1. By this time, I have become annoying about it, spouting its benefits to the people around me.

"It's like, Asian and gay," I parrot.

"It's like, my house, turned into a set for a drag queen," I say, nearly hysterical.

"It's like, vaguely and overtly Asian," I yell over the music, at a pregame in Crown Heights, to a stranger I will maybe sleep with, while Julie and Michelle nod politely.

The scale of the Lunar New Year Bubble_T party is much larger. Red confetti streamers by the artist Nicholas Andersen emblazon the walls, and multiple vendors sell second-gen overpriced Asian sauces. When I arrive it's a little too crowded, so I cower in the corner by the speakers, contemplating whether to buy a themed drink. Over forty-two hundred people had replied "interested" to the Facebook event. Julie was excited that the Japanese model Kiko Mizuhara was going to be there. I am having fun, but I am also self-conscious. I feel like everyone—in particular the Asian guys—is checking each other out. Competition or prize? My friend Julio says that Bubble_T has quickly become a place for hot Asian guys to pick up other hot Asian guys. Their shiny, pretty faces are implacable as we sift through the crowd.

Using social media, and especially Instagram, helps these parties grow queer communities by making gatherings visible and creating opportunities for people to connect outside of an explicitly romantic or sexual context. When Bubble_T's Instagram feed isn't filled with event pictures, it often broadcasts trips to Jacob Riis beach or impromptu Hawai'i getaways with the core Bubble_T friend group. To see representations of queer POC having a good time—laughing, dancing, kissing one another—is inspiring to some (or causes FOMO in others).

And, to state the obvious, the parties are fun. As Joshua Chambers-Letson writes in *After the Party: A Manifesto for Queer of Color Life*, performance—broadly defined across nightlife, art, and activism—is a vital means by which a person from a minority "demands and produces freedom." These parties emphasize joy and celebration, in response to a dominant media ecosystem that wants primarily to solicit stories of trauma. Their hope is that these effects can then migrate beyond the dance floor.

But who can perform an identity here? These parties primarily cater to upwardly mobile urban professionals and creatives, with ticket prices reaching more than fifty dollars. They've taken place in neighborhoods like Bushwick, Ridgewood, and Williamsburg that are at the forefront of the city's gentrification, as event planners are driven deeper and deeper into the borough in pursuit of affordable venues. Many of these parties have tacitly acknowledged this impact, offering discounted or free admission to queer POC or community members. But the optics can still be uncomfortable, sitting uneasily with a rhetoric of inclusion and acceptance.

The near total Instagram coverage before, during, and after one of these parties, usually by a combination of professional photographers and attendees, also influences the way people express themselves. If the club allows partygoers to test out who they want to be, then it matters that the presence of the all-seeing Instagram eye tends to encourage and reward modes of expression that are camera-happy, spectacle-driven, and social.

The consequences of this hypervisibility are ambiguous. Despite more and better media representation than ever before, many queer communities are still deeply imperiled. The warmth of representation is an integral aspect of a longer effort toward protecting more of our most at-risk communities, but it can be easy to forget that representation is a *support* to activism, not a replacement for activism itself. Social media feeds on a trend-based logic, and so long as

questions of inclusivity still rage in the public sphere, these debates will create currency, both cultural and economic, for the gay capitalism machine. On Instagram, the personal is political is profitable.

Granted, neither Bubble_T nor Papi Juice operates in a vacuum; both are closely affiliated with more directly political and service-oriented organizations. Bubble_T's parties have raised funds for Planned Parenthood and Apex for Youth. These parties have collaborated with more explicitly activist groups to share resources and raise funds for social issues. Other parties, like GUSH, a party for "queer women of color to work and play, with a lesbian focus," seek to reflect their politics in their prices. They institute a sliding ticket scale: $5 for femme/nonbinary folks, $10 for gay cis men, and $75 for straight men. "The idea behind it is that it's a reverse economic system from the world outside of GUSH. Men make more money than women, so GUSH is cheaper for women and nonbinary folks," says cofounder Angela Dimayuga.

On the Uber home, as we glide through Brooklyn, driven by an older Chinese man who looks like my father, Julie and I use a tissue to press the glitter off our cheekbones. We ask each other about what work looks like the next day. I ask her if she managed to see Kiko Mizuhara and she says no; I tell her I thought I saw her, but it turned out to be a different tall Asian model in a qipao.

From my museum cubicle the next day, scrolling through Bubble_T's Instagram, I look for a picture of us at the party. The photographer has placed a shimmery red tint on the nearly fifty pictures from the event, coloring the memory with more beauty than I remember feeling. I see a picture with the model and send it to Julie: "oh she was on stage the whole night." Toward the end of the page, I see a picture with a side profile of my head. I look like I remember feeling: a little out of place, overthinking,

not softened enough by drugs or alcohol to be having more fun. I look at the other pictures, how people tag one another, how thirsty people ask for the @'s of hot faces. I scroll back to mine and sigh. I opt out of tagging myself.

While subcultures have long flourished in New York nightlife, what feels distinct about these events is the language used to describe them. Bubble_T is not only a queer party, but an *intersectional* queer party that uses words like "POC," "trans," "gender-nonconforming," and "femme-identifying" to describe its audiences. Papi Juice advertises itself as "an intentional space for queer people of color." When I look them up, their Facebook event description explains, "Any racist, classist, sexist, homophobic, and/or transphobic behavior will not be tolerated."

I was starting to see this framing not only in these queer spaces but also in venues across New York, like the Ridgewood club Nowadays or Bushwick's Mood Ring, which often house these parties. They self-avowedly seek to create "safer spaces," giving their attendees mandatory briefings on consent and harassment before they can enter. Dance floor monitors patrol the floor to enforce this rule, and provide an easy point of access in case someone is feeling unsafe or violated.

Some of this language comes from developments in feminist and social justice organizing. But the ethos of these parties—come as you are, heal through hedonism, lose yourself—is drawn from a long history of dance, disco, and rave cultures that created a community around shared experiences of marginalization, even if they never advertised that aspect of their practice explicitly.

Partying, especially by marginalized communities, has a fraught history of policing and regulation. As recently as 1971, it was illegal for two men to dance together in New York. The

municipal Cabaret Law—written in the 1920s to target Harlem jazz clubs—prohibited dancing by more than three people in any New York City "room, place or space" that sold food or drinks, unless that space had a rare and expensive cabaret license. Until it was repealed in 2017, it was used as a discriminatory tool and a weapon against marginalized communities' ability to dance, party, and build community. Bubble_T, in foregrounding a marginalized, intersectional identity, reclaims the right to build collectivity through individual and social expression.

But they also offer a contradictory experience of freedom and security. To enter these parties, we suspend some of our rights, allowing ourselves to go through near airport-like security, pat-downs, and decree-like proclamations so that we can enjoy the relative safety of a suspended space. Here we feel safe, but we are also surveilled. It is an unruly, challenging collectivity that is not inherently radical. More than a space to manifest identity, the queer party is a zone of temporary rights and rules. It is a tenuous, contradictory blueprint.

In October 2019, the musician Frank Ocean announced that his new album would focus on queer club culture and regional dance music, including "Detroit, Chicago, techno, house, French electronic," and New Orleans bounce. To accompany the album's release, he announced a series of parties called PrEP+ after the lifesaving pre-exposure HIV-prevention drug. PrEP+ was to inaugurate "an ongoing safe space made to bring people together and dance," one that would serve as an "homage to what could have been of the 1980s' NYC club scene if [PrEP] . . . had been invented in that era." The event announcement arrived alongside a no-tolerance discrimination policy, with an all-caps warning in language reminiscent of Bubble_T and Papi Juice—"THIS IS A SAFE SPACE"—but without the monitors and continued en-

forcement of spaces like Nowadays. Despite the inclusive branding, tickets weren't released to the general public; it was an event Alberto got a ticket to by DMing one of the DJs.

The venue is Basement, which was, at the time, a recently opened techno club. When I get there, I am wary. I see straight couples, hypebeasts, and Frank Ocean diehards desperate to catch a glimpse of the artist. Parts of the party are fun. Arca is here. Joey LaBeija is DJing. People are excited. But I wonder if we can still call it a proper queer party, especially after witnessing the more homegrown efforts of Bubble_T and Papi Juice. And I worry about how those efforts would survive, if their language and structures had become so visible that they could be wielded by celebrities, as an urban nightlife safari for straight voyeurs.

PrEP+ embodied these queer parties' worst tendencies. Because the no-cameras rule wasn't really enforced, the glint of celebrity exacerbated a feeling of surveillance. People take pictures and live stream. The mood is one of incredulity; everyone is trying to document the fact that they are there. Michelle Kim, writing for the magazine *Them*, recapped the most salient contradictions: "PrEP+ is what happens when a mainstream queer musician envisions a sex-positive, inclusive club night that ultimately becomes a 'who's who' of celebrities, influencers, and industry players."[35] PrEP+ was also criticized for ignoring long-standing organizations like ACT UP and the centrality of the queer nightlife scene during the AIDS epidemic.

What do we do when attempts at subversion mimic the structures they're intended to subvert? What makes for "good" party politics?

Tensions around self-presentation, class, and access have defined American dance music culture from its very beginning. In the early

1980s, house music took its name from a three-story former factory in west central Chicago called the Warehouse, where around two thousand mostly gay and mostly Black men found refuge. At the height of the AIDS epidemic, clubs like the Warehouse provided spaces for gay men to socialize and find community. House was born of a double exclusion—not just Black, but gay and Black—and its refusal took the form of embracing and remixing disco, a music that the mainstream had by then rejected. In New York, clubs like Paradise Garage, which existed from 1977 to 1987, provided similar spaces of communion within a larger gay nightlife landscape that catered primarily to white men. Without the lexicon we have today, spaces like the Warehouse and Paradise Garage were organized implicitly as responses to shared experiences of exclusion.

Concurrently, in 1980s Detroit, in a post-Fordist industrial landscape, a largely Black population left in the inner city partied to techno in empty warehouses. Techno's founding myth claims that the spareness of a crumbling landscape manifested in rigid, minimal music made by and for the Black working class. But the origin point for techno's most influential innovators was actually Belleville, a small suburb thirty miles outside of Detroit where three Black teenagers—Kevin Saunderson, Juan Atkins, and Derrick May—began producing computer-generated music inspired both by the rigid mechanical beats of the German band Kraftwerk and the philosophies of African American culture and science fiction that would later be called Afrofuturism.

In *Energy Flash: A Journey Through Rave Music and Dance Culture*, music writer Simon Reynolds recounts that the Belleville Three, as they came to be known, belonged to a new generation of Detroit-area Black youth who grew up in affluent families that had benefited from the golden years of the automotive industry. Their fascination with European avant-garde music was in part a form of class aspirationalism, an attempt "to distance themselves from the kids

that were coming up in the projects, in the ghetto," according to Atkins.[36] As the music gained traction and the warehouse parties got larger, some parties would put phrases like "no jits" on their posters ("jit" is short for "jitterbug," the Detroit slang term for ruffian or gangster), which further solidified the class divisions that could sometimes emerge even within primarily Black spaces.

From immigrant and working-class communities—including Jamaican immigrant communities in the U.K.—this music made its way to middle-class teens, both Black and white, who began to set up sound systems in illegal spaces. Skirmishes with the police soon followed. In the 2019 documentary *Everybody in the Place: An Incomplete History of Britain 1984–1992*, artist Jeremy Deller suggests that this rave scene was a catalyst for social transformation. In an increasingly atomized country, these parties were considered a direct response to the Thatcherite mantra "There is no society, only a collection of individuals." An emerging youth culture found community by listening to acid house, taking ecstasy, and dancing all day and night. Raves like this represented the first large-scale mobilization of people in the U.K. since the miners' strike in 1984–1985, and the correspondence between social gatherings like raves and political actions drew a great deal of attention and subsequent policing. The movement peaked in 1992 at a huge free party in Castlemorton Common, organized by the anarchist collective Spiral Tribe. This weeklong gathering of over forty thousand people in the Malvern Hills of Worcestershire led to the passage of Section 63 of the Criminal Justice and Public Order Bill of 1994, which notoriously banned parties of more than twenty people from playing "a succession of repetitive beats." Evading the police became integral to the antiestablishment ethos of rave culture, as it migrated around the continent from Great Britain to Belgium, Germany, and beyond, including to the U.S.

The whitening of rave culture went hand in hand with a moral

panic about drug use at unlicensed dance parties. Throughout the '90s, local governments tried to stamp out what concerned parents and alarmist newspapers called "drug supermarkets." Drugs both reflected and informed the music that was being created, condensing it into the musical structure of the drop.

By the early 2000s, police crackdowns—Senator Joe Biden's advocacy for "stiff criminal penalties for anyone who held a rave," and New York City mayor Rudolph Giuliani's revitalization of the 1926 Cabaret Law combined with broken window policing (a theory that visible signs of crime instigates more crime, thus justifying more stringent patrolling)—had largely corralled the rave scene into conventional nightclubs and the live event industry. In contrast with the abandoned buildings, remote farms, and desert wilderness where raves were held in the '90s, promoters began to seek out ultra-mainstream venues like sports stadiums and motorsport courses.[37] This type of music could exist legally only in the context of capitalism, where its more radical political roots could be inoculated into the container of a one-off event.

Soon, performers were pouring as much effort and money into LED panels and beat-synchronized animated graphics as they were into their music. In 2009, large, spectacularized events like Electric Daisy Carnival, EZoo, and Ultra Music Festival began finding popularity and profit in a Top 40 climate increasingly amenable to electronic sounds. Skrillex released his "Scary Monsters and Nice Sprites" in 2010, and the 2010s came to be defined by this type of aggressive electronic music. Leather daddies sharing bumps with finance bros on the dance floor; dark, shiny clubs next to tall, shiny skyscrapers.

Julie and I learn about Unter from our friend Hai-Li, who consistently responds "going" to raves on Facebook with posters so

elaborate and esoteric that it's hard to discern what they actually are.

Someone hugs me from behind and their sweat leaves my back cool to the touch. How are you doing, when did you get here, Daniel asks. He smells like soil. How are you doing, I ask. He shrugs. I feel badly, he says, working too much. I assure him he deserves a night off, give him a hug. It is the Halloween leather edition of Unter. Founded by New York nightlife organizer Seva Granik, the party aims to revive the transgressive rave culture of the 1980s and '90s, with a strict door policy and techno focus. Tonight's venue is Sugar Hill Restaurant and Supper Club, a historically Black Bed-Stuy venue, recast as a labyrinth of rooms with various techno acts. Most people are in black, although there is some unironic leather and ironic workout clothing in the bunch as well.

Do you think the nineties are more or less corny as an imitation, I shout to my friend Michelle. She smiles. We dragged her out despite her misgivings about large, druggy parties in general. The carpeted floors and drop ceiling of this restaurant give the party a DIY feel and contrast with the overblown, futuristic sets of EZoo, and the celebratory mood of Bubble_T. After asking Hai-Li about the party she added us to the private listserv, which purposefully made information about the party opaque, only releasing the location a few hours in advance, supposedly to evade legal detection. These precautions cultivate mystique but are still practical: Unter has taken place mostly in illegal venues, such as Superfund sites (landfills over hazardous waste sites) and warehouses in Ridgewood and outer Brooklyn. (Ekin: "Marginalized matter attracting marginalized bodies.")

I notice that people party differently here than at Bubble_T. At Bubble_T, the lights are on. It's about celebration, social dancing, chatting with friends, drag performances, community engagement, partnership. People are singing along to Madonna. They're there

to see and to be seen, by an immediate audience and a greater community, both physical and digital. At EZoo, the music is poppier and more energetic, the mood more overly sentimental. At Unter, the overall mood is darker; you feel like melting into the crowd. The absence of cameras makes a big difference. It doesn't feel like it is about showing off an identity, belonging, or celebration. It's more like a debauched kind of hell, where anything goes.

People are trying to make eye contact and the attention feels kind of nice, especially because it is diffused by the fog. I'm glad no one can really see me here. Nearly invisible, I feel that Unter is the closest to the idea of "going out" that I had conceived of as a child—a kind of total ego-loss, a dissolution of the self. But now that it's here, I'm a bit scared. What exactly have I found, and am I sure I want it?

Michelle and I walk outside to meet Julio, who is having a rough night. I clutch my elbows and grind my teeth. Michelle says she doesn't feel anything. Julie sits next to Julio, rubbing his shoulders. Friend groups sit in circles, on fake grass and makeshift pallet benches, and I wonder if the social membranes that separate us could ever be transcended by the promises of the music inside.

I take a walk back into the techno room, slipping past the front left hardcores rattling at the cage in front of the DJ. I find my place against a wall, and let my thinking settle as I focus on the movement of the lights, the soft fuzz of the artificial fog, and the metronomic bass. The elbows around me dissipate, and for a moment, I feel bodyless.

For some thinkers and artists, the kind of ego-loss valorized at Unter is a politically powerful tool in anticapitalist protest. In a 2016 exhibition called *Energy Flash—The Rave Moment* at the Museum of Contemporary Art Antwerp, curator Nav Haq pre-

sented raves as a "highly politicised phenomenon" that opened up "temporary autonomous zones" which "eluded formal structures of control." For those who felt "failed by both the market and the state," raves created their own logic based on collectivity rather than individualism that could "[transgress] race and class." Others, like Jenny Schlenzka, director of Performance Space New York, argued in *Frieze* that contemporary art institutions should stop looking to museums or theaters as role models and instead learn from nightclubs' ability to "break down the alienating barriers of class, capitalist temporality and individualism."[38] Even if they may ultimately replicate many of these existing structures, the possibility of this dissolution is enough for people to wax political about these parties.

The rave can embody anticapitalist protest in other ways as well. As Alex Billet asks in *Jacobin*, "What . . . is so much more offensive about kids throwing a rave in a shuttered Toys R Us than the fact that the bankrupt retail giant simply fired its workers and abandoned its facility to rot in the neighborhood?"[39] Raving might reclaim spaces, and time. Consider the rave as technology detox, one of the few contemporary experiences left that are so all-enveloping that you forget to check your phone. Taking place in the dead of night, it is definitionally in conflict with the schedules and pressures that define contemporary American life.

But the reality feels a little more conflicted. Raving is the perfect cathartic activity to revitalize you before your busy workweek, and with ticket prices often even more expensive than parties like Bubble_T, it is an activity often even more striated by class. The language of parties that are not explicitly organized around identity, like Unter, can also serve as a cover for an implicit whiteness, something the language of parties like Bubble_T has sought to combat. What's more, these parties can embrace the aesthetics of vintage rave culture without necessarily taking on its politics. If

historical rave culture saw itself as partying against something—fascism, Thatcherism—it's unclear what all the antagonism at parties like Unter is directed against today. Despite the association of the rave scenes of the '80s and '90s with transgressive or left-leaning movements, Unter doesn't profess any explicit politics. "There's nothing radical about Unter," says Granik. "We're just trying to have a party where people can feel like themselves, primarily queer people."

And what are we to make of spaces that try to decenter identity in an age of identity politics? These kinds of parties could suggest a way of organizing that de-emphasizes our identity markers, pointing toward forms of collectivity beyond race—an ethos of come-as-you-are acceptance very much in line with the history of dance and rave cultures. Techno music, with its roots in Black and diasporic immigrant communities, is the premiere music of displacement. What better soundtrack to a generation without roots, but flowers? Parties may have the ability to point to new collectivities, but they also can turn us into individual atoms, dancing alone to the beat, lost in a mindless, directionless crowd.

Something has opened in my brain. The music insists. My eyes shake loose and everything becomes more lurid and serene. A geyser. Sulphurous music and my body, a marionette. Michelle is a blur to my right.

But suddenly it stops. A whoop from the crowd in protest. The lights, without music, spin aimlessly in their tracks. Perhaps the track has skipped; someone stepped on the cord. Or is someone not okay? All the signs with banned drugs at the door . . . Did something go wrong? I hug Michelle, who is just now coming up. Her teeth chatter even though it is so hot. The lights turn on, and the silence blows wind in my ears. A flash of red and blue lights splatters through the windows.

Something is wrong.

"Is someone hurt?" I ask no one in particular. Michelle is grinding her teeth, involuntarily smiling, holding her elbows. "Did someone OD?"

I find Julio again out in the backyard, sipping some water; he does not feel well. I gather near the door, to try to figure out what is happening.

The police are here now. We are asked to evacuate, but in the moment I am just trying to figure out what to do with the fact that I am so high. The jarring incongruity between the scene of evacuating, listless partygoers and the roiling emotional hills within me. Should we take a car elsewhere? Where is everyone? I still want to dance. Is everyone okay? Our friends gather, soaked in sweat as if emerging from a pool, the raw wound of a high left open to the October night. In the moment, I wished for the safety patrollers at places like Nowadays. All the community that seemed possible on the dance floor dissipated as the party was roughly dissected by the presence of police. But there is no time to feel shame, only a desire to find an outlet for our collective, substance-infused euphoria, to make sure a good time is still had.

The next day, I text around to find out what happened. Through a mixture of Twitter and Instagram stories, I gather that the police shut the party down on the vague notion of "sound disturbance." Although Unter is often a DIY party, that night was entirely legal—they had rented the venue through proper channels. The shutdown, for a queer party on Halloween at a historically Black venue, was hard not to interpret with a certain sense of systemic malice.

It was a reminder of the precarity of this site, of these spaces that were so hard-won. That I had been so eager to critique and pick apart. A newfound sense of appreciation that these parties even existed washed over me, as well as a bit of shame for being

so hard on them. It was an appreciation that would only sharpen as the year would continue, as I would hear about fires at these spaces, overdoses at raves, shootings at gay clubs.

Partying performs a dual, somewhat self-contradictory social function: it can let you perform an identity, and it can let you forget you have one at all. In queer spaces, partying can reclaim the right to exist in certain ways, with certain bodies. Or the energy of a crowd, especially with the help of alcohol and drugs, can induce an out-of-body sensation, as you're subsumed into a greater, dispersed collectivity. Both ways of partying have seemed, to me, rife with political pitfalls.

Not all of our parties need to have politics. We can assign political significance to a party, but it might also be a retroactive justification for something that is too vast, too varied, too complex, to be just one thing. At my most optimistic, I am almost convinced that our ways of thinking and being on the dance floor condition us for ways of thinking and being beyond it. Other times, it's just a release.

Party or activism, rave or protest: so much of queer club culture lives in the space between these terms. The stakes of a potent and responsible party politics seem to lie in understanding these distinctions and blurring them whenever possible—being both relentlessly pragmatic and hopelessly romantic.

I look through the photos from last night. Despite the phone ban, I had managed to capture just a bit of sound. I scroll through my camera roll to a blotchy, bruised black square; a video with no image, just ambient noise. I press play. There is muffled, excited chatter, the rattle of an overblown bass, and a metal cowbell sound over sketchy techno. The ripping sound of skin against the microphone. I close my eyes so I can hold the party a little closer.

A TERRIBLE SENSE OF WHEN HE WAS WANTED AND WHEN HE WAS NOT

Tseng Kwong Chi and Keith Haring at Club 57 in 1980.
Photo by Harvey Wang.

Much of the personal investment in this study derives from my awareness of being an "Oriental" as a child growing up in two British colonies. All of my education, in those colonies (Palestine and Egypt) and in the United States, has been Western, and yet that deep early awareness has persisted. In many ways my study of Orientalism has been an attempt to inventory the traces upon me, the Oriental subject, of the culture whose domination has been so powerful a factor in the life of all Orientals.

—*Edward Said,* Orientalism *(1978)*

I'm a human being

—*Robyn, "Human Being"*

I.

This is the hottest summer we've seen in a while," said Vince, my new roommate. I lifted my suitcase onto the step, sweating. I was subletting a room in Kreuzberg, a neighborhood in Berlin known for its large population of students, artists, and Turkish migrants. Vince was a friend of a friend of a friend, and was curt and muscular and wore his long black hair in a ponytail. Half of his face was covered by large black glasses, the other half with a neat beard. His accent seemed to hem the corners of his mouth into a permanent pout. He had studied art and was now trying to figure out a studio practice. He wore his shirts tucked into black pants that ended in rubbery outgrowths—shoes that I learned were limited-edition Nike collaborations he'd gotten in Hong Kong while visiting his parents.

The flat was tall and white and airy, and my room was long and rectangular, ending in a window that looked out onto a tree. The living room had been converted into a makeshift studio with a low-lying couch, the floor strewn with charcoal sketches. Pulling my suitcase into my own room, I saw that Vince's room was similarly minimalist, with wineglasses and black clothing arranged in artful piles and a mattress resting on a bed of pallets. A red orb light in the corner made the room amniotic.

Earlier in the year, in New York, I had attended a talk by an artist. I don't remember a word she said, or what the talk was even about, only her response to a question during the Q&A. Someone had asked her what advice she would give to a young artist, and she said that the best thing a young artist could do is live in Berlin for a summer. In the movie version of my life, after the talk I walk out onto the street, pull out my phone, and immediately purchase a one-way ticket.

In reality, though, the thought lingers in my brain for the next

several months. I buy a notebook at Muji and pretend to be a Person Who Journals. I add the line *think about berlin?* to my work to-do lists. The thought of actually going unnerves. It's one thing to go to a place as a tourist, but another thing entirely to go for a month and cosplay as an artist. Plus, even though I'm a Gemini sun, I am only aspirationally spontaneous. The Virgo in my chart disallows me from actual chaos.

Eventually, in a gap between jobs, I make it to Berlin. My college friend Colleen joins. She had also recently left her job. Together we'd worked up the courage to go. The tickets looked reasonable, but still I counted and recounted my savings. It took careful deliberation and planning to be this reckless.

On our first night there Colleen and I ambled down the street to look for some food, passing an Italian gelato shop, an antiques store, and finally rows and rows of Turkish doner kebab restaurants. I was told that tech was changing Kreuzberg completely. Many of the Turkish families who historically populated the area were descendants of "guest workers" (*gastarbeiter*) who had been brought into West Germany starting in the 1960s, mostly to fill unsavory manufacturing, mining, and construction jobs. The Turkish German identity was another diaspora, with its own histories of exclusion, integration, and generational rifts, and I was observing it entirely from the outside. But all of this would not be clear to me until I started dating Ekin, who is Turkish, a few years later. I would tell him about the curious number of kebab shops in Berlin and he would shake his head at my American ignorance of European history.

We passed glassy, industrial buildings marked with the threatening optimism of coworking-space logos. We let the guilt of our participation in this system rest for a while. Colleen, who also came from a working-class family, was in a bit of disbelief that we were here, pretending a kind of creative-class bohemia.

We pick a kebab shop whose picture-based menu allows us to evade our language deficiency. Against the better judgment of the cashier, and Colleen, I point to a kebab with hot sauce. We sit on metal chairs outside the restaurant and eat while sauce dribbles down our fingers. Back at the apartment later that night I christened my entry to Berlin with a bout of percussive diarrhea. I felt smudgelike against the pristine, white tiled bathroom, but I imagined no better beginning to the trip.

On the toilet, I opened Grindr. In New York I had deleted and redownloaded it like a rash you shouldn't scratch, embarrassed at how infrequently my affection was returned, ashamed at my boomeranging desire for connection amid an unforgiving sexual hierarchy. Grindr and its black grid were a collective humiliation whose promise of connection was perpetually unfulfilled.

I pulled myself away, saving my future self from the blunt sting of rejection. Instead, I hovered over to my Notes app, trying to make good on my newfound resolve to become a Person Who Journals. *If gays don't make babies when we have sex what do we make?* I type, my fingers pausing as I scour my brain to come up with an answer, or at least another question: *Just the idea of ourselves, over and over?*

I opened Instagram, and then I closed it. I opened Grindr, and then I closed it. I opened Tinder and wondered if they had an office in Berlin. I turned off my phone and put it facedown. I waited for what felt like hours to turn my phone back on and looked at Grindr again. Nothing had changed.

I swapped in and out a few different photo variations, but decided that most of the photographs in my camera roll were too wholesome. A square with a torso, the tagline "NOW," and a green dot popped up at the top of the grid, and I realized it was my roommate in the other room, Vince. His tagline was "Asian, and I like em big ¯_(ツ)_/¯."

Vince was decidedly Asian German; he had schooled at Cam-

bridge and was now living in his parents' apartment in Berlin. He was not Asian American. But online, he was just Asian. However complex and multidimensional our identities might be in life, in the sexual marketplace simulated on Grindr, we were made to sell our wares in 2-D. I messaged a man with a beard and tight hips. He had a nice butt and advertised a large apartment, but what most attracted me to him was the fact that we had the same name.

On Grindr, when I would see other Asian men, there would be a little spark of revulsion. It was a kind of suspicion reserved for kin. What were you looking for? What was I looking for? At the same time, as my career progressed, I became more interested in artists who looked like me. I received—and sought out—curatorial and writing opportunities about gay Asian dudes. This was a curious doubling.

One of the artists I became familiar with was named Ching Ho Cheng. From 1976 to 1989, he lived and worked in the Chelsea Hotel in New York, where he made one of his most iconic paintings, *Chemical Garden* (1970). In it, he depicts a vibrant, intricately detailed vision of natural, mythological, and biological elements mixing. The work is sharply delineated by two squares. In the inner square, a smiling intestine resides in a bed of blue tendrils. In the larger square, sperm-like red droplets grow into increasingly complex paisley beings over a background of green bacilli. The lips of the sinister, lizard-like smile look like they might part at any moment.

I saw the painting for the first time while I was waiting to meet Sybao Cheng-Wilson, his sister. She tells me that although his first name was "Ching Ho," he often went by just "Ching." I sat on her couch in the same apartment Ching used to live in in the Chelsea Hotel. She directed her daughter to go back to her remote work in another room as she told me about his life.

Born in Havana to a Chinese diplomatic family, Ching was raised in Queens. He was an avid world traveler and deeply influenced by ancient spirituality. *Chemical Garden* may have been directly inspired by psychedelic drugs, Tibetan mandalas, and Taoist religion and it appears to capture that sense of interconnectedness, depicting a writhing, hyperactive space of cells reproducing, dying, and regenerating. "For me painting is a very spiritual thing," he said in a 1977 interview in the *Soho Weekly News*. "It is the most spiritual thing I do."[40] But standing in front of the painting, I wondered if the imagery had anything to do with his sexuality.

I turned to Sybao. She is a straightforward, elegant lady who wears a Bump It in her long jet black hair and elbow-length gloves. She was reluctant to describe his sexuality.

"Actually, he would never say anything," Sybao told me in an interview I conducted with her in an April 2022 edition of *Public* journal. "He would just show up with his person, and I would figure it out. In those days, everyone used the word 'lover,' whether you were gay, straight, or whatever. He was involved with Vali Myers for a while, then Tally Brown for six years, and then there was Greg, the wonderful Gregory Millard, and lastly Gert Schiff. It [the word 'lover'] is completely 'out' now! Ching didn't use labels, because what attracted him was the person."

Interpretations of Ching's work rarely mention his sexuality, partly because it didn't seem to interest him very much; he was much more interested in the cosmic than the earthly. But, of course, sexuality was an aspect of his life. He just might not have described it the way we would today.

When I asked Sybao if he might have used the word "queer," she was taken aback.

"God, in the seventies 'queer' was such a derogatory word to use! So horrible to say to anyone," she said. "My generation does

feel that 'queer' is a derogatory word. We remember the pain it inflicted on our friends so there is no way of getting around those memories." Ching and Sybao were those elusive elders—often queer, often Asian American, sometimes both—who were hard to come by. Learning about their lives was like studying blueprints on how to live.

Ching's work, in its emphasis on spirituality, wanted to transcend the label of "gay" or "queer." And yet, why did I feel such an urge to categorize him?

Simon—the other Simon, that I matched with online—pronounced his name *Zee*-mon. For our first date, we sat on the banks of the river Spree, which separates East and West Berlin. It turned out Simon was from Munich but now very much considered himself a Berlin person. He lived in a coliving space that was adjacent to a coworking space, which was as convenient to him as unnerving it was to me. I liked his small, compact body, and his laserlike separation between life and work. I disliked his pretensions about the nightclub Berghain—it's the *best*, he would say—and the eagerness he applied to discerning where the best "scene" would be on the weekends, even if I recognized a bit of this chasing in myself. For another date, I brought him to a party that Colleen and I were going to at a friend of a friend's. We introduced ourselves like it was a bit in a comedy sketch, Simon and Simon. In the only picture I have of him from there, he is holding a piece of cake on his palm.

Other days passed slowly. Colleen and I were excited to go to a park and to try to do nothing, which was difficult for our Type-A souls. We brought books and wandered. We explored the Vietnamese restaurants, learning more about the Vietnamese German communities in Berlin. In the fall, Colleen would go to law school.

She, too, was having a simulated summer of aimlessness, and we were both anxious about wasting it.

To make better sense of Ching's *Chemical Garden*, I read a lot of books that circled around the idea of "queer ecology," a theory that seeks to leave behind "gay" and "straight" for a more expansive relation to nature. Artist Lee Pivnik, founder of the Institute of Queer Ecology, defines queer ecology as "a visioning tool" and a "functional cosmology."[41] This lens allows you to imagine a world based on the fluidity that queerness promises, the ability to resist categorization. Zooming out from the human scale and considering our place in the larger ecosystem makes sexuality labels seem arbitrary. What is gay or straight when you're a tree? What is the sexuality of an amoeba?

Queer ecology goes beyond sexuality to redefine what it means to be human in the first place. The Human Microbiome Project suggests that only 1 to 10 percent of us is actually uniquely "human"—we are composed of bacteria, fungi, archaea, and a few microscopic animals invisible to the naked eye. Some queer theorists suggest that we are like lichens, multispecies composites of fungi and bacteria in a fleshy bag. Of all the organisms on Earth today, only prokaryotes (bacteria) are individuals. All other live beings ("organisms"—such as animals, plants, and fungi) are metabolically complex communities composed of a multitude of organisms, the edges between them blurred. In other words, looking up is not so different from looking down; the galaxies above us are mirrored in the galaxies within us.

The affinities between queer ecology and Ching's philosophy are perhaps already self-evident. His psychedelic works contain a kind of multiplicity—human and animal and cosmic—amenable to queer ecological theory. He might have pulled these ideas from

spiritual or Taoist terms, and we might give them a costume change via critical theory, but at the end of the day, it's the same picture: we are not individuals; we are embedded in a web of ecological connections, and there we will find harmony.

But if *Chemical Garden* is an image of multiplicity, it is not one that is particularly harmonious. It's cacophonous and chaotic. The painting is rendered in lurid, dark colors. The intestine wrapping around the image is not a penis, even though on initial glance it looks like it could be one. Anatomically, it is a rectum, made all the more prominent as the only element that supersedes the two-layer frame.

It is from this rectum that the red droplets, or some kind of life force, seem to erupt. The droplets look like sperm, although biologically they should be excrement. (Unless, of course, they are sperm being released from the aftermath of anal sex. Perhaps here the rectum is not a grave, but a nursery.) The droplets spew forth and become more complex as they travel upward in the painting, growing additional organelles of various shapes and colors. The coloring is so beautiful that it's easy to forget we're looking at something (or someone) releasing sperm. The center smile begins to look sinister, like a voyeur.

The process depicted in *Chemical Garden* is not necessarily the human cycle of life. In fact, it seems to skip a few steps, but in that way it's similar to the function of fungi—mushrooms, yeasts, and molds that break down dead matter and turn them into usable nutrients for plants. This makes *Chemical Garden* an image of survival. The scale of what we're viewing is unclear; it could be microscopic, or unfathomably large. If humans are themselves networks of living and nonliving agencies, then we are not singular sovereign individuals. Every cell is a universe, and "God" is in our heads.

Despite all of this, when I stepped away from the image in *Chemical Garden*, I had trouble fathoming consciousness at any

scale other than my own. I had tried to read and consume and dance my way into states of communion with the multiplicity of natural life around me, but I still felt stubbornly, resistantly, human. If anything, the experience of reading about the various ways that I was "not alone" or "not one" just made me feel more lonely. If I was a "multispecies composite," with the cosmic breathing in and through me, why was I on a dating app? If my body was a party, why didn't I feel invited?

For our second date, Simon and I went to the zoo, and with each step, the park seemed to be shrinking. We'd walk down a path thinking it was new, only to find ourselves back where we began. We bumped into roped-off sections with dangling signs that read "KEINE MENSCHEN," ("NO HUMANS"), checking and rechecking the digital maps on our phones. In New York, Julie and Michelle and I went to zoos in pursuit of a sense of expansiveness: a reminder of the context of humans amid animal life on Earth. Yet, instead of humbling, we came away with a sticky gratefulness that it wasn't us in the cages.

In a great circular hall, the animals were presented to us behind glass walls. We peered into the glass as if David Attenborough were narrating their movements on flatscreen TVs. Automatically, we imposed human traits onto what we observed: gay monkeys, gay snakes, humping frogs—probably gay. At a new toucan exhibit, the glass wall in front of the enclosure was obscured with dirt and soapy debris, almost to where we could not see the animals. A placard told us the dirt was there to acclimate the birds to their new home. The clear glass had caused injuries, apparently, because the toucans kept flying into it thinking they could escape. We peered at the painted sky behind the pair of *Ramphastos toco*, the common toucan, and imagined ourselves with broken beaks. From the in-

side, the glass must have appeared as a screen, although mired by dirt, it became a mirror.

In the afternoons, plagued as I was by a restless need for productivity, I watched free lectures on macroeconomics and HTML, a stopgap measure for the uselessness I'd assigned myself in pursuing a creative, fiscally irresponsible profession. Below this restlessness was a groundwater of guilt. This kind of planless travel was something I'd adopted from the lives of the curatorial art-world elite, this looseness with ambition, finance, and stability. I would couch surf; I would find money to eat. It would be fine.

I spent hours on YouTube. "What if our machines could be more than just our tools, and instead, a new type of companion species?" the artist Anicka Yi, who had first introduced me to the Telfar bag, mused on stage at her 2020 TED Talk. "I believe we need to embrace who we are as symbiotic living beings, and design machines to reflect this. What if the world was populated by machines that were more like animals and plants, instead of something you'd find in a factory?"

Anicka's artwork—which had become famous for engaging smell as an undertheorized realm of aesthetic experience—employed things like soap, potato chips, expired powdered milk, snail slime, and tempura-fried flowers to explore this molecular sense of self. In *Grabbing at Newer Vegetables* (2015), with the help of Tal Danino, an MIT postdoc, she made a paintlike "superbacteria" synthesized from all the individual samples drawn from one hundred of her female friends—many of whom had ties to the art world—swabbed from a body part of their choosing.

Perhaps it was a fatigue with the gridlock of contemporary identity politics, which sometimes operated on the same essentializing logic that it sought to critique; or the increasing imposition

of climate disaster, made all the more real by the COVID-19 pandemic, itself a product of increased climate control, that led more artists toward the microbial. What was microbial identity, any identity really—Asian American, Asian German, Asian Asian—when it came to the planet ending? The dissolution of the self, whether through the social deconstruction of race, or the cosmic and earthly forces that arraign us, is both a long-running pipe dream and something that happens every day, if you're lucky enough not to think about it. The fantasy of transforming into a bag of bacteria and microorganisms is as simple, and as complicated, as undoing our sense of being human.

After his psychedelics, Ching turned his interest in the cosmic to the mundane. In the early 1980s, his works reduced dramatically into quiet tableaux: scenes of plants, lights, and windows from his apartment in the Chelsea Hotel. "In the peeling, crumbling, cracked walls of my studio, there is a lunar landscape," Ching once said. "I travel through the wood grains of my floorboards. They are lofty mountains and calm lapping waters of a lake. Sometimes they are the drifting sands of the desert."[42]

Sometimes, these images were of friends' and lovers' rooms, as in a painting of his boyfriend Gregory Millard's shower (*Waterfall, Chelsea Hotel, New York* [1978]). Or the peeling, cracked walls of his studio beside an ironing board and iron, paused midchore to admire the glimmer of a rainbow on the chipping walls in *Untitled* (1980).

If the psychedelics imagine our connection to life at the microbial level, maybe these still lives investigate Ching's connection to humanity: a petri dish of the social ecology of the Chelsea Hotel. More than elaborate metaphor, a queer ecological framework in understanding his work prioritizes his social life as an integrated aspect of his artistic production. Even as he painted images of

the mundane, the buzz of parties and trysts and hangouts in and around the Chelsea Hotel vibrate just outside the frame of these quiet canvasses. During the 1960s and '70s, the roster of residents at the hotel included celebrities like David Hockney, Marilyn Monroe, Arthur Miller, and Charles James. Ching was also a regular at Max's Kansas City, where he became friendly with Andy Warhol and Bette Midler.

The ghosts of these social webs stick around today. Since 1989, Sybao has run Ching's estate out of his original apartment. His paintings, now proudly displayed, were often gifts to his loved ones. *Chemical Garden* was a twenty-first-birthday gift to Sybao. It hung in her apartment for many years before his death.

Simon took me to my first Buttons, a monthly queer party hosted in the Berlin neighborhood of Friedrichshain. Simon told me that Buttons was happier than the gay death trance of Cocktail, cooler than straight-infested Sisyphos, and less self-serious than Berghain. He said that the party was happier, but not too happy, as is the chicest standard for nightlife. It is even permissible to wear color, he said, with a seriousness which made me laugh.

Simon took my hand.

"Oh my gosh."

"What?"

"Are you feeling it? I think I'm feeling it."

Earlier in the day, Simon had carefully worked out the timing; if we took our pill by Ostbanhof station on the S-bahn, we could be high by the time we were through the door of the club, queuing time included. He was right; walking into the club, the ground rumbled beneath our feet, as if we were standing on the skin of a drum.

We shared a celebratory popper and then walked out to sit on one of the makeshift pallets that doubled as a bench, where

we met a stranger who had safety pins pierced through his ears. Other Simon sat in front of me with his back pressed against my knees while the stranger told us about a party he had gone to last weekend.

"You waited in line for four hours to get in?" I asked.

"It's like gay Easter. We got in eventually, so it was worth it," he said, matter-of-factly. "Why are both of your names Simon?"

"Is there a straight Easter?" I said, twirling a finger against Other Simon's back. The patio was a barely polished junkyard with an outdoor shower and old mattresses to lie on, a dilapidated Volkswagen to sit inside if you wanted more privacy, and sets of old couches and tables under clusters of trees. Clumps of people lounged under the starlight. The bass from the dance floor made an intimate cover for conversation.

"I have a trick," Other Simon said, "for line cutting." The stranger's expression did not change. "The Asian guys, the right ones, they're easiest—they usually let me cut with them, if I ask."

I pulled my knees away from Other Simon's back. I suddenly felt like being as far away as possible from him.

"Have you enjoyed living here?" I asked the stranger, trying to firm up my tone. He appeared unbothered, turning away from me to light a cigarette.

"Mostly," he said. "I moved to work this job and for the parties. Nothing like this back home."

I took in his outfit: the chains crisscrossing his shirt, the intentional holes in his pants. "Are the parties boring back home?" I asked.

The stranger released smoke between his teeth. "I can't be gay at home," he said.

I decided to take a quick bathroom break. The restrooms were just a trailer in the middle of the garden. As I approached the urinal, I saw a figure hunched on the ground, next to a different

urinal. I thought he was asleep until the man turned toward me on his knees and opened his mouth, expectant. I wondered if peeing in this man's mouth would count as a practice of the theory of queer ecology.

As I walked through the patio back to the dance floor inside, I paused as the microbes within me rustled in their slots, jostled by the chemicals. I tried to imagine myself becoming many different people at once: Ching. My mom. Simon (him). And Simon (me). I let my grasp on my drink loosen and looked down as the bottle fell, leaving a pockmark on the dirt outside the threshold of the dance floor.

Simon led me back into the building, past the ramp and the patio, past the bar and the darkroom, up to the upstairs lounge. I took stock of my mental state. Fuzzy. Bubbly. Pleasant. I pulled at the waistband on Simon's shorts. It was insane that we had the same name. It was also insane that I was in Berlin. What went wrong, or right, in my childhood to bring me here? Was this overcompensation for not drinking in high school? Was there anything that my parents could have done to prevent me from getting here? Did a well-adjusted adult feel the need to pursue a feeling of self-annihilation?

Sitting on the couch, Simon offered me a choice of two white powders, which apparently looked the same, but were not. "One will make you feel woozy, the other will keep you awake," he said, "and doing them together will make you feel more alive." We took both and I had never felt further from everything I knew than in that club lounge, looking down at myself, hair buzzed, topless, in gym shorts and black sneakers with a German stranger.

When I find Simon again, he is by the DJ in the smaller room, where the music is lighter and bouncier. He points to his nose. "Let's go see the Shaman?"

The shaman sells drugs in the Volkswagen. Outside, the gardens of the club unfold in a series of pavilions. I duck under a circular wooden structure where another dance floor lies dormant. The night is carbonated, everywhere people are alert, even as their bodies sink into hammocks and cushions. A fountain dribbles amid a tangle of bushes.

The Volkswagen is already packed with people. We push our way past the queens and frat boys and kneel in front of the Shaman. The string lights above cast little shadows on the windows, as if we are at a pit stop on a demented road trip. The Shaman is bald and white. Sunglasses. He doesn't answer when we poke his stomach.

"One or two," the Shaman asks.

"Two?" I say.

"No, we want one," Other Simon corrects.

"One or two," he asks again.

"Just one." Other Simon says, handing him the cash.

Other Simon bites the pill in half and pushes the other one into my mouth. We amble back into the garden. I feel fantastic. This was such a good decision. There was a version of myself that hunched over a desk from nine to five, and then there was this one, who frolicked in club gardens. Even though I had neglected my journal, I imagined myself returning to it, writing a new, brief entry: *A new day! Drugs!* This was the future and the past, all here on a platter. I spin in little circles, bumping into strangers, who laugh. I love them. They love me too.

II.

Born Joseph Tseng in 1950, the conceptual artist Tseng Kwong Chi grew up in Hong Kong and Vancouver and left home at sixteen after coming out to his father (in a basement, following a fistfight). He studied photography in Paris before moving to New

York in 1978, into an East Village apartment that his sister, the dancer and choreographer Muna Tseng, found for him, which was just down the block from her own place. On a spring day a year later, outside of his apartment, he met a boy with round glasses and curly hair. First (maybe) lovers, then friends, the artist Keith Haring and Kwong Chi became inseparable. They were mainstays of the nighttime swirl of artists and celebrities in the 1980s East Village scene—Madonna, Kenny Scharf, Ann Magnuson, John Sex, Bill T. Jones, Cindy Sherman, and so on.

It had only been a few months since I met Sybao in Ching Ho Cheng's apartment when I met Muna, who is the executor of Tseng Kwong Chi's estate. I went to her Christopher Street apartment in the winter of 2022 to do research for a magazine assignment. At this point, I felt that I had cornered myself into a market of gay Asian dude artists and their sisters, somehow. Ching and Kwong Chi didn't know each other during their lives (I asked), but their names were so close I had to make sure to separate them in my head.

Muna's apartment houses her brother's archive, and, with part-time help, she negotiates her active dance practice with the assiduous management of his estate, a balance palpable in the space's artful clutter. Boxes of photographs were stacked in a soft Tetris-like grid behind mirrored closets, and as she pulled out binder after binder, I was aware that, outside of the apartment, a Sweetgreen was opening. The city was changing. Yet, inside, records of old New York lived on through the diligent care of loved ones. I felt like I was back in my parent's garage, in another archive that was also a home.

In New York, a rich stranger on Grindr offered to pay for my ticket and drugs to a party so long as I would keep him company.

It was a circuit party, so called because such events go around the world, and men travel to them so that they can see the same men. I had never been to one, wary about the forests of shirtless, harnessed men, but I was curious.

I had just returned from Berlin, and had not yet recovered from the dopamine modulations. I looked at the stranger's headshot, assessing what I felt about him. His round features and shiny forehead. After Simon I was cautious about extending my desire, having retracted it like a snail's sensitive feeler, but I was not attracted to this stranger, and this emboldened me; I could not be hurt by him. And he was Asian, so I did not have to worry about being fetishized, probably.

I lay flat on my bed in New York. My suitcase from Berlin was lying open like a split orange. Adidas tank tops and crop tops from thrift stores in Berlin that I hadn't had a chance to wash yet sat in a heap. I parsed through the pile for something that was not too stale. I sniffed a T-shirt's ripeness; I figured I would be taking it off anyway, if what I had researched about circuit parties was true. I messaged back the stranger: "im down!"

By the early 1980s, when Ching was painting the cracked walls of his Chelsea Hotel apartment, Kwong Chi was making a name for himself in the downtown nightlife circuit with his distinctive Mao suit, a sartorial signature he'd arrived at almost by accident. Months after landing in New York, his parents treated him and his sister to dinner at Windows on the World, the restaurant at the top of the World Trade Center. Kwong Chi wore the only suit he had: a gray Mao suit that he had purchased at a Chinese boutique in Montreal. The store's owner had bought an entire warehouse of the suits, betting that they might be the next big fashion trend in Canada (they weren't). In the Western imagination, the suit was popularized when

Mao Zedong wore it while meeting President Richard Nixon in 1972, although it was originally introduced by Sun Yat-sen, China's first president following the fall of the Qing dynasty.

When Kwong Chi walked into the restaurant, his parents were mortified. "We escaped from China because of this," said Muna, recalling their parents' reaction. "How could you do this to us?" But the maître d' mistook Kwong Chi for an ambassador and gave them the best table in the house.

Taking photographs in the suit would become a way that Kwong Chi would meet people in the city. In his "party panel" performances, he would set up a camera at the entrance of a party and take a selfie with each person as they walked through the door. After getting each attendant to sign the picture, he would pin them to a board and it would become an impromptu roll call for the night. "The whole reason I started that was because I didn't know very many people in New York," Kwong Chi said in a 1987 interview with Roland Hagenberg about the party panels. "And that was one way for me to meet as many people as possible in a party context, as well as a way for me to be noticed by other people." He would soon make similar collaborative images around the city—standing with tourists on the iconically orange Staten Island Ferry or walking down Fifth Avenue on a summer day.

Muna pulled out another black binder, the plastic pristine but clouded with some age. It was full of negatives Kwong Chi had taken at a ball in Harlem for a magazine assignment. He is in his characteristic Mao suit, surrounded by drag queens and kings as they death drop and pose. In the dynamic played out across their fashion, those around him are "gay" but he is "Asian"; there is no grammar to imagine that he could be both.

Another binder. Here he's in his Mao suit next to a group of nude sunbathers at Jacob Riis Park in Queens, a historically queer beach. Kwong Chi smiles, fully clothed, hand on his long-range

shutter, as the sun bears down on him and a circle of beachgoers hanging out, sandy and tan. Kwong Chi must have been baking in the full suit.

"The commitment," I said to Muna, "to take a suit all the way out there." She nodded. I had gone to Riis for the first time a few weeks before, taking a subway to a subway to a train. I had marveled at the carnival I encountered, the warring camps of pop music, the beach fences marking out territory, the topless torsos, so many boobs. It was a little too crowded, a little gross, and smelled too much like weed, but we found a spot in the throng just to be near the energy.

In my imagination, after the picture, Kwong Chi parts with the sunbathers to find his friends. He strips off the Mao suit, like a banana peel. He's naked now too, his skin unwritten by stereotype. He runs into the blue-green shore, the Rockaways' surf a shock on his sweaty skin.

The party was in Chelsea. I hadn't gone out anywhere other than Brooklyn in ages. It would take a while to get there from Park Slope, but I was happy to be a little late, not wanting to appear too eager in any capacity.

The gray nondescript building on 21st Street had no line in front of it, other than a forlorn metal stanchion, but an imposing bouncer stood outside. I texted the stranger and he came out to meet me in a black T-shirt and black jeans. In person I felt even less enthralled by his presence, but when he handed me the ticket, and a plastic baggie with a little white pill, I understood that this was a transaction. I was using him and he was using me, and I felt okay with this.

Inside, I walked through warrens of rooms—security, coat check, lockers even. I pushed past throngs of men in black har-

nesses, punctuated by the occasional maverick lady with colorful hair. I quickly swallowed my pill. I came to a group of other Asian men, their brown torsos lithe and glittery, also collected by the stranger. Together we were a big impromptu friend group of gay Asian dude strangers. Two of us were blond, and we nodded at each other. I made a note to ask everyone else how they had gotten to the club. Maybe we could Uber home together later.

No one was wearing a shirt, so I figured it was time to conform. I took my stale shirt off and felt my nipples harden from the cold. I turned my cap backward, like some others had done, and adjusted my crossbody bag. One of the men gave me a thumbs-up; I imagined he had taken his pill too. I could feel a slight pressure behind my eyeballs, a lifting inside of my chest. I swallowed spit. Someone wanted to take a picture—just one, to commemorate—so we posed. My hand rested gingerly on the torsos to either side of me. I pulled my lips open for a smile and blinked as the flash turned the world temporarily white.

Kwong Chi referred to the making of his Polaroid panels explicitly as a performance—even if today it might just seem like a human photo booth—and a performance connected to identity-based subject matter. In the aforementioned 1987 interview, he describes the panels as an extension of the play on tourism seen in his most famous series, *East Meets West* (1979–1989), in which he dressed as a Chinese tourist in front of American and international monuments such as the Statue of Liberty, the Hollywood sign, Disneyland, and the London Bridge. "It's kind of like an exchange of confidence," he said. "Instead of just shaking hands and saying 'How are you?' I invite them for one Polaroid. Which I keep. [Laughs]."

The "touristic" element of his nightlife photographs feels even more apparent when we look at the panel that he made during a

party with an "East Meets West" theme at the nightclub Danceteria. It is unique among the Polaroid panels because the photographs have been arranged to resemble a passport book. The images sit above a space with signatures and stamps that read: "EAST-meets-WEST," "SLUTFORART," and "P.R. ISSUED." The East-meets-West dynamic is also enacted, perhaps unintentionally, across the fashions featured in the Polaroids. Kwong Chi stands in for the East as he takes pictures with the mostly non-Asian partygoers, who represent the West. Kwong Chi's Mao suit remains a constant, while the partygoers' clothes change.

In 1980, he would crash the Met Gala in the same suit, taking pictures next to the city's socialites, who wore orientalized costumes for the opening of *The Manchu Dragon*, an exhibition (organized by Diana Vreeland) of Chinese costume from the Qing dynasty.[43] In this series, Kwong Chi, in his Mao suit, stands out next to the outsized fashions by the party's mostly white guests. He unintentionally stands in as the exhibition's real-life Manchu Dragon.

On the circuit party dance floor, radio hits were held hostage in electro and dance-hall remixes. I peeled away from the group to stake out the room and do some exploring, trying to feel wanted. The stranger trailed behind me, trying to slip an arm around my waist. I had no eyes for him, and I'd taken what I needed so I guiltily slinked away, looking for something else.

Finally alone, I tried to dance, but found the music distractingly generic; not even in a fun, camp way, just a bland, limping, electronic way. (A minute for me to hate on circuit party music: it has the worst, derivative quality of something like Shaq DJing at EZoo, but none of the propulsive or emotional heights of EDM. It has the monotony of techno but none of the minimalism or precision. Instead it sags, a soundtrack made to be inobtrusive for

contemporary cruising.) An enormous, muscled man thrust his way past a thicket of dancing twinks. In my peripheral vision, I thought I saw one of the Asian guys from the group chatting with a group of men, his eyes twinkling. I pretended not to know him.

What was I looking for? Something cute. The embodiment of boyishness. A soft landing. A shapeless fog inside of me sharpened and then receded. I didn't feel unattractive, but I also didn't feel hot. My internal monologue swung drastically from confidence to self-hate and back, localized around a hip or a waist. I hadn't asked what the dose was on the pill the man gave me, but it was turning the world lurid very quickly. *I should have come in a full Mao suit*, I thought. How hot that would have been. The men around me wanted to wear as little as possible, and yet it felt that they were in a costume of their own as well; vaguely athletic, vaguely fetish, vaguely white.

My eyes landed on a blur of color and light at the center of the dance floor.

"Fashion is a very western statement," Kwong Chi would explain. "It's a very western concept that you change your clothes every day, instead of wearing the same clothes all the time." Discussing a planned but unrealized sequel to his *East Meets West* series, he envisioned traveling to mainland China dressed as an Americanized Chinese tourist—which, to him, meant wearing designer jeans, Ferrari sunglasses, and an Armani suit jacket. "I would like to grow my hair a little bit longer and have a permanent, like so many westernized Chinese do, and um, you know, wear designer sunglasses. And I would keep changing clothes—which is a statement in itself." Kwong Chi's body is the through line across his photographs. "I'm always in the photograph because it all has to do with tourist snapshots," he explained. "It's a reaffirmation by a

tourist—by someone, you know, who has gone somewhere, and it's like proof I was there."[44]

Although Kwong Chi predates the flourishing of identity politics in the 1980s and '90s, his work resonates today because of its provocative engagement with stereotype. Terms like "East" and "West" sound kind of silly to me now, but they are still useful shorthand. At the time Kwong Chi donned the Mao suit at Windows on the World, he had never stepped foot in mainland China, yet the suit seemed to manifest what everyone else saw in him: the Chinaman.

"He was dealing with identity politics," Muna remarked in a 2022 *Zolima CityMag* interview. "Even though he did not ever say 'I'm a Chinese artist' or 'I'm a Chinese-American artist' or 'I'm a Chinese-Canadian artist.' He just said, 'I'm an artist.'"[45] This tension between what others saw of him and what he thought of himself would become the playful, and painful, afterimage of his art.

At the source of the light was a man. Kind of chubby. Maybe Chinese. He wore an open pink plaid shirt and jeans, with Christmas lights that he had strung all over his body. An inflatable pirate hat on his head. He must have had a battery with him too. The visual disruption of his lit-up body amid the sea of slim torsos made him both entirely visible and absolutely invisible.

No one wants to sleep with this guy, I thought. He's overtly Asian. He does not have a good sense of when he is wanted and when he is not. Or he has too good a sense. I was both repulsed by his flaunting of the room's conventions and a little jealous of his resolve. How weak my own will, that I had bent to the standards of a room and a culture that I knew, categorically, was detrimental to how I saw my body.

A circle of aversion formed around him, as if his desperation were contagious. I looked around for the other Asian guys, I looked

around for the stranger. I was alone, pretending not to know anyone, yet unable to stop looking. I felt that I had to leave the room and put as much distance between us as possible.

The legacy of Kwong Chi's intentional self-orientalization remains complicated. The Mao suit granted him access to various worlds of white power. It was a nonthreatening way to exist in these spaces because it did not presume any kind of assimilation or fitting in. A forthright admission of his otherness somehow inoculated him from being a threat, as if, in wearing the suit, he was saying: My allegiance is to China, rest assured; your America remains untouched. Like the man in the club, covered in Christmas lights, it rendered him both hypervisible and invisible.

Kwong Chi decided to be overtly Asian, exacerbating stereotypical qualities to preempt the punch line. There was no need to go back to where he came from, because he had never left; there was no presumption of being American. The costume was a deadpan tautology: Asian = Asian. The exact hurt of being flattened in this way is being associated with the word's American stereotypes—emasculated, bucktoothed, effeminate, sexually inviolable, fetishized—and exacts an emotional cost that is lost to history. Did Kwong Chi avoid other Asian people because of it? How many Asian friends did he have or lose? There are only two or three Polaroids in which he appears with another Asian person. In one he's with Benjamin Liu, Andy Warhol's studio assistant, and in another he's with his sister. Did they go to the party together, and then separate? Did he ever pretend not to know them?

I was repulsed by the man in the Christmas lights. He was what I sought to expel from myself. He was the Manchu Dragon, a

racialized eunuch that I feared others saw me as. He was a piece of emotional flypaper, on which hundreds of moments of doubt coalesced, writhing, shimmering paranoia. How could this be possible? It went against the equity I believed in theoretically, personally, and yet I felt its hot wet fingers on me. Had I not read enough books to escape this prejudice?

Someone grabbed my waist and I pushed them away. I grabbed someone else's waist and they pushed me away. A beautiful boy with cold black eyes and spiky black hair eyed me from a thicket of white men; he was the only Asian one among them, but before I could reach him he disappeared.

A group of bearded dudes from Brazil mimed play-fighting with me, capoeira-style. They swung an undercut, and I tried to play along, giving back a punch and a kick. One of them grabbed my arm, and I accepted, alighting in the reprieve his attention provided. We were together for a song, before he rejoined his friends, and turned cold suddenly. A friend whispered in his ear and he snickered. He turned back to me, the expression on his face unreadable. I did not know what to think, before the crowd parted and the Manchu Dragon, resplendent in Christmas lights, writhing, gyrating, came back into view. They pointed to him, the man strung up with lights, and then they pointed to me. They pointed to the man, and then they pointed to me.

Today it is rare to see photographs of Kwong Chi without the Mao suit, his own self and his performance of being the "other" having merged. The suit had become both a superpower and a prison of his own making. I searched for photographs of him without it. Did any exist? Why didn't I see more of those? Was this what he intended?

Of course there are images of him without the suit. Some great

ones. They just don't get the same attention; I imagine few people had gone into the archive with the intention of looking for the human Kwong Chi, the Félix to his Felix, the Steven to his Telfar. In a particularly nice photo, he's reading a poem onstage next to Keith at Club 57. In others, he's at dinner, in a black suit and blazer; in a green dress for a Halloween party; on the beach squinting at the camera. I felt relief. I felt, involuntarily, that he was like me, and I wanted to know that in the future my image would not also be limited to a caricature of my race. Even if Kwong Chi had done it on purpose, I couldn't help but mourn a version of his practice that was not predicated on an imposed otherness. "It is not easy being a Chinese tourist," Kwong Chi told *Inside Magazine* in 1989. "Should I tell them the truth . . . ?"

I had lost the stranger, and I had lost my Asian frenemies. I had never had either of them, and some of them had wanted me, perhaps, but I had only wanted to use and distance myself from them. The Manchu Dragon was still dancing, a blur of light on the floor. The pill, however, did not let me linger in any kind of sadness. Instead, emotions throttled me to extremes, despair washing at my throat and then giddiness abolishing it immediately, like a frenetic procession of royal decrees.

And now you shall be optimistic.
And now you shall be alone.
Go suck a dick!
Hole?

I shuttled from corner to corner, trapped between the music and the thicket of untethered desires. I was unable, in the absence of mindless techno, to even find dancing as refuge. Attentions from others came and they went. I talked to a man who hugged me on sight, mistaking me for someone else, the sweat from his

hairy stomach leaving a stamp on my cheek. As the pill seemed to wear off, the ragged edges of a comedown began to feel more and more inevitable. I felt that I had to leave, that there was no option for me but to leave.

Outside, Chelsea was a pillow of silence. The sun would rise soon, but the night still felt like the day before; it had not yet turned over with early risers. I had returned to New York from Berlin with a thicker skin and lower tolerance for fetishization, but I had ended up using others, abandoning strangers, and becoming more judgmental.

I checked my phone. Other Simon had texted me, from thousands of miles away in Germany. A video of a block party in Berlin. "Miss this?" he had written. I was not sure that I had really left.

Back in Berlin, I found Other Simon amid the sea of other gay men at Buttons. There was another man with him, one with black spiky hair and tan skin, like mine.

"This is _____," he said. "A friend," he added too hastily.

The man smiled. *There can only be one.*

I felt suddenly possessive of Other Simon, this Simon who I felt collected Asian men like toys. I let the drugs wash over this realization. A realization that wouldn't land until later, in the comedown. The realization that I was exactly the type of Asian guy who fell for Other Simon, who wanted him even, because in those fleeting visions of white desire I felt powerful and better than other Asian men.

This was the ugly core of this attraction. In this proximity to whiteness, I felt real. I felt like an image of Simon's desire. My desires were betraying me into a feeling of total fungibility. Maybe there was something good about being replaceable, that the only individuals are bacteria—I was one of many, an amoeba—but at

the time I just felt raw, unfortunate, cheap. What would be left after I removed Simon's desire from myself?

I wrapped my arm around Simon's waist and pulled him away, barely acknowledging his friend. I knew my way around by now; I felt I had been in the club for days.

I slipped my hand into the waistband of Simon's shorts, but he stopped me.

"No?" I said.

Simon pulled back, seeming to chew on something. "I'm positive. But undetectable. It's not a big deal. Just FYI."

The room seemed to shrink. I took in a bunch of short breaths. I tried to think back on the last week, everything we had done. I ran out to look for someone to talk to. A friend cocked her head. "All okay?"

"I may have done something stupid," I said.

Anger simmered somewhere above my stomach, until it soured into something like embarrassment again. I was starved for the kind of self-possession that everyone around me seemed to have. I thought maybe if I surrounded myself with it, with its musk, that I might learn to do the same. I had not yet internalized the idea that life was not like school, and I felt, in these smallest of personal trifles, like I was failing. The shame of being another Asian dude in a long line of Asian dudes for Other Simon.

Later, I would test negative, and learn that being undetectable meant that Simon was not infectious, and then I would feel dumb *and* prejudiced. But this was the closest brush with the virus that I'd had so far.

This was the rumbling inheritance of queerness that I had stepped into, that my parents had unwittingly brought me into, by growing up in America. It was another reason that it was so difficult for me to get behind the push for queer ecology; so much of historical gay life was about monitoring our fluids,

making sure our molecules stayed where they should. I can't even imagine the grief that generation must have endured, but I know that my blissful ignorance of it is a marker of some kind of luck, and progress.

When I got back to the throng, my new friends were arranged on top of a pile of pallets and it seemed that some substances had worked their way into their systems as well. I sat next to them and stared into the dirt below as the particles I had ingested ventriloquized my nervous system into a heightened state of excitement. My body felt that it was cresting the top of a wave while my emotions were churning, leaving what was left of me in a state of cratered suspension. The tiny cosmic galaxies in me and those of Other Simon had intermingled and they would always be intertwined, those parts I was both attracted to and repulsed by.

I couldn't really speak. The words were stalled in my throat. A friend placed a gentle hand on the back of my neck. I asked her to make sure I got home okay and she laughed, nodding, asking if I wanted a cigarette. I had never had one before, but degeneracy was a slippery slope, and I was slipping and sloping. The wind blew the smoke back towards our group and formed a halo under the dance floor's lights.

How terrible it is to be on a dance floor, to be wanted and unwanted by people. It seemed uncouth to want that much attention in public. Easier to cauterize the want, before it festered into need.

In the morning, I woke up too late. Other Simon had texted about meeting up but I had resolved not to talk to him again for a while. I lied and texted "sorry im sick." I made plans to get Turkish breakfast with Colleen. I moved sluggishly, inspecting my brain for signs of a comedown, but I felt good, happy even.

At brunch I took a picture of a funny-looking cigarette holder

and posted it to Instagram stories, and asked her about her night. Colleen, her boyfriend, and her sister had been ahead of us in line at Buttons, but had gotten rejected at the door. Colleen's sister, who identified as queer, had been crushed. For a space open to queerness, it hadn't been so welcoming after all.

We resolved that there were bigger things to care about. We would fly out in a few days. Colleen was going to Prague with her boyfriend, and then we would reconvene on the East Coast. As my food arrived, I got a notification from my phone. Simon had responded to my Instagram story: "ur room looks like a restaurant. r u avoiding me?"

I flushed. Had I treated him poorly? Was I being unfair? I was not absolved of interpersonal problems even if I resented the way he seemed to fetishize Asian men. I had wanted to hurt him, but I knew it was harmful to spend any more time around him. I had also treated him as a novelty, dated him in part because his name was like mine. He was not the only person who could use people for experiences. I had gone on other dates with men in Berlin, they'd all shown me different parts. Some I would even stay in touch with from the States. I had reduced a country to a playground in a way that only an American could.

Colleen told me to put my phone away. She sipped her orange juice, picked at her feta. Sitting in the presence of a good friend, my late-night ruminations seemed to congeal. Colleen was white, but we spoke frequently about topics of gendered and sexual politics. We bemoaned that neither of us could fulfill the ideal of becoming political lesbians. We often allowed race or gender to overdetermine our relationships. *It was bad to date men, it was bad to date the white colonizer,* we thought but didn't say. We bullied our desires with our politics, even if, as queer people, we had famously unruly desires.

But our emotions would not and could not be contained by

our politics. Relationships were about a lot more than just race or gender. Our desires would never be entirely evacuated of political responsibility, but there were so many other intangibles: Did they treat you well? Did they text you back? "Good" and "bad" desires sometimes had less to do with race, and more to do with being a good partner.

Desires were also susceptible to change, Colleen offered. I agreed. I remembered how differently I felt towards Asian men after spending a summer in Beijing, bombarded by Asian beauty standards, how my center of attraction had shifted entirely. Our desires could change, but they are often resistant to *deliberate* change, even if, as sacks of bacteria and cells and microorganisms, we were changing all the time. Of the nearly 30 trillion human cells that compose a human body, about 330 billion are replaced every day. Some propose that all of our cells are replaced every seven weeks. If we took queer ecology as an aspirational philosophy, then at least I could take solace in the fact that this particular configuration of identity and desire, one that had led me to Other Simon, might come and go; it did not have to define me indefinitely, even if I wanted it to.

Across the street, I noticed colored, twinkling lights in the window of a doner kebab restaurant. They were almost like Christmas lights, but barely visible in the harsh summer sunlight, which seemed to rinse them of their color. Still, they glowed like tinsel, beautiful for a moment.

Our food was getting cold. Colleen told me I was doing the right thing, to put my phone away, again, and to eat my eggs. So I did.

In 1986, seven years after moving to New York, Kwong Chi flew to Vancouver to celebrate his father's eightieth birthday. While

there, he started photographing himself against the Canadian Rockies, and came upon a new vein of his *East Meets West* series, where he reimagined himself dissolving into natural landscapes. Now armed with a Hasselblad and the assistance of his partner Kristoffer Haynes, Kwong Chi was no longer tethered by a shutter-release cable and was free to lose himself in his surrounding environment. In *Grand Canyon, Arizona* (1987), he has his back to the camera, sitting on a ledge overlooking a jaw-dropping view—a winding river, marbled cliffs, the biggest sky you've ever seen. One imagines his legs swinging over a thousand-foot drop. In *Lake Ninevah, Vermont* (1985), a tiny Kwong Chi, still in a Mao suit, rows a boat across the placid water. The mist of the early morning, the gray of the water, and Kwong Chi's tiny figure are nearly indistinguishable. In *The Expeditionary Series*, Kwong Chi sought to dissolve his figure into nature.

Curiously, in the 1980s, Ching Ho Cheng also started submerging himself into a kind of ecological sublime: he made literal landscapes out of his paintings, with ponds and rock formations in his studio. When Ching went to Turkey in 1981, he visited caves and grottoes, fascinated by their colors and textures, and studied ancient stele and monuments. Taking these images back to Chelsea, he explored various oxidation processes, which led him to submerge paper, covered with copper or iron filings, in water for several weeks. "It was as if lightning had struck," he says in a 1988 interview. "This act affirmed the creative and destructive aspects of nature." After tearing and gessoing 100 percent rag paper, he would cover it with an acrylic medium, gray iron powder, and modeling paste. For two weeks he soaked the work in pools of water and the powder would rust into lush browns and reds. Ching changed the water daily, to keep the oxidation process going so the work would become richer in color. "Rust is ferric oxide," he said, "among the most permanent substances in nature. The Egyptians

used ferric oxide for pigment and their frescoes are as fresh today as they were when they were made."[46]

This all led to one of his first solo shows, at the Bruno Facchetti Gallery in 1986—the same year Kwong Chi was in the Rockies—where he turned the gallery into a pond. Here, he visualized the gallery space as a natural landscape, and placed large basins of wood on the floor containing water in which he floated torn papers covered with iron dust. There was nothing on the walls. Only the basins, their slowly reddening papers, and some newspapers were spread on the floor. Viewers would have stared down into the live rusting processes of his work.

Drawing inspiration from Turkey to the Grand Canyon, two men, Ching and Kwong Chi, on opposite sides of Manhattan, sought to meld their art into an infinite nature that was to betray their bodies imminently.

Kwong Chi's final photographs—and his last trip with Keith—took place in Italy. While photographing Keith's projects in London, Paris, Bordeaux, and Berlin through the years, he took the opportunity to expand his *East Meets West* series into Europe. I can't help but romanticize this last trip. From a section of Keith's journals while he was in Pisa with Kwong Chi, dated Sunday, June 19, 1989:

> *I had music hooked up to a big speaker while I was painting. Every day was like a block party. One day (the last day of painting) we had a DJ and a crowd dancing at the [Berlin] wall. Constant autographs and photographs. There are some of the most beautiful boys here I've ever seen in my life. We met a posse of military kids (parachute jumpers) who come every day and hang out. Kwong Chi has been taking tons of rolls of film.*

Did they know it was their last trip? Did they share a bed to save some money, or did they find a boy who could host both of them? In Rome, Kwong Chi photographed himself in the early morning and late at night, waiting for a moment when the crowds had dissipated, so that he could appear to be alone in his photographs, like in *Rome, Italy (Coliseum, Night)* (1989). "Later we went with Kwong Chi to do his night shots at the Colosseum," Keith writes. While Kwong Chi shot, Keith and his boy at the time, Gil Vasquez, hung out with some guys playing soccer and smoked hash with them. "They were really crazy, but fun," he writes.

In 1989, Kwong Chi tested positive for HIV. He was hospitalized with pneumonia for about fifteen months before he died. He had begun to shrink in his work, dissolving into his pictures, and so was his body. "The biggest blow, I believe, was when Keith died on February 16 when Kwong Chi was staying in a Toronto hospital," Muna said. "It was the moment I saw in his eyes he gave up the fight. I brought him back to New York." Kwong Chi died at home three weeks later, on March 10, 1990.[47]

When Ching Ho Cheng was diagnosed with HIV in 1988, his sister, Sybao, had recently gotten married and moved to L.A. She tried to fly back and forth but couldn't bear the thought of him alone, so she moved into the Chelsea Hotel to take care of him. She never left, and she continues to live there today with her family. When the time came, Ching decided to leave his paintings to Sybao. "I did not understand what that would entail, but that didn't matter. I made a promise to Ching, and at his memorial I stated that I would care for his work." She told me this as I sat in her apartment, and the sun passed through the window as it did in his window paintings from the '80s.

"Every year that passes, I discover something new in Ching's paintings. Ching speaks to me through his artwork. It's wonderful

to discover and a comfort in many ways!" she told me. "There's so much that I wish that I had understood when he was alive so that we could talk about it, but the fact is, I wasn't ready. I was too young and immature. But Ching was already there, light-years ahead of his time."

Ching and Kwong Chi lived through the greatest civil rights campaign before our current moment, as well as the Vietnam War, and the death of many of their friends in the continuing HIV/AIDS epidemic. It's hard not to read the trajectory of their work as a response to all this turmoil, to look to the solace of the cosmic, to the interconnectedness of the natural world.

I had come to learn of both artists, gay and Asian American, and couldn't help but fabricate a relationship between them. I imagined what might have passed between them had they lived long enough to travel in the same circles. Would they have dated? Would they have hated each other? Would they have been cordial, even friends, but held each other at a moderate distance? Formed a collective? Or would they have eyed each other from the safe harbors of their white boyfriends, two magnets repelling?

I had not had the chance to encounter them, but I did meet their sisters, Sybao and Muna, who diligently balanced their own lives with the tender maintenance of their brothers' legacies, and through them, their art came into conversation with each other's. Maybe this was itself a real queer ecology, a less theoretical and more humble one, in which younger generations looked to the living traces left by their elders. How it is that my exact combination of microbes, and those of Sybao, Muna, Kwong Chi, and Ching, all came to be connected in New York? Even for a brief, brilliant moment, across times and dance floors, this is perhaps evidence enough of some kind of cosmic plan.

In New York, on the subway back to Brooklyn from Muna's

apartment, I sit on the Q train as it crosses the Manhattan Bridge, and look for Robyn: *There's a big black sky over my town / I know where you're at, I bet she's around.*

At the Chelsea Hotel, Ching watches the sunlight dapple his room and picks up a paintbrush.

In Club 57, Kwong Chi tries to do nothing, staring instead at the light above the stage, vulnerable and still without the armor of the Mao suit.

In Berlin, Colleen and I sit at brunch, forking small bits of cucumber and feta onto crusty bread, Christmas lights refracting in the steam of our tea.

Ching Ho Cheng and his sister, Sybao, on their way to Studio 54. Hotel Chelsea, 1979.

WITHOUT ROOTS BUT FLOWERS

Tom Finkelpearl's contact sheet of Godzilla: Asian American Arts Network group portraits, 1991. Courtesy Godzilla: Asian American Arts Network Archive/Fales Library and Special Collections, New York University.

Having looked for politics in order to avoid it, we move next to each other, so we can be beside ourselves, because we like the nightlife which ain't no good life.

—*Stefano Harney and Fred Moten,
"Politics Surrounded," from* The Undercommons

You can take that superficiality and just reach for it and just, heh, tan at it, and pull on it, and like.... Yes, I can kidnap it and use it as a mirror, or a contrast to describe myself.

—*Robyn, on the shallowness of pop,* Bon *magazine, 2010*

In the summer of 1990, on a late July day fuming with the smell of pavement, three artists—Ken Chu, Bing Lee, and Margo Machida—met in a Brooklyn studio. Ken and Bing were part of Tuesday Lunch Club, an informal weekly gathering held at Chinatown restaurants where they could get cheap food, hang out, and gossip, but they were also all of part of a friend group of Asian American artists. They had met one another through community projects and self-organized group exhibitions. And parties, of course.

The purpose of this particular meeting was to discuss the formation of a new kind of institution, one that could support the needs of contemporary Asian American visual artists like themselves, but also—at first implicitly and eventually explicitly—challenge the whiteness that pervaded the city's mainstream cultural institutions. They hoped to stimulate visibility and discourse and, in some ways, make more official the loose artistic and activist activity that they were already engaged in. The group, after many more meetings and added friends, would come to be known as Godzilla: Asian American Arts Network—a name they selected for the spirit of its city-destroying monster namesake. At that first "official" meeting in 1990, Margo, Ken, and Bing shuffled between hopeless romanticism and relentless pragmatism, between big goals and immediate takeaways. Their initial idea was the formation of an Asian American art museum, "a place which we could 'call our own' as other ethnic minorities have formed their own institutions." But this had to be tempered with the reality: Who was going to run it?

"[We] should consider both short- and long-term goals," Margo says in the meeting minutes, pragmatically, "and try to identify a project that would be feasible, considering that all of the participants are artists who have other professional commitments."

For Bing, education was a big priority, so the short-term solution

he proposed was to start a publication, journal, or newsletter where the coalition could share news and updates about the community while also commissioning Asian writers to build a critical discussion around work by other Asian American artists.

From the very beginning, Godzilla had a shrewd outlook on the relationship between the world of symbols and material reality. While it could be critical of representational politics, it was also pragmatic, supporting Asian American visual artists in exhibitions, programs, commissioned writing, and events. And even this early on, you get a snapshot of the existential anxiety in trying to build an organization around a term like "Asian American."

"Two important issues," Ken says in that meeting, "1) how we define our identities as Asian, and 2) how to present Asian culture in America.... We need to redefine Asian culture from an Asian American / Asian perspective, and there also has to be a context where Asians can begin to better understand each other through dialogue ... it is vital, in the planning process, to define what we mean by Asia and Asian American." Although they had come together through their shared experiences of being Asian in America, perhaps even of being "vaguely Asian," each of them had varying relations to those terms: Bing was born in China and grew up in Hong Kong, Margo was third-generation Asian American from Hilo, Hawai'i, and Ken was born in Hong Kong but attended college in the U.S.

To root themselves in a longer lineage of activism, Godzilla turned to the Asian American movements of the 1960s and '70s. A timeline by the artist and Godzilla member Arlan Huang starts with the 1970 founding of Basement Workshop, a New York City political and artistic collective that focused on Asian American artists, but the diagram then branches off into organizations such as the 1974 Asian American Dance Theatre and the 1980 New York Chinatown History Project, and more abstract eras like

"Late 1960s, Increasing Political Awareness" and the "Japanese Christian Church." Godzilla aimed to link artistic production with political struggle, influenced by Third World internationalism, the Black power movement, the Chicano movement, as well as antiwar, labor, and feminist movements of the 1980s and '90s.

Shortly after their first two meetings, they decided on the official name for their group. As the late curator and writer Karin Higa details in her 2006 retrospective essay "Origin Myths: A Short and Incomplete History of Godzilla," the group had selected Godzilla on a whim, but now were wary: they worried if it was too "camp," if its Japanese origins would inadvertently signal a predominance of one ethnicity rather than the pan-Asian American coalition they intended, or if they would get in trouble for using a copyrighted name. But they picked Godzilla ultimately because the monster's troubled origins seemed the perfect metaphor; Godzilla isn't even the monster's real name, but rather an anglicization of the Japanese *Gojira*. Higa reflects further in her essay: "His [Gojira's] reemergence from the depths of the Pacific was tied to postwar American atomic intervention in the region. His celluloid existence was filled with Asian masses whose English words didn't match their lip movements and the primary vehicle for his dissemination was the mass medium of American TV. Nothing about Godzilla was authentically Asian. He was the ultimate hybrid monster."

Over the next ten years, at potlucks and apartment gatherings and openings and shows, Godzilla would expand to become an international network of Asian and Asian American artists, at one point having over two thousand members on its mailing list. Its mailing list, of course, was an actual mailing list; large chunks of their meetings were dedicated to writing envelopes and attaching stamps and tending to this ever-growing address list. The group published a newsletter, organized "slide slams," and spon-

sored symposiums on Asian American art. Its individual members staged additional protests, collaborative projects, and exhibitions, as they fostered intergenerational collaboration on both local and national scales.

The bulk of this activity was collected in a 2021 anthology compiled by the curator Howie Chen.[48] It includes meeting minutes, posters, installation photographs, flyers, articles, reviews, and exhibition ephemera, and was my real first engagement with Godzilla, although I had met some of its members before. Paging through each of these documents in their original format, I got a sense of the charm and deeply analogic quality of the era's visual language; the way news of forthcoming meetings was disseminated via phone chains and paper flyers. In flipping through this archive, one comes away with the adaptive quality of Godzilla's ideas and the cobbled-together nature of their resources as the typography, logos, and letterheads change—sometimes abruptly—over time.

I got the sense that Godzilla was a movement made of friends who just decided to take one another seriously. At the end of the meeting minutes from the second official meeting, on September 14, 1990, a note for the next gathering reads: "Ken and Byron volunteered to cook, the rest of us can bring drinks and/or edible 'supplementary materials.'" These sweet notes dovetail with more public documents, such as "A Clash of Symbols," Margo's 1991 article about Ken Chu's artwork, which originally appeared in a magazine. While these documents were written asynchronously, you get a lovely moment of narrative, as if Margo went, energized, from the meeting directly to her desk to write out the thoughts that were bubbling in her head.

This thriving, constantly shifting social network is best captured by an early, now iconic image of Godzilla: a black-and-white group photo taken for the collective's first newsletter. I moved

through New York without a real sense of a history of Asian American artists, let alone Asian American artists who were critically engaged. I imagine many young artists feel this way. But learning about Godzilla made me feel that we didn't necessarily need a very long history, just a robust one. We were without roots, but flowers.

Although I had seen that image before, the anthology included a contact sheet of outtakes that were particularly helpful in evoking what it might have felt like to be there: think of the moment right *before* the group picture: imagine bodies shuffling, awkward hand placements, ill-timed smiles, and aching cheeks. My eye traces the movement across different shots, and the sequences illustrate the momentary coalescence—flash!—and then the release, the laughter, as the image crumbles back into the disorder of life. There was the original, in all its grainy, blazer-filled 1990s chic, but the rejected shots give this legendary moment in Asian American art history a pulse, a window into the unruly disordering of collectivity.

Three years into living in the city, I had finally made it to the site of my art world aspiration, or at least close enough. Turns out the temple of modernism provided health care, a stable salary, and unfettered access to a color printer. I was an administrative assistant who moved pastel blocks around on my Google Cal for my boss and opened mail with a little metal knife, but I was working for a person I admired and respected, whom I could learn from.

As part of my job at MoMA, I could suggest artists for acquisition, for exhibition, and in that way make an indelible mark on the art world and its future. Not in an official way, of course, but even at this insignificant of a level, I could feel the power that I was

sitting near. Entry into the MoMA collection had ripple effects for an artist's career, the artist's market, their life. I felt a kind of responsibility. I had access to the gates now—or at least, access to the gatekeepers. Who would I help let in?

When I arrived, MoMA was on the eve of its 2019 reopening, after two years of renovations. The history of the renovations is a story in itself. The 2004 Yoshio Tanaguchi renovation, which connected the galleries, sculpture garden, and offices with translucent glass boxes, cost more than $850 million. This most recent expansion, by the architecture firm Diller Scofidio + Renfro, bulldozed the American Folk Art Museum next door, selling its air rights to a shardlike luxury apartment building to fund a $450 million expansion. I was sitting, casually, in my little cubicle nestled in over a billion dollars' worth of construction, sandwiched between multimillion-dollar investment properties, on the grave of "folk and idiosyncratic" art, in my Uniqlo pants and Tevas, with my little "Best, Simon" email signature.

I was generally wary about the proximity of extreme capital accumulation to art, unnerved by the unsavory ways those fortunes were made, but truthfully I was just so happy to have health care and a stable salary for once. It was my first, actual, full-time job in the art world after three years of internships and fellowships, and I didn't even mind the corporate-feeling nature of it; it felt like growing up. As a first-generation immigrant child who abated my guilt with success, working at MoMA was a tangible, even somewhat recognizable marker of success; it validated what I felt was the sacrifice inherent in the pursuit of a creative passion. (My parents didn't know what MoMA was, but when I showed them pictures of the building they were impressed.)

I felt that I could do good work championing "marginalized" artists there too. As part of its reopening, the museum would be rehanging its permanent collection galleries, those galleries that

house *The Starry Night* and *Les Demoiselles d'Avignon* and Pollocks, that inscribed Western art history into canon. The renovation was an opportunity to complicate MoMA's largely male, largely European collection, considering decades of art historical research, critical race theory, feminism, and common sense. Part of this was reflected in the museum's acquisition strategy; in the fall of 2019, it announced that it had deaccessioned a painting by Fernand Léger to acquire a work by Brazilian artist Tarsila do Amaral, as well as many others by "pioneering women modernists."[49]

My part in this rehang was small. Most of the planning was completed when I arrived, and my job description was largely administrative anyway. But it didn't matter so much what I did really. I was happy to staple and make Google docs and meeting notes so that I could observe and learn. I was inside one of the largest, most influential museums in the world, and the corporate cushion and strict job description allowed me the headspace to continue with my other activities outside of it, to nurture my more DIY and subcultural interests.

I did feel, at MoMA, a kind of tension between the institutional work that paid my rent and the anti-institutional activity that fed my soul. I remember, one day, those interests coming into conflict: I sat in my cubicle at MoMA and sorted mail. I memorized phone extensions and made transfers. I typed in my Notes app about potential acquisitions, finalized an itinerary to China for my curator's travel. I took a lunch break. I took minutes in a meeting about getting image rights for a catalog we were producing.

Afterward, I went home. When I opened my phone, I saw on *Hyperallergic* that there had been a protest at the museum. Presumably, I had been there—in meetings, at my cubicle, in my room—but I had not known. I had been so caught up in the day, in the bureaucracy of diversity, that I had not noticed an interruption on a lower floor. The tenets of the protest proposed that the museum

stood for a colonialist mindset and that, on principle, it should be radically rethought. They pointed out the museum's ties to the NYPD, the unsavory activities and investments of its board members. I felt torn between the kind of work I was doing in the office—acquiring artists from marginalized groups and historical gaps and producing programs around it—and my solidarity for the initiatives of the protest just a few stories below me, initiatives that reminded me of the energy of a group like Godzilla.

From a bird's-eye view, I imagined two versions of myself: one in a cubicle, watering the little succulent I had gotten for my desk, updating Excel sheets in meetings, picking little corporate outfits—grateful to be climbing the ranks of the art-world hierarchy. And another down below, holding a picket sign, copyediting manifestos, making Gmail listservs—working to dismantle it.

A year after its founding, in 1991, Godzilla penned an iconic letter to David Ross, who had recently become director of the Whitney Museum of American Art (where I would later intern with Alberto and Rosa in 2017), and made good on its promise to advocate for Asian American artists across the city. On a swanky new letterhead with a long, oval logo and a tilted "G" watermark, the letter begins:

> GODZILLA: Asian American Art Network offers its congratulations and welcomes you to New York. GODZILLA would also like to draw your attention to the conspicuous absence of Asian American visual artists in the current Biennial. . . .

In September of that same year, Godzilla would write a follow-up to Ross after an in-person meeting and summarize the problem

as stemming from not only the lack of Asian American artists in the museum's biennial, but also the lack of Asian Americans in the museum's collections, exhibitions, curatorial and executive boards. Written by a working group that included Byron Kim, Paul Pfeiffer, Eugenie Tsai, Margo Machida, and Young Soon Min, the second letter argued that the public's understanding of art was limited by the viewpoints of an institution's curators, and that the museum hadn't caught up with demographic shifts. Ross conceded that "people tend to order what's on the menu."

In the anthology, the letter is scanned and reprinted in its original form, but the topic also appears as an agenda update in the two Godzilla meetings that followed. The protest ended somewhat amicably; the museum agreed to exhibit more artists and hired Godzilla member Eugenie Tsai as a curator for its satellite branch in the lobby of the Champion paper company in Stamford, Connecticut. We could say, considering the amount of work that was still to be done in diversifying the board and the collection, that it was just a stopgap measure to avoid larger disruptions in the art world, but it was still tangible, real progress. Reading these letters, I felt like I was experiencing a quiet representation of the way individual injustices—things you might chalk up to being paranoid fantasies—can be validated and elevated through collective work. A collective is sometimes the abatement of paranoia.

From my job at MoMA, I considered the distance the artworld had or had not traveled since 1991. I attended protests but, more often, I worked in a museum while it was being protested. This is a conflict that I imagine many young curators are torn between: deciding how and when to work in legacy institutions. There is no such thing as working "outside" of the institution if the institution is capitalism, but there are varying levels one can engage with it. Maybe I was also afraid of losing a job and not being able to pay rent. Maybe I was a coward, and I could have done more. But I

had just gotten here, on what felt like the multigenerational planning of my parents in Burma and my great-grandparents in China. Should I leave already?

Before I worked at MoMA, since 2017, I worked for a smaller collective, one called the Racial Imaginary Institute (TRII), run by the poet Claudia Rankine. The first project I worked on for TRII was curating an exhibition called *On Whiteness*. "If whiteness gains currency by going unnoticed," wrote the philosopher Sara Ahmed in her 2007 article "A Phenomenology of Whiteness," the central text of the project, "what does it mean to notice it?"

I had always used the term "whiteness" casually, with friends, to refer to bland food, an obsession with small talk, wearing shoes in bed (that's so *white*), but I had never encountered it, as I did in the Ahmed piece, with such poetic or theoretical force. It felt vindictive to an extent, a feeling that a worldview that had been deemed the standard, objective, was in fact also subjective. Ahmed's text defines whiteness as "an ongoing and unfinished history, which orientates bodies in specific directions, affecting how they take up space, and what they can do." TRII found this useful because it centered the body, calling whiteness a "habit" and an "orientation." By this, Ahmed meant that those perceived as white move through space and time differently than those who are not; they are allowed entry into more life.

I learned that whiteness studies came into prominence in the 1990s, with texts like the English scholar Richard Dyer's *White: Essays on Race and Culture* (1997), Toni Morrison's *Playing in the Dark: Whiteness and the Literary Imagination* (1992), and Ruth Frankenberg's anthology *Displacing Whiteness* (1997), although it is a concept that has existed in different forms within the creative and social imagination since antiquity. Writing in a 1998 issue of *Artforum*, the cul-

tural critic Homi K. Bhabha described the "blizzard of 'whiteness' studies" that emerged in the '90s as a symptom of an intellectual left somewhat "obsessed" with identity, perhaps at the risk of questions of class and nationalism.[50]

What distinguishes the writing on whiteness in the '90s was its focus on representations of whiteness. While white supremacy and structural racism had long been articulated throughout the twentieth century, whiteness studies focused on how those ideas were perpetuated, strengthened, and challenged through art. In the U.S., whiteness had been articulated across the twentieth century by writers like W. E. B. Du Bois, Audre Lorde, and James Baldwin. One of the most useful passages I encountered came from Baldwin, who framed whiteness as a willful system of belief rather than a naturalized order. In an essay titled "On Being White . . . and Other Lies," originally published in *Essence*, he calls whiteness "a lie" that people chose to believe: "America became white—the people who, as they claim, 'settled' the country became white—because of the necessity of denying the Black presence, and justifying the Black subjugation. No community can be based on such a principle—or, in other words, no community can be established on such a genocidal lie." It was this lie that was being perpetuated and strengthened through its representations in art and culture.

Like any racial identity, whiteness refers to a diverse set of experiences, but unlike other racial identities, it somehow escapes being understood as a race at all, operating as "the norm" or the center of consciousness. While the aesthetics of difference—Blackness, Asian Americanness, Indianness, etc.—are heavily taxonomized and theorized, whiteness is often left uninterrogated in common speech, the blank background on which difference is articulated. In the U.S. context, whiteness is constructed as a monolith despite the fact of the well-noted diversity of the country's historical, ethnic, and class backgrounds. If my identity

was founded on difference, I was trying to understand what it meant that that difference possibly hadn't existed to begin with.

The early meetings of TRII were informal. There was never enough sushi. Like Godzilla, the most vital meetings were conducted in person. When the pandemic happened, this switched primarily over to Zoom. It was a group of colleagues convened by Claudia, including esteemed poets, writers, art historians, and filmmakers, and I was happy just to be a fly on the wall. We sat in Claudia's apartment and talked well into Sunday afternoons. Sometimes I nursed a hangover.

To discuss the whiteness exhibition, we met at The Kitchen, an alternative art space in Chelsea. I mostly just took notes. Immediately, we were beset with some foundational questions. How can we stage a critique of whiteness from a format (the exhibition) that is inextricably tied to histories of white violence? In what ways would our presentation of work be complicit with the production of whiteness? We agreed that this would not be another "people of color pony show" where nonwhite luminaries make expensive art about their traumas, yet we found a particular irony in the fact that it fell to a group of mostly nonwhite people to do the emotional, intellectual, and artistic labor to check and give shape to whiteness. Were we doing the work of the oppressor for the oppressor?

As most group exhibitions go, the selection of artworks for *On Whiteness* was a mixture of conceptual adherence, availability, and logistics. They could be broken down into two categories: an artwork illustrates something about whiteness (its psychology, the damages it causes, etc.); or an artwork should be looked at through the lens of whiteness, for anything latent within the work. For some artists, we identified a sensibility within their work that made it seem like they could speak to the topic, even if they didn't have an existing body of work about whiteness.

Ken Gonzales-Day's photographs fell into the first category—illustrating a psychological aspect of whiteness. *The Wonder Gaze (St. James Park)* (2006), from the *Erased Lynchings* series (2006–2013), took historical images of lynchings (originally used as postcards) and erased the body of the murdered Black person to leave just the white people watching it, grinning, holding the hands of their children. It emphasized how whiteness turned Black subjugation into a spectacle. Ja'Tovia Gary's video *On Punishment* (2017) displayed archival footage of psychological experiments on mice, mapping those dynamics onto those that whiteness creates on nonwhite people. Titus Kaphar's *Pillow for Fragile Fictions* (2016) dramatized the dynamic of white ignorance of colonial violence in sculptural form: it featured a hand-blown glass head of George Washington partially filled with rum, tamarind, lime, and molasses resting on a pillow made of marble, questioning the popular image of Washington as pure and virtuous as an American myth. These works were included, at least from how I see it, because they "noticed" an aspect of whiteness and gave it form.

Other artists allowed us to reference recent and historical traumas caused by whiteness. Anicka Yi's *Immigrant Caucus* (2017)—an installation composed of three small cans, the industrial-style metal ones that exterminators carry—silently sprayed a chemical compound into the air. Anicka worked with a team of scientists at Columbia University to derive this compound and its aroma from the sweat of Asian American women and the emissions of carpenter ants. In the exhibition, the work seemed to eerily reference the spray cans used on migrants at the border.

And then we included other artists not necessarily because their work was about whiteness, but because we sought to cast a lens of whiteness upon their work. This probably most applied to Cindy Sherman's photographs—*Untitled #352* (2000) and *Untitled #353* (2000)—both of which depict the artist in garishly white makeup

and florid clothing. I remember, talking to viewers at the opening, that they thought our inclusion of the work in our exhibit gave Sherman more credit and awareness of the concept of whiteness than was animating the creation of that artwork. In the end, her photographs seemed to work both ways: as a presentation of the constructed nature of white performance, and a provocation to the undertheorized question of race within Cindy Sherman's work.

Four out of the twenty artists in the show identified as white—Josh Begley, Mores McWreath, Kate Greenstreet, and Sherman. In retrospect, there was probably a version of the show that was entirely white artists. That was something that lingered with me long after the exhibition closed. Would working with more white artists destabilize existing conventions for exhibiting race more effectively? After all, wasn't whiteness a construction that white people should be dissecting as well? But then, wouldn't that just give more of a platform for white artists? I worried that the exhibition was also just another exhibition on a theme—a collection of variations to illustrate something that had long been illustrated before. Noticing the frame we were placed within was not the same as breaking it.

The night before the whiteness show opened, I dreamt that the gallery was on fire. I walked from room to room and watched its treasures melt into unrecognizable shapes. Yet the guards remained stationed at their posts, impervious to my increasingly impassioned appeals to leave. I moved my hands and yelled and jumped. Soon it seemed that there would be no time for me to evacuate, and as it stood, there was no time. I ran my hands along the soot blackening the white walls.

After the TRII whiteness exhibition closed, I tried to take stock of what this kind of criticism had given me. It had started a conversation, but in the end it had been a group show on a theme. TRII

was distinct from a university, or a museum, in some respects (own board, own curation, a floating institution), but the same in some of the most embedded ways possible (funded by foundations, partnering with existing institutions). I knew that TRII was buoyed on the wings of literary prestige, that its members were people who had a foot in the door of these institutions already. Sometimes, I had the feeling we were building elaborate intellectual sandcastles about terms like "whiteness" and "aesthetics" and hyphenated identities that had a threshold of usefulness before they toppled into indulgent liberal hand-wringing. The idea of whiteness took on a life of its own, and it became increasingly important to develop a relationship to it that was rigorous but also practical.

I felt, with this shift, the desire to escape the gravitational pull of identity—to consider myself in bigger terms, or no longer in terms at all. I wanted to expand into the boundlessness of life, lying in Green-Wood Cemetery with Julie or walking down Vanderbilt Avenue with Ekin. It was easily accessible in daily life, yet on the page I still felt corralled into a shallower, smaller version of myself. Race was but one container, and queerness was another; but even with an "intersectional" approach it was as if I had relegated myself to a two-room hotel, instead of roaming the meadow outside of its windows freely. Who had put these walls here? Was it me? And even if I had taken such care to decorate these walls and make them my home, was I not still constructing a beautiful prison?

In the evenings, after work at the museum, I avoided my room because it was small and hot, instead double-booking myself for drinks and dinners and openings. It felt natural at the time. There was so much to do, and even though I loved reading about disaffected, languid narrators who did not want to do anything, I wanted to do everything. I wanted to see everything and go to

every store and work out in every gym and be in every home and meet everyone.

I expended this excess energy at a CrossFit gym near my apartment, another sort of cultish thing I had started when I moved to New York. While most of my other social activities were bound by a kind of conversational bonding, I appreciated that at CrossFit the bulk of the time we spent together was not focused on talking. I would arrive to warm up—a 100-meter jog, five down-dogs to push-ups, ten air squats—taking note of how my body felt: stiff? sore? stale? After a day staring at a screen, acting as a disembodied brain in a tank, CrossFit was my way of returning to my body.

It also provided its own kind of collectivity. It was a compromised euphoria, if there ever was one, but I found that there was a particular kind of familiarity one develops with people you sweat with. I saw them four to five times a week, sometimes more than my actual friends. Some of them I spoke to but most of them I did not. We may spend an entire year working out together and never say a word. At times, in the midst of a CrossFit workout, I felt I had been cast in a strange, synchronized ballet, with these people who I encouraged unequivocally, for whatever level of fitness they were trying to achieve. I was plugged into a form of being together that was preverbal: union in movement. CrossFit, in its intensity, presented its own form of self-annihilation; for a few minutes or so there would be nothing that I could think about.

At the box, in the middle of warmups and cooldowns, sometimes words and phrases returned to me from my readings, as if dislodged from a high, dusty shelf in my brain. *The trap of diversity is always the question: diverse from what?* Something that Monica Youn, a TRII member had said earlier that day. *There has to be a center in order for there to be a periphery.* That center was whiteness, and giving shape to it helped dislodge it from its throne.

I had always considered the museum a place to infiltrate, a

space to critique, one that had not been built for me. This approach felt like the natural conclusion to a kind of art developed in the 1960s and '70s that I had studied called Institutional Critique. Artists like Coco Fusco, Andrea Fraser, and Fred Wilson used art to reveal the relationships between money, power, and culture. A critical art practice was inseparable from this kind of uncovering, and this was what the whiteness exhibition had been about. But I was beginning to question this critique.

"Uncut devotion to the critique of this illusion makes us delusional," Fred Moten and Stefano Harney write in *The Undercommons*, their difficult, poetic 2013 book.

> In the trick of politics we are insufficient, scarce, waiting in pockets of resistance, in stairwells, in alleys, in vain. The false image and its critique threaten the common with democracy, which is only ever to come, so that one day, which is only never to come, we will be more than what we are. But we already are. We're already here, moving. We've been around.

I understood this to mean that critiquing an institution that was never built to include you will exhaust you. If you play their game, we will always be marginalized, identitarian, subcultural, hiding in the clubs and in the night. Salvation is always in the future, when we will become "more than what we are," but we need only to look around us and see that we are already everything we need.

On the speaker an EDM remix of a new Taylor Swift song echoed around the gym. The opposite of love isn't hate, she sings in "I Forgot That You Existed," it's indifference. I pulled my knee into my chest for a stretch, rolling a lacrosse ball under my hip for a massage. I thought the same could be applied to how I was beginning to feel toward large institutions: we didn't need to love them,

we didn't need to hate them; sometimes we could be indifferent to them, building out our own forms of legitimacy.

I stuck my water bottle under the fountain and absentmindedly packed my grips and chalk into my gym bag. I said hi, and bye, to people I saw nearly every day; I thanked the coach and washed my hands.

Suddenly I remembered waiting in line for a stupid fashion party with Rosa and Alberto, bumrushing the door when it opened for us, charging down the stairs, dancing to SOPHIE amid pouty fashion types. I remembered what it felt like to wait in line, how dumb it felt to play by those rules, and how giddy we had been running down the back stairs. It had always felt that we were trying to find our way into the center. Yet I was beginning to think that we had already arrived—that everything else around it was already ours. We already belonged; all we needed to do was look around.

Back at the museum the next day, its shiny chrome surfaces suddenly seemed distorted. I picked up a stapler, heavy and sure in my hand, and imagined the money that had purchased it. I felt newly aware of the resources required to build something so enormous and sustain it over decades. My salary, a librarian's salary, the janitorial staff, the interns, the overhead. The buzz of the fluorescent above me, the silent, morguelike rasp of the air-conditioning. The enormous, yielding color printer that obliged seemingly to any requests.

At 5:30 p.m. I logged out of my computer in my cubicle, packed my little baggie, and took the E train downtown away from the fortress to set up for a monthly conversation series that I had helped organize for TRII. We were revisiting the material from the whiteness symposium, asking some academics and writers into talk-backs, where they could elaborate on their presentations.

The room was already sparsely populated when I arrived. I shep-

herded several desk-chair combos that faced away from the podium, as if forlorn or lost. TRII did not have a physical location—we thought of it as a moving collaboration, an institutional virus that would provoke internal reflection at existing spaces—so whoever was in this room right now was in the temporary instantiation of the institute. It was institute as a verb rather than as a physical place.

The speaker, a white man, was elaborating on a project he had been working on for the last few years, interviewing other white people about their relationship to whiteness. On the projector screen hanging in front of the dry-erase board, a grungily dressed teenager in a video interview confessed never having thought about her whiteness before. Afterward, a tattooed young man expressed confusion about the question.

I looked around the classroom. There was a group of middle-aged white women, tote bags leaning against their ankles on the floor, diligently taking notes on neat notepads; a young woman in a headscarf, clicking her pen impatiently; a tired-looking vaguely European grad student in flannel and a circle scarf; a few other members of TRII; and a pair of young, Black art-world types.

At the conclusion of the speaker's presentation, the white people in the room launched into a slate of questions: How could they implement this in their churches, their synagogues, their community centers? I actually found this quite radical: white people figuring out ways to dismantle whiteness. It should be their job, I thought, rather than that of people of color, as it had felt at TRII. But I noticed how bored the art-world types seemed. Joanna, a successful Black gallerist and member of TRII at the event, texted me an emoji with eyes rolling—*I'm so over this.*

I looked at this mix of people and suddenly felt unmoored. We were in the institute right now, and it was filled with people who all wanted different things out of participating—to advance their careers, to build prestige, to meet Claudia, to question whiteness,

to learn something. Why was I here? A mixture of those things. I wanted to feel better. Learning about whiteness sometimes made me feel like my problems were not my own. Was this the best use of my skills? Is this what the interior of a history like Godzilla's looked like? Would I recognize a collective even if I were in one?

I set out to leave the institution. If museums were historically imperial or colonial projects, built on imperial or colonial social relations, we were now living in a bad relationship. For artists of color, maybe this was a toxic relationship. The museum wasn't made for us, but I was still dependent on it; it was the only way I knew how to feel affirmed, how to feel distributed, how to access resources. So could I leave? I set out in pursuit of the "surrounds," the spaces where artists were off-duty, proximate to the museum, informal institutions of their own—the nightclub, the studio, the gym—to see what could be made outside of this dynamic.

I met the artist Viva Ruiz at Sweet Moment bakery in Chinatown, interviewing them for what would be my first art review ever. The bakery was outfitted like a doomsday bunker, with the floor, ceiling, and seating all clad in seamless titanium, but with enormous windows overlooking the busy corner. Viva had their first solo show at a gallery in New York, titled, amazingly, *Pro Abortion Shakira: A Thank God for Abortion Introspective*. Viva seemed to waft into the room on a neon cloud, their hair a soft Kool-Aid pink at the time.

Viva is the descendant of Ecuadorian immigrants, a Queens native, and an artist for whom showing in a gallery is the exception rather than the norm. For the last two decades, they had forged a collaborative practice *in and around* institutions, gracing nightclubs, telenovelas, and online spaces as equally vital forms of engagement. Their ongoing project *Thank God for Abortion (TGFA)* (2015–) had recently appeared as a float in the 2018 New York Pride March,

mobilizing a crew of dancers, activists, and performers to advocate for free, safe, and legal abortion.

Viva moves between the spaces of nightlife, organizing, and sculpture without regarding any one "medium" as better than another. The works in their show were originally conceived of as "practical protest gear" and had been used just a few months before in their Pride float. These included riot shields, protest posters, "ABORTION" flags, and T-shirts that feel fugitive in the gallery; it was not hard to imagine them getting pulled off the walls to be used imminently, given how their platform invited right-wing extremists. Two riot shields lay propped against a wall, placed directly on the floor. Gold mannequins they called "Icons" wore TGFA "Party Looks," custom costumes that were previously worn and were "infused with the energy of many conversations and actions."

I described their show as "a pit-stop, a garage to hold their stuff, a fabulous floating-through" that articulated a "touch-and-go relationship" to the institution. For me, Viva mapped a way of engaging with cultural institutions that didn't treat showing their work in a museum as the apex of their practice. I saw it as a potent critique because it was not really a critique. If a subculture was beautiful, why did it have to be moved to a museum to become art?

When I asked my friend the artist Maia Chao, about what she thought about this kind of "leaving" in a 2019 *Bomb* interview, she complicated my initial impulse: "It's important to recognize that we as individuals have been well served by art institutions," she said:

> We care deeply about these spaces, as fraught as they are. It feels honest to our identities and experiences to engage the institution and utilize our access and fluency. Otherwise, it's a slippery slope of downward mobility—choosing to reject

one's privilege rather than leverage it. The question of how to engage or disengage from institutions is less a declaration of which strategy holds the most value and more an active response to the questions of, "What can I do in my subject position? What can I contribute to ways other people are acting from their subject positions?

I took her words to heart; it was not going to be so easy to "leave" the institution. Maybe it would be better to stay, to leverage my position from there.

Was Godzilla able to leave? Did they "dance on their own"? Godzilla was resistant to existing nonprofit structures—it was decidedly nonhierarchical and allowed anyone who attended all the public meetings to be a voting member. This approach worked: by 1995, the group, which started with sixteen founders, would have more than two thousand members nationwide. But even as Godzilla resisted becoming like other art institutions, some individual members began finding work in more mainstream venues. As Howie Chen recounts in the framing essay of the anthology, "The tension between a desire for legitimacy within an institutional system and a deep ambivalence toward museums and professionalization would become an enduring dynamic in Godzilla."

Ultimately, this tension is what came to define the work of cultural activism started by Godzilla: the impulse to become *separatists* (with talks of creating their own museum for Asian American artists) alongside the strategies of *reformists*—fighting from inside the system. Eugenie Tsai became a curator at the Whitney, as previously mentioned, then the Brooklyn Museum; Margo Machida, an academic at the University of Connecticut; Alice Yang, a curator at the New Museum, before her untimely death; and so on. I imagine some of the members stopped coming to the meetings as their museum day jobs became more pressing or their studio careers

took off. Many succeeded in becoming prominent artists, curators, and academics within the institutions they once protested; others, like Ken Chu, left the art world altogether. Howie cites a 2019 study that the representation of Asian Americans in museum collections, administrations, and exhibitions is now close to parity with national demographics, while other nonwhite racial groups remain severely underrepresented. Was the story of Godzilla ultimately an assimilation narrative, even if its roots were separatist?

I asked this to Margo at a panel that I was speaking on with Howie Chen after his book came out. Her response was short. "Why not both?" The trouble with outlining "separationist" and "integrationist" approaches to power and institutions, or whiteness, is that a clean dichotomy rarely exists in the wild; often people are navigating both, at different times, places, and points in their life. Sure, making an Asian American art museum, an alternate institution, would be amazing, but Godzilla was an artist network, with their own creative interests. The members didn't want to become bureaucrats. And perhaps there was something sneakily covert in their dissemination into all of these structures of power. I guess the question is, is it better to gain power within a new institution with that morality intact while compromising on some things, or to refuse to compromise or cooperate and exist on the sidelines?

Compare the trajectory of Godzilla with that of an older Chinatown organization, the Asian American Arts Centre, which predated them by nearly two decades. Initially founded in 1974 as the Asian American Dance Theatre (AADT) by the dancer Eleanor Yung, the group would change its name to the Asian American Dance Theatre/Asian Arts Institute (AAI) in 1979, after a young curator named Bob Lee came on board (and fell in love with Eleanor). In 1987, AADT/AAI announced the new name of their organization as the Asian American Arts Centre (AAAC), saying it would add visual arts classes, an exhibition series, artists' slide archives, and a residency

program out of a second-floor space at 26 Bowery. Its first exhibition, in 1985—*Ten Chinatown: First Annual Open Studio Exhibition*—showed art from Ai Weiwei and Tseng Kwong Chi. In fact Bing, Margo, and Ken, before founding Godzilla in 1990, worked at AAAC as artists in residence or staff members from 1984 to 1990.

If Godzilla was fast and hot, the bulk of their activity lasting between 1990 and 2001, the AAAC was long and slow, organizing over eighty exhibitions between 1974 and 2009. The AAAC's remit was a little different from Godzilla's; it attempted to answer the question "What is Asian American art?" through a mixture of programs and exhibitions, merging folk and contemporary art.

While Godzilla's energies were directed outward, uptown, to the legacy museums—where many of their members are now well entrenched in milieu—organizations like the AAAC were focused on a more local kind of representation, while still showing big names. They collaborated with institutions that were more DIY at the time, like PS1 and the New Museum. They focused primarily on artists who came in and out of Chinatown.

Critique binds the criticizer to the object of their ire in an unhappy marriage; indifference risks invisibility, but also presents the opportunity to foreground a different community. The PR associated with Godzilla's oppositional work elevated the group into the annals of art history while AAAC's more local aims left it in obscurity. Director Bob Lee never took a job at a major museum; artists passed through the AAAC on their way to something larger, and subsequently the AAAC remained where it was, a relic of a different time and formulation on the relationship between Asian American identity and art making.

I romanticized this kind of obscurity, because it felt like concrete and incremental change, even if it wasn't sexy. They had done it;

they had made their own institution. But the challenge with this kind of work was resources: how to derive a sense of scale, a larger public, and a sense of sustainability across time.

When I did finally meet Bob Lee, curator and director of the AAAC, in 2017, at an opening in Chinatown, I felt like I was meeting a living legacy. He arrived, chest bared, in a zipped-open Lycra biker top and helmet, a wispy white beard trailing from his chin, at the opening for a show I was working on. He spoke with the slow cadence of a skater and the stamina of a philosopher. He was gregarious and friendly, and I marveled at his accentless English: he looked like my father, but he spoke like I did. Growing up on the East Coast, away from an Asian American community with deep roots, I did not know very many Asian Americans who had chosen creative or artistic careers, let alone grew up in the U.S. It was a breath that I did not know I had been holding until I was able to release it.

The AAAC archive that Bob took me to, later, when I was working on an exhibition with him, did not resemble any of the fancy, well-ventilated, meticulous museum archives that I had seen. It was much more modest: a storage room with metal shelving units in the basement of an apartment building. Large canvasses and paintings leaned against the wall. Scraps of yellowing papers peeked out of legal boxes. The fluorescent light above lit the room feebly, and I remember not knowing where to set my tote bag down. Bob told me that he had an archive of over a thousand additional works at a storage locker in New Jersey.

What alienated me from Bob's approach, initially at least, was the commitment to this question of "What is Asian American art?" To me, it had cultural nationalist undertones that I didn't care for; I'm not sure I needed to know the answer to that question, nor did I want to ask it. Perhaps it was because he drew his idea of Asian American from the 1960s, when Eleanor, the original founder

of the AAAC, was in school at Berkeley as the term "Asian American" was coined. For my cocurators and me, young-millennial-cuspy-Gen-Z, we lived in the shadow of postmodernism, and even as identity seemed to become increasingly prevalent in the discourses around us, we still operated on the idea that there was no such thing as a solid or stable identity, only a contingent thing that we performed every day.

Still, this was an archive that deserved preservation and study. There was an inventory, but it was not comprehensive. There had been a flood a few years before, and that had damaged some of its contents. The extent of the damage had been documented to the best of Bob's and his occasional interns' ability, but the objects were too physically unwieldy for any single person.

My cocurators, Jayne Cole and Lisa Zhang, and I picked through the materials, holding them up one by one to ask Bob what each object was. We sifted carefully through posters, prints, and flyers, but also enormous paintings, fragile sculptures, and framed photographs. Submerged histories surrounded each object like a miasma. But what intrigued me more than the objects was the overall fact of their obfuscation. Why hadn't I heard about this stuff? I had the feeling, as I learned about this history, that what I had presumed to be the ground—the base on which I was building my career in New York—had at one time been the penthouse. Layers of time and sediment and memory had obscured its contents, and the surface inhabitants moved blithely unaware of the work that lay below them, building lean-tos over castles.

In my favorite photo of Bob, which he emailed us later that day, he and Eleanor are dancing. The flash from the camera makes it seem as if the photographer is also dancing alongside them, the image a bit off-kilter. Bob doesn't remember much

about the night, other than that the photo was taken after an opening, sometime in 1982. Beyond the flash of the camera, out of the light of visibility, sets of folding chairs seem to evidence a larger party, where plastic cups stand out. Bob and Eleanor are taken by some kind of spontaneous energy; they lead each other in twirls while other people watch, or join.

It's hard to say what kind of dance they are doing: a square dance? a tango? You can't see, but in the dark beyond the photograph's flash there is the suggestion of other people, many other people, at this party, who represent a collective—of ancestors and friends—that they are dancing along with, even if they appear to be alone. For a moment, the grand plan of their project, its aspirations to be a space for Asian American artists, slips away, and it's just one night, with friends. Streamers dangle from the ceiling, framing their faces as the scenery seems to melt away,

Gene Moy, *Untitled* (Bob and Eleanor dancing), 1982.

the movement of their bodies through space saying everything they need.

In late 2019, two Godzilla members, Arlan Huang and Tomie Arai, drafted a letter to the then director of the Museum of Chinese in America (MOCA), Nancy Yao Maasbach, pointing out the connection between the museum's acceptance of a $35 million grant and the city's plan for a new jail in Chinatown. A retrospective of Godzilla's work was well under way to open at the museum, focusing on the group's efforts in art, activism, and community building over the twelve years of its active existence—the first institutional exhibition of its kind.

Under the 2019 Borough Based Jail Plan Points Agreement, New York City's Rikers Island jail, infamous for its violent treatment of its inmates and inhumane conditions, would be dismantled and its population would be distributed across new jails in each of the five boroughs. The existing fifteen-story Manhattan Detention Complex on White Street, colloquially known as the Tombs, would be torn down and replaced with a twenty-nine-story building in the same location. The funding MOCA received was part of "community reinvestment" funds that came to cushion the blow of these new jails. Neighborhood organizations like the Chinatown Art Brigade and the Neighbors United Below Canal, among others, had vocally opposed this plan, on the grounds that it would disrupt commercial activity in the area, not to mention further perpetuate the incarceration of people, the majority of whom are Black and brown, and are often simply in jail because they could not afford bail.

When the museum reached out to consider including this protest letter in Godzilla's upcoming retrospective, it prompted greater consideration from its members: Were the products of its

protests meant to be "historical" but ultimately relics of an ongoing protest, in an art exhibition? Or was the spirit of their project still alive?

On March 5, 2021, after months of negotiations, nineteen Godzilla artists (known as G19) signed a letter of withdrawal from the exhibition, stating: "We cannot, in good conscience, entrust the legacy of Godzilla as an artist-activist organization to a cultural institution whose leadership ignores and even seeks to silence critical voices from its community. Differing viewpoints serve to strengthen an organization and allow it to evolve in healthy and necessary ways. How can we exhibit our work within the walls of an institution when the values of its leadership betray our own founding principles?"[51] Having to pick between framing their practice as art—a protest letter as ephemera—and having it remain an active protest, Godzilla chose the latter.

I realized that I had been wrong. It was simplistic to think that a collective ends when it disbands. There was power in the "sleeper cell" effect of lying in wait via loose ties. Godzilla had not disappeared or disbanded, as many thought, but rather morphed to adapt to the needs of its constituents over time. While collectives might arise seemingly overnight, true community takes time to build.

To determine a plan of action, ten Godzilla members (G10) met over Zoom. Compare the grid of Godzilla's revived Zoom meeting with the unruly contact-sheet grid of their original conception. The members, some original, some new, sit in their own boxes, no longer touching in person. The grid is not the organic layover of film, but the rigid and finite boxes of digital space. Each square is not a variation of the same image, like on the contact sheet, but rather a unique image on its own, with its own life and trajectory.

More than thirty years ago, a group of friends had met over

cheap food, at studios, over potlucks and baked goods, to discuss shared problems, and it had grown and strengthened over time, diffused and concentrated across individual lives. It's unlikely any of their members could have anticipated what the world would look like so many years later, the déjà vu they might be feeling. But stretched across these two grids—the contact sheet and the Zoom—across thirty years, is the continuity of a radical spirit, made lighter by sharing the burden between friends.

G10. Top row (from left): Kerri Sakamoto, Tomie Arai, Todd Ayoung, Shelly Bahl; middle row: Lynne Yamamoto, Sowon Kwon, Arlan Huang, Chanika Svetvilas; bottom row: Paul Pfeiffer, Alexandra Chang. Courtesy Shelly Bahl.

AFTER, LIFE

James Baldwin with water carrier, Istanbul 1964. © Sedat Pakay

He asked himself why he of all living beings should be singled out to possess an identity that made him very like the stars.

—*James Baldwin,* The Fire Next Time *(1964)*

She's great, she's very sincere and kind of a stubborn and emotional person. She's an actress and works in theatre. I don't see her as much as I would like to. She lived in a different city so I couldn't see her, but now she's back in Stockholm. We're close.

—*Robyn, describing her mother in* VICE, *2018*

After "Dancing on My Own" and *Body Talk*, the album that came with it, Robyn took a hiatus from music for eight years. There was the stray single here or there, but, for the most part, she decided to take her thirties off from stardom. In her absence, "Dancing on My Own" saturated itself into culture. In season one of HBO's *Girls*, Lena Dunham's character, Hannah, danced alone to it in her bedroom. Lorde wrote a blog about Robyn and covered one of her songs—"Hang with Me"—live on *SNL*. She placed a framed picture of the pop star on her piano. A party—This Party Is Killing You—cropped up in Brooklyn just to play Robyn's music. A video of a crowd at the Times Square subway station chanting her song after a concert went viral. The Philadelphia Phillies, a baseball team, picked an EDM remix of British singer Calum Scott's cover of the song as their official anthem, playing the song after every big win.[52]

Perhaps one of the most jewel-like moments was in 2015, on episode five of the first season of *RuPaul's Drag Race All Stars*, when best friends Jujubee and Raven were asked to "lip sync for their lives" to Robyn's song. One of them was going to be eliminated. According to *Drag Race* lore, before the battle, Jujubee told the producers she would give her place in the competition to Raven even if she won, and the producers replied that Raven had told them the exact same thing. Both chose to throw the battle so that the other could stay. Onstage—you can watch the video on YouTube—the queens are not their usual, bombastic selves, dancing for their lives; they purposely downplay their performances. They hug, dance together, and cry onstage. The moment would be dubbed "the most emotional lip sync of *Drag Race* herstory" by *Dazed*, and Robyn herself would comment on the video five years later, in an interview with *Entertainment Weekly*. "Oh my God, it's good. I love that they're already crying, they're getting into it. I'm getting chills," she said.

"It doesn't feel like a battle, it feels like they're supporting each other."

It took time for people to develop a relationship to "Dancing on My Own." I didn't think much of the song the first time I heard it either. But it grew more poignant with age; even today, the precision of her lyrics and the soft fuzz of the production can move me. A song about loneliness had produced a feeling of community. As one *Pitchfork* writer observed, Robyn fans are unique for their intense, personal devotion to her music; they don't compete with other fandoms, they just love Robyn.[53]

When Robyn came to New York in 2019, for two sold-out nights at Madison Square Garden, my friend Colleen went. I decided not to buy tickets—for me, Robyn was headphone music, music to be alone with, and the thought of experiencing her live in a crowd seemed overwhelming.

"What was she like?" I asked, years later.

She told me Robyn was humble and grateful, thanking the audience for all the stories they had confessed to her, how she had just wanted to write some songs and she was overwhelmed at the effect it had had on people's lives. "It was like church," Colleen said. "She sang 'Call Your Girlfriend' and 'Dancing on My Own' back to back and I thought—ahh—I thought I was going to die."

Meanwhile, Robyn was dealing with her life outside of music. She separated from her romantic partner, Max Vitali, the director of one of her most beloved videos, "Call Your Girlfriend," in 2013. A year later, the producer Christian Falk, one of her closest collaborators and mentors, passed away from pancreatic cancer. She started intense psychotherapy, three or four days a week, forty-five minutes at a time, and went for six years. According to her *New York Times* profile, from 2014 to 2015 she was in her lowest place. In

the beginning, she didn't get out of bed. "Then, getting out of bed to get a coffee. Maybe going to therapy. Maybe seeing my brother. Maybe going for a walk," she said. Gradually, she moved into a friend's studio and started processing her grief through music. Somewhere during that time, amid deep personal healing, she began working on "Honey," the successor to "Dancing on My Own." After working on it for four years, and teasing an early version on *Girls* again, she would release "Honey" as the gooey, warm-all-over lead single to her next album in 2018.

There is a tangible sense of healing in "Honey." The opening synths sound like a sunrise. Her voice wafts in from far away. The first lyric is *No*. . . . "Dancing on My Own," on the other hand, is raw; she's looking for something in a place where she might not be able to find it. She has described it as "a teenage version of me that I was happy to let go of." The synths are percussive, full throttle, insistent. In comparison, the Robyn of "Honey" is patient. Settled, like a cat. *No, you're not gonna get what you need*, she all but coos, *But baby, I have what you want / Come get your honey*.

Loss of the kind Robyn experienced would change anyone, so it's no wonder it transformed her music. "I feel like I almost became another person," she said in the same *New York Times* interview. "Like the goal wasn't for me to come back—I really feel like I rearranged my insides in a way. I didn't know what I even had to go back to. I felt like a lot of things that I believed before were not true anymore."

The first summer after the pandemic, people emerged like pollen splayed across the tops of cars. I met my boyfriend Ekin and we started dating. The weather became beautiful. When Biden was elected, I laid my head on Ekin's lap in Prospect Park in a circle of

friends and let myself feel good. We listened to "Honey." Exhibitions that closed reopened. I left my job at the museum to write more.

When it was safe to travel again, Ekin took me to Istanbul, the city he grew up in. Before we left, we stopped by HMart to buy gifts for his parents: American delicacies like Chinese wasabi peas, Japanese rice snacks, and Korean ramen, things that were hard to get in Turkey. We reflected on the irony, the variety America had reaped through globalization and war. Chinatown, Little Italy, HMart: the best parts of America are the places you can pretend to be somewhere else.

Ekin says that Istanbul is a city defined by an identity crisis. Are we European? Are we Balkan? Are we Arab? We sat on a ferry on the Bosphorus, looking at mosques, palaces, and skyscrapers all at once. I imagined scaling the questions I had been grappling with—when do we want to dissolve, and when do we want to define our identity?—to the level of a city, a nation.

Istanbul sits between two continents—Asia and Europe, between "east" and "west"—with a turquoise strip called the Bosphorus Strait running between them. The word "turquoise" originates from the Turkish *turkeis* (now *turkuaz*), and you would be forgiven for thinking that the color of the water on a shimmering day was the inspiration for the word itself. The hills on either side of the water look down onto the strait like bleachers in a stadium, as if the strait were a stage to watch the ferries and boats chug across. Ekin lived on the Asian side as a child and took a bus to school on the European side nearly every day. I had been so preoccupied with rifts—cultural, generational—that to see a bridge between Europe and Asia felt like a material answer. How did people deal with rifts? They cross between sides casually every day. The real barrier was traffic.

That night, we were going to a gay bar in Istanbul. Ekin had

never been to one there; it was difficult for him to imagine that there were gay bars at all in the city that he had grown up in. Turkey had enjoyed secular golden years in the 1980s and '90s only to become increasingly conservative in the last few under President Recep Erdoğan. It was a place where secularism and religion coexisted in a tumultuous, often violent embrace, even before the devastating 2022 earthquake. Turkey's identity crisis produced extreme political and economic instability, but it also made it a beautiful, complicated place. It's hard to heal when you don't feel that you belong, Ekin said, but you might be able to find other kinds of healing.

The sun dips below the horizon, dyeing the Bosphorus a shade of peach. We exit the ferry onto a large plaza where carts sell simit and flowers. The hills of the Kadiköy neighborhood stretch up above us. In some parts of Istanbul, street cats seem to model the pace of life, their very public displays of stretching and napping an invitation for everyone else to do the same. Even the busiest passerby stops briefly to give a languid cat a nod or a small bite to eat. But here, in busy, thriving Kadiköy, the cats are harder to come by, hiding from the din and the crowds. I follow Ekin through the plaza, passing small alleyways with students and young people walking to bars, couples smoking at cafés, blinking signs for street food.

We meet Ekin's friends, who became my friends. Talya, who went to high school with Ekin and has a thoughtful, floating demeanor like she's in the middle of a complex thought. Başak, who studied architecture with Ekin in the U.S. and commands any room she walks into with her self-assurance. Earlier that day I had also met his friend Derin, an aspiring actress who seemed pulled through life by both head and heart. After a catch-up at Talya's apartment, where we shit-talked Derin for bailing on our outing that night, we walk to the bar nearby.

The first floor of Mecra (pronounced mej-*rah*) opens directly onto the busy street. Inside, we hear American pop playing over a dimly lit tavern. We climb the stairs, passing another bar on the second floor playing Turkish pop, to the third floor where a DJ plays electronic music.

We slip into a dark, cigarette-filled dance floor. Başak and Ekin peel away to find us drinks; Talya and I stand and survey the scene. A group of American men, identifiable by their loud talking and cargo shorts, shuffle awkwardly in the corner. It is crowded, but it does not yet feel lively. The music is inoffensive and easy to dance to, and its familiarity, the international language of house music, sets me at ease. I ask Talya about her job—she is an agent for actors—and her new boy; Başak and Ekin return (cheap drinks!). We dance. The group of Americans yell as another, larger group of Americans comes to meet them. Maybe a business trip. I want to apologize to the dance floor on their behalf; the room feels suddenly too small with their jostling.

We take a smoke break outside. A man with a little hoop earring and a glittery tank top leans over and asks if we speak English; he had overheard me joking with Talya. We nod. He laughs. I watch my friends and this new friend converse in Turkish and I see them become increasingly animated. I pick up words like "UCL," and "postdoc," and deduce that he is a grad student in London back home for the holidays. He switches to English when he notices my blank look.

"I was talking about last Pride," he catches me up. "In Istanbul. I was arrested by the Turkish police. They wanted us to sign a document that said we were terrorists, that said we were gay terrorists." In my alcohol-softened state, I worry I cannot effectively arrange my facial features to express concern. I open my mouth to simulate my jaw dropping, but it feels too wide.

"You okay?" he asks.

"He's a lightweight," Ekin adds. I nod and close my mouth.

"They took us into a room with no windows," he continues. "And started beating us." I take a sip of my water.

"They only stopped when they saw my British passport," he says. "If I had been Turkish I might not have even made it through the night."

We shake our heads, our brows furrowed. The solemnity of his words has a delayed impact. The pop music from the bar suddenly sounds strident.

He smiles. "Shall we take shots?"

In America, I felt Asian, but with Ekin, I felt American. This was most prominent, of course, outside America. Earlier in the trip, Ekin had told me that James Baldwin had actually spent a good amount of time in Istanbul, which I was surprised to learn. In 1961, Baldwin took a magazine assignment to travel to Israel and Africa, and then, seemingly on a whim, made a detour to Istanbul. He was drinking too much, not getting any sleep. He was having trouble writing his novel, *Another Country*. He was distraught from a breakup and to distract himself, it seems, he found himself at a house party in the Taksim Square apartment (on the European side) of Engin Cezzar (pronounced *Jez*-zar), an actor he had met in New York.[54]

"What are you doing here?" Cezzar might have asked Baldwin, the music from the party behind him making him shout to be heard.

"Where are we?" I ask Ekin as we go back down the stairs of Mecra, to the second floor where a remix of a Turkish pop song blares.

Baldwin came for the party and decided to stay. Cezzar gave him a spare bedroom, and, steadied by the warmth of a kind friend and the excitement of a new place, he began writing again. Over the next ten years, from 1961 to 1971—the height of the civil rights movement in the U.S.—he would come in and out of Istan-

bul to write for months at a time, as the scholar Magdalena J. Zaborowska documents in her 2009 book *James Baldwin's Turkish Decade*. Baldwin found refuge in a place where he didn't belong. He fell in love with the cosmopolitan metropole where men held hands and embraced with no sexual import, giddily and willfully misreading this friendly PDA as freedom. He enjoyed his relative safety as an American. In the U.S., he had begun to garner a reputation as a spokesperson for the Black race—by 1961, he had published two essay collections, as well as two novels, some short stories, and a play—but in Istanbul, a city whose place at the center of Africa, Asia, and Europe reminded him of Harlem, he could alleviate himself of these positions.

"I feel free in Istanbul," Baldwin once told his friend the Kurdish writer and activist Yaşar Kemal.

"That's because you're American," Kemal replied.[55]

"I suppose many people do blame me for being away from the States as often as I am," Baldwin says in Sedat Pakay's short film *James Baldwin: From Another Place*, shot in Istanbul in 1970. It shows him wandering like a tourist, talking to local simit sellers, with the unmistakable outlines of minarets in the background. He lounges in his tighty-whities, in vignettes that I imagine had to have been staged, smoking a cigarette with the window open to the Bosphorus. "One sees it better, from a distance," Baldwin says in the voice-over for the film. "And you can make comparisons," he adds. "From another place, from another country."

I'm sure the distance helped, even informed his criticism. But how nice, also, to imagine Baldwin lying on a beach on vacation. I am warmed by the image of Baldwin healing, relaxing in the sun.

Baldwin eventually moved out of Cezzar's apartment into a red wooden *yalı*, a waterside mansion once owned by an Ottoman-era

intellectual and statesman. Outside of America, Baldwin was a literary celebrity, and it granted him access to a new class status. He also spent some time at another multistoried home on the Bosphorus, this one located near the fifteenth-century stone fortress Rumeli Hisarı, from which Mehmed the Conqueror launched his attack on the Byzantines.

"Those are some of the most famous, historical buildings in Istanbul," Ekin says when I tell all of this to him, excitedly.

In these mansions, Baldwin finally finished *Another Country*, the novel that had so plagued him. He held all-night parties and gave talks, entertaining the likes of Marlon Brando, Alex Haley, and Beauford Delaney.

I was not in Turkey for refuge, but I was, like Baldwin, there as a tourist. I felt, by virtue of my American blinders, like an orientalist of the Middle East. Even as I write this, I'm not sure I can escape its tropes. I tried to reconcile the kind of cosmopolitanism that I had found myself within, embodied in the figure of a jet-setting, international curator, and the unintentional cosmopolitanism—or "vulgar cosmopolitanism," to borrow a term from the sociologist Paul Gilroy—of my parents, who had emigrated from Burma to the U.S. and then chosen to immerse themselves entirely within American culture for an extended period of time. Did we measure cosmopolitanism in the volume of countries traveled or in the depth of one's engagement with that country?

Tonight we are on the European side, in Taksim, with another friend, Mina, who is taking us out. The streets on this side of Istanbul are older, ancient even. They wind and dip, the architecture forlorn and majestic. "A poor man's Rome," Ekin calls it. Taksim is known for its large, touristy promenade called Istiklal. But off the

main road, the side streets are dense and busy, filled with scores of traditional *meyhane*, literally "liquor houses" (*mey*, old Arabic for liquor, and *hane*, Turkish for house), restaurants where one goes to drink rakı, an anise-scented liquor that is clear at first but turns cloudy blue when you pour ice and water into it.

"When you go to *meyhane*—or as we say, 'go to rakı'—you eat little plates, like dips and breads—mezze," Ekin had told me after one of our earliest dates, sitting on the floor of my living room. Julie and I sat on the couch. "And talk about your sorrows."

"What a sweeping word," Julie said. "Not troubles or sadness but *sorrows*." We rolled the word around our mouths, feeling how it weighed down our tongues.

"People cry, and talk about whatever. Sometimes sob. Breakups, deaths, troubles," Ekin continued. "And you drink the rakı and get drunk. And then at a certain point, you just start dancing. Crying and dancing. And you rinse the sorrows."

Taksim is full of *meyhane* and we passed many as we wove through the streets. But nestled between them were also other clubs and bars, like the one Mina was taking us to. So many subcultures nestled into the cracks, hidden by flights of stairs yet rubbing shoulders with one another.

The façade of this bar was entirely different than Mecra, unmarked and nondescript. There was no music blaring from the first floor. Around us we could hear the din and ruckus of rakı places rolling along, but we were led by Mina up several flights of stairs, passing closed doors and what looked like residential apartments, until we arrived at a spiral staircase and a bouncer. We checked our coats with a tall, androgynous they/them with a mullet and emerged onto a rooftop dance floor and bar where techno music was pulsing.

I was surprised by the scene we encountered. The music would not have been out of place at a queer club in Bushwick—pop re-

mixes, trance and '90s rave hits, dark and minimal techno, the occasional hyperpop. I went to get a drink.

Immaterial boys, immaterial girls, the music said.

"We're too enmeshed in the global language of hyperpop gay to escape it!" I shouted.

There was a scene, a queer scene, here as well—of course—but we weren't tapped into it. The DJ wore the tiniest halter top and a plaid skirt while sipping their cigarette. I spotted a small gay flag behind the speakers. The crowd was mixed, casual, some people maneuvering the dance floor and others sitting around, smoking. The smoking indoors was kind of brutal, but I was willing to forgive a lot for a queer space.

I was happy to know that spaces like this could exist, hidden out of sight, especially after what we had heard from our friend at Mecra. Ekin went to get us a drink, and I moved to a window to look down at the streets of Taksim.

Below, I could see the yellow light from a rakı restaurant scraping the cobblestone street. I imagined that directly below this dance floor, to the right and to the left, all around, were *meyhane*, filled with tables where people shared sorrows, dancing, drinking rakı. I realized that what we were doing here, listening to techno in this hidden queer space—that Robyn seems to encapsulate so well in a song like "Dancing on My Own," of ecstasy bedrocked by deep sadness—was not so different from the sadness to joy method of rakı. That this club was its own kind of *meyhane*, another place to purge sorrows connected to a vast fog machine sea of dance floors.

Back in New York, we go to Yalla!, the queer Middle Eastern party at the Deep End, near Bushwick. It is a Friday, so we are all

exhausted from work. Michelle buys us shots to wake us up. An EDM remix of "Ya El Yelil" by Mezdeke plays, and Ekin says it makes him miss home.

"Can Middle Eastern people be orientalized?" I ask, looking at the music videos of women belly dancing. Ekin is quick to point out that orientalism, the term, originally came to describe the European gaze on the Middle East anyway, from Edward Said, before it referred to East Asia.

Anything mixed with EDM feels somehow like mixing your old home with your new home. In the U.S., because a Middle Eastern American demographic label is not legally recognized, many tend to find community through religion, which Ekin finds abhorrent as a queer person. When Ekin first moved to the States, as a college freshman, he considered joining a religious community because it would be the only way that he could find a community. It made me reflect on the queer scene. What was our religion? Global hyperpop? Who was our god? The dance floor? Did that make Robyn our prophet?

It had not been easy for Ekin to come out to his parents. On my second trip to Turkey, we went on a road trip with them in their new RV, which consisted of a lot of uninterrupted dinners and car rides that tested the limits of my piecemeal, once charming Turkish. We made a stop in the small beach town of Urla, where I obsessed over the number of cats again. We walked through an ancient colosseum. Where we were now, on an RV trip all together, was the product of many phone calls and discussions about queerness instigated by Cansın, Ekin's sister, and their parents. She was the architect of keeping their family together. Even if we had essentially minimized the role of religion, or tradition, in our lives, it insisted on its presence through our relationship with our parents.

The demographic term "Asian American" exists but "Middle Eastern American" does not, census-wise at least, and as Ekin tells me, this is strategic: If the demographic label were to exist, it would mean that the government would have to divert resources to that community in the U.S. And yet, because Middle Eastern Americans remain paradoxically subsumed and foreign under the idea of "whiteness," these resources are diffused, and the identity remains underacknowledged in a legal sense. This was partly why the term "whiteness" didn't sit right with Ekin; it swallowed and erased him. To find a place where he could manifest two aspects of his identity that were otherwise corrosive to each other without recourse to nationalism was a special thing.

In comparison, the Asian American diaspora is very prominent and visible in the American imagination. There are now courses and movies about this identity. I realized how much I had resisted making Asian American a monolith, but also the advantages of a little bit of strategic essentialization. It also made me wonder if the future of Asian American identity should entail a radical expansion, an expansion that could include Ekin. It would rename the Middle East as West Asia (a.k.a. Turkey), and yoke other parts of the Asian continent together like Palestine (South West Asia) and Afghanistan (South Asia) just as improbably as Japan, Korea, and China are yoked together in the U.S. through the shared trauma of U.S. imperialism. It would be what Viet Thanh Nguyen has called an Asian American identity revived by "an expansive solidarity," an identity that allows us to ask questions and seek possibilities beyond those given to us within the confines of racism and colonization.

"Turkey's already in Subtle Asian Traits," Ekin said when I mentioned this to him, referring to the Facebook group sharing

memes common to the Asian diaspora. "Turkey is a very subtly Asian country," he added.

Toward the end of his time in Istanbul, Baldwin staged a Turkish version of a controversial Canadian play called *Fortune and Men's Eyes* (1967). Translated as *Düşenin Dostu* in Turkish ("Friend of the Fallen"), Baldwin directed the play at the Sururi-Cezzar Theater in Istanbul; it ran from 1969 to 1970, traveling across rural and urban Turkey, from Istanbul to Ankara and Izmir. The play focuses on the power struggles and sexual violence between white inmates at a Canadian correctional facility. Baldwin's direction focused on the violence, homophobia, and homosexual panic at the center of the play, situating it in a Turkish context. It was also a chance to work with Cezzar again, who translated the play, and with a young Turkish journalist, Zeynep Oral, who served as Baldwin's translator to the actors.

As a famous writer, Baldwin was given license to a set of issues that might have been taboo in Turkey otherwise. *Düşenin Dostu* made waves in Istanbul, where it generated controversy for its representation of explicit gay sex and rape and also the use of Lubunca, a kind of secret language used by trans and queer people, some of whom are also sex workers. Ali Poyrazoğlu, another translator on the play, translated the English slang that is central to the original into this vernacular. Derived from slang used by Romani people and containing words from many other languages—Arabic, Persian, Armenian, Russian, Greek, etc.—it still features in the queer community in Turkey today.[56]

Some argue that the play, which was at the time more progressive than some American theater, even contributed to the momentum of the Stonewall Uprising amid an international network of

gay rights campaigners and activists. *Düşenin Dostu*'s frank discussion of both sexuality and incarceration helped forge connections between gay activists and prison abolitionists, as many gay people were serving prison sentences for their sexuality.[57]

I wondered how radical Baldwin's actions really were, ensconced in the privilege of being an American abroad. Was it irresponsible to start an uprising in a foreign country and then leave? How much responsibility does a tourist have to finish what they started? I felt myself navigating similar tensions, especially the privilege involved with interacting with only certain parts of a culture, picking and choosing and reaping the rewards of a country's beauty while avoiding its consequences. I assuaged the guilt by taking aggressive twice-weekly Turkish lessons.

"Turkey is a wonderful place to visit," Ekin would say frequently, "especially as an American. Living here—as a queer person—that's a different matter.

"But I don't know," he continued. "I left too."

Ekin was speaking to his parents. Cansın was getting married in the fall. We were discussing what we would wear. I showed them a picture of this sheer pink suit I had bought from CFGNY a few months earlier.

I felt the urge to dress more queer in Istanbul than I did in New York. Tank tops and shoulder bags, sheer things. Amid all I had heard about LGBTQ groups in Istanbul, and their denomination as terrorist groups, it felt even more important to emblazon my gayness in public, perhaps as something like solidarity.

Ekin was wary about the pink suit. He cautioned that it might elicit unwanted attention. He showed me a TikTok of a Portuguese tourist getting arrested, beaten, and detained for wearing a crop

top in Istanbul. I hesitated. I could see the words I would say next. *But I'm American*, I thought, *I can wear what I want*.

I stopped before I could open my mouth. I was repulsed by the part of myself that so flagrantly used my American identity, by the ideology pumping through my blood. I swallowed the words in my throat.

When Baldwin died at sixty-three, of cancer, in the South of France, he was supposedly at work on a novel that would have been in part about Istanbul.

This relative quiet, the absence of writings by Baldwin on this time, intrigues me. His other international haunts—Paris, London, etc.—were long written about, and indeed, it is almost cliché for the American intellectual to fantasize about Baldwin abroad. He wrote copiously about other things, like the aftermath of the Harlem Renaissance, the protest movements, his own novels; yet Istanbul, a place of so much warmth to him, he left untouched (unscathed, perhaps) from his pen.

"I cannot imagine a country in the world as beautiful as Turkey, a people as nice as the Turks," confided Baldwin in a television interview he gave in Paris in 1969. When a reporter from *Ebony* magazine visited him in Istanbul, he made no mention of the city, instead praising his time in Turkey as a refuge: "To begin again demands a certain silence, a certain privacy that is not, at least for me, to be found elsewhere."

The day after going out with Mina in Taksim, Ekin and I rested. We laundered our clothing from the smell of smoke. We dropped off our stuff at our rental in Moda and walked to a Caffè Nero

near the shore. A calico cat came and rested its head on my lap. Ekin ordered a cappuccino. We sat and watched the boats come and go and thought about what we might do next. *In Istanbul, we dance on the ruins of the empire*, Ekin liked to joke. He wondered if Istanbul was what New York would be like when the American empire falls and some city in China becomes the new capital of the world.

On my phone, at the café, I learn that early Turks came from the Altai region in Central Asia, on the western border of present-day Mongolia. They might even have had distant links across straits to Alaska (in some native Alaskan languages, the word for "bear" is the same as the Turkish *ayı*). One of the first written reference to Turkic peoples is in Chinese—*tyu-kyu*, in the second century BCE. The word referred to nomadic warrior tribes practiced at raiding civilizations, meaning both "strong man" and referring to the name of the dominant tribe at the time.

These tribes caused a lot of trouble to the Chinese. They were spread out over the vast tableland of Central Asia, sometimes establishing steppe empires lasting for generations before being absorbed. Great tracts of Chinese history were about these battles on the long open frontier; the Great Wall was built for this very purpose. Some dynasties have obvious Turkish antecedents, the most notable being Kublai Khan (Kubilai being a common first name in Turkey), who in 1272 established Hanbalık, "City of the Ruler," or modern-day Beijing.

In the afternoon soap opera of our lives, a Turk and a Chinese pass messages through the wall. On my night shifts, I look expectantly into the dark beyond the wall for my Turkish warrior lover, who risks it all in these daring trysts . . .

Early Turks apparently did not leave a literary trace, so the history is most often studied through outside sources—Chinese, Persian, Arab, Byzantine. I joked that I was doing the same by

writing about Ekin, his presence in the book only as my boyfriend, through my words.

Turkish is a relatively poor descriptive language, Ekin reminds me when I ask, for whatever reason, if there are words for scurry, scuttle, dash, or crawl.

"What does a cockroach do then? Walk across the room?" I ask.

"We just say a cockroach passed," he said as he finished his cappuccino.

But Turkish has four words for "victory," which are common names: Zafer, Galip, Mansur, Kazan. It also has many words for "fight"—partly because modern Turkish comes from Turkic, a mixture of nomadic languages. It also has multiple words for "love," a multiplicity that I find wistful.

"*Sevgi, aşk*, and *sevda*," Ekin explains to me. "But those words are not interchangeable. *Sevgi* is the most universal, the most general. *Aşk* is typically for intense, romantic love. And *sevda* is like love and longing mixed."

But my favorite fact is that Turkish has a specific word for the way moonlight sparkles on the surface of water. In Google translate it gives me "sea sparkle."

"*Yakamoz*," Ekin says. He looks up the exact translation on his phone. "It says the 'sea sparkle produced by the movement of fish or rowboat spades at night.' The second one is something like bioluminescence, for the algae or shrimp that glow." Ekin can see I'm smiling. Fewer words (at least compared to English) means that each word must do more work, but it also lends Turkish a poetic quality.

"It also makes the fact that it has specific words for things like 'sea sparkle' seem very special," I add. "At least to an outsider to the culture like me." He laughs.

I ask Ekin if he felt like Turkish history was his history. He said maybe. He despised nationalism, but there were things about

Turkey he loved. He still felt a pull toward the country he was from. It made me wonder. Did I?

I tell Ekin that my dad has been really obsessed with videos about China on YouTube lately. At first he was just listening to news outlets outside of the U.S., but it has become a kind of daily intake of news headlines like "China Surpasses U.S. in GDP" or "New Study Shows That Chinese Standard of Life Higher than the U.S. Standard."

It's funny, because we're not Chinese. We don't speak Chinese. We've been there a total of maybe three weeks in our lives. One day, my dad was recounting one of these articles to my mom, who usually just ignores him, but she finally had had enough and confronted him about it.

"Why do you care so much?" she asked. "You know we live in America now. China is not going to take you if stuff goes south. If it's bad for America, it's bad for us." I was struck by her frankness. We were American, and we had been Chinese—two generations back, at least. We were still kind of Burmese, and according to my tally, I'd officially spent more time in Turkey than in any other Asian country.

Back in the U.S., I stop by my apartment in New York to drop some things off, and then I go home to my parents, excited for them to see the souvenirs I bought them. I tell them about the mosques, Ekin's parents, the cats. We are in the car to the Burmese Buddhist temple in New Jersey for a seasonal celebration. In Istanbul, you can hear the call to prayer five times a day, I say. Religion is a feature of the urban fabric in a way that reminded me of my visits to Burma, where I used to watch the monks walk for alms

in the mornings, of which we will experience a small simulacrum today at the temple. There will be dozens of Burmese people there, the largest group of Burmese people I've seen at once in the U.S.

The temple is in the small town of Manalapan. As a child, I always thought Manalapan was somehow an extension of Burma, or was even a Burmese word, because it sounds so much like one. But it is Indigenous occupied land, and the consonance is largely incidental. My family has been coming to this temple since they first immigrated to the U.S., and it is the only place I can point to as something my parents have roots in; they helped found the temple. What is more American than building immigrant roots on stolen soil?

I tell my mom about this crazy TV show we watched while we were in Istanbul, *Gelin Evi*. In the show, a group of women invite one another over to their respective houses and judge each other on their housewife skills: their decor, their cooking skills, their dowry chests (replete with knitted goods, gold necklaces, baby clothing), their hospitality, the cinematography and location of their honeymoon videos, and—of course—how good of wives they are. They are catty and witty and their lives are their own Ottoman court epics. I tell her that it reminds me of the aunties at the temple, and she laughs.

At the temple, women introduce themselves to me as "the auntie who held you when you were born" or "the auntie who you peed on." The same aunties now tell me I deserve a hot wife, because I've been a good son.

My parents taught me and my brothers to meditate from a young age, as well as the basic tenets of Buddhism (desire is suffering, nirvana is the cessation of suffering), but I never took much stock in it as a child. The denomination of "temple" is really a misnomer because the actual translation from Burmese is "school," or "monastery." It's where my parents come for meditation retreats

and festivals and occasional sermons, but it's more like a community center, an excuse to gather.

It is also a place to gossip. To show face and keep tabs and share sproutlings and seeds of rare Burmese plants. My mom asks a woman with bangs where her children are, and others ask her if this is all her children. I wheel my grandma around in a wheelchair with my brothers, and we wait in line for a bowl of *mohinga*—a Burmese fish noodle soup and a staple of the cuisine. We wear easily removable shoes so we can quickly slip them off before entering each room.

People are dressed in cultural transition. Sneakers and *tamain*, essentially tailored skirts. Sensible jeans and blouses. Louis Vuitton bags and sandals. A man—a friend of a friend of my mom—comes up to tell me, unprompted, that I've gotten fat. It's been a while since he's come, he's a friend of my mom, can I help his son with college apps? He overheard I had gone to a good school.

"My son, he's glued to his phone, and his GPA is bad, how can I do anything? What GPA did you have? What APs?"

I introduce myself with my Burmese name, which I don't use in any other context. I point out my parents, whom I'm realizing he actually doesn't know, and I deflect by giving him an email address. A lady with jasmine flowers in her bun, a familiar Burmese style, comes over and asks if I have a girlfriend yet, but my mom is back now, and interjects, saying I've been too busy "working in New York" for that.

When they first moved to the U.S., my parents came to the temple for a place to have Burmese food my mom didn't have to cook herself, to wear Burmese clothing, and occasionally meditate. And now, as her kids were growing up, my mom turned back to community organizing at the temple to feel connected: clothing and food drives, meditation retreats, scripture sharing.

Zoom and Facebook had revolutionized the Burmese Buddhist community. Now she could participate in retreats with childhood friends and other mothers across the world from the comfort of her own home.

Religion, which I passively consumed as a kid, was always only a nuisance—something that got in the way of my Saturday cartoons. Later, once I became old enough to understand what everyone was talking about, it became an ideological affront, an opiate, a tool of placation.

Now, in my late twenties, I found myself developing a creeping feeling of solace to the religion of my youth, especially amid increasing climate disaster and political uncertainty. Even if my friends and I mostly considered ourselves *spiritual* and not religious, even if we had suffered trauma and erasure at the hands of it, I wondered if the forms of community it produced could be salvaged, remade in some way for our own purposes.

In the space between "Dancing on My Own" and "Honey," Robyn had found a new kind of refuge for herself. She'd come to terms with not being able to come to terms. "When you're listening to club music, there's no reward," she has said. "The reward isn't, 'Oh, here's the chorus, here's the lyric that makes sense.' You have to enjoy what it is. You have to enjoy that there's no conclusion."

It's not far off to say that Robyn's music has been elevated to the level of religious experience for many queer people, if one could imagine a song as a kind of fog that you can access from anywhere in the world, a church built of synths and cowbells. "The club has become like a church, a community where you get to live things out," she said in a 2010 interview. "My generation has gotten more out of club culture than any religion. It is said that religious people

are happier because they have a network around them that supports them. And I think that's what club culture is for people. Affinity. It is primal and simple." Was it about religion, or was it about belonging, and its instrumentalization? Robyn has said that the pillars of songwriting for her are love, the club, feeling like an outsider, eternity and death, and losing control. Are these not the pillars of living a life?

I was most attracted to her insistence on "feeling like an outsider," instead of fighting for belonging. "Dancing on My Own" paradoxically helped people dance with others and access collective belonging in new ways, but I was more interested in what kinds of healing could be produced in not belonging, what the color, texture, and quality of that refuge would be.

I wondered how queer culture would age. Could there be a church of Robyn in Manalapan, New Jersey? Could it serve as a network for immigrants? Would the tenets of the club be able to hold moral and ethical frameworks robust enough to carry us through middle age, climate disaster, and death and rebirth? I wasn't sure. I wasn't sure if it needed to either. But it felt like an immense privilege to be alive to find out.

I was back at my parents' house in the suburbs for a funeral. My grandmother, my father's mom, had passed away. We were not very close to her, but I wanted to take care of my father; funerals were another arcane American system he would probably figure out with admirable cheerfulness, but I knew it would be difficult. He came to tell us about the funeral operations.

"The funeral will be a closed casket because we didn't want to pay the cost for an open casket funeral," he said.

"How much is it?"

"Three thousand dollars," he replied. "They also only showed

us crazy expensive caskets, so I threatened to buy one from an external place."

"You can buy them from Costco," my mom interjected.

"What?" I laughed.

"Yes, Costco has caskets for budget prices," she said.

I looked on my phone. They did indeed. They even had pink colored coffins emblazoned with roses "For Mother" and black ones "For Father." I messaged Julie almost immediately about this discovery.

> Look

Omg I've seen them at Costco before

Right next to the playground equipment

> A whole life cycle
>
> so crazy

but they're so much cheaper than the funeral homes ones haha

Makes sense lol

> They aren't Kirkland branded are they
>
> hahaha that would be foul

ok they don't seem to be

Very moving and fitting I think for ur family haha <3

I was trying to write. My mom came to place a blanket over me. She sat down on the couch.

"I've been thinking," she said.

"Yes," I said, not looking away from my screen.

"I think I want to write."

I stopped typing.

"I think I want to write about *Asian housewives*"—this she said in English. "Maybe kind of like the ladies on your Turkish TV show. I could write it little by little every day, in Burmese. And you could translate it into English later and do edits to it."

I was struck by this thought. "I think that's a great idea," I said. "That's such a good idea," I repeated.

"And I thought instead of going to therapy I could just write it down," she said.

"I still think you should go to therapy," I interjected.

"I have so much to say," she continued. "I know it'll all just come out. Now that you're writing it, you could just publish it under your name."

"I think it should be under yours, or at least both of ours," I said.

"Sure," she said, and her eyes seemed to go somewhere else. "I just think a lot of people feel the way that I do. Or have felt what I felt."

By "Asian housewives," I imagined she was speaking in part about her desires that had been cut short in coming to the U.S.: medical school, dressmaking, other creative pursuits. My grandparents hadn't approved of my mom's marriage to my father, but she had done it anyway. She hadn't planned on coming to the U.S., but the day she found out she was pregnant with me, she also won the Diversity Visa Lottery. (Mom: "You were destined to come here.")

I looked at the room around us, noticing how its enclosed nature was a manifestation of American individualism: the Chantilly Lace white walls that shut out the outside world of suburban lawns and driveways; our car, a metal house on wheels, in the driveway that further insulated us from other people; the bay window full of jade plants with heavy, cancerous leaf bundles that brought

nature inside. I could only imagine how isolating the suburbs of Richboro had been in comparison to the bustle of Yangon, where relatives, friends, and strangers wandered past the open veranda of their house.

I scrolled idly through TikTok. A grumpy cat. An unnerving live stream of a woman pretending to be an NPC. A talking head with the banner "How Capitalism Works." I paused. America takes away everything that makes for stable living—convivial family structures, homegrown food, casual exercise—and sells it back to you as talk therapy, organic produce, and workout classes, the post told me, over the audio of an Olivia Rodrigo song. *Damn*, I thought, sending it to Ekin. My friends and I, we bought into this: we therapied, we worked hard, we CrossFitted, we lived in cities away from our families. Partly because we had to, partly because we wanted to. But I wondered if my parents would have been happier in Burma. Capitalism is fun and convenient; capitalism is an escape from capitalism.

"When are you going back?" My mom interrupted my scrolling.

"Let me ask Nick and Duke when they are," I said. We came home periodically. "I'll just go when they go. I think tomorrow," I said.

"Do you want anything from Costco?" my father asked. I shook my head.

In the morning, my mom wakes up at six to pack food in containers for us.

"Can you bring back some containers from New York?" she says. "I'm running low. Also these are really good"—she holds up a bag with a picture of Japanese yakisoba. "They're from Costco. I know you didn't need anything but I think you will like," she says. "They're really good."

"I believe you," I say, still groggy. The train is in an hour; my dad works in Trenton and will drop me off at the station.

I watch my mom as she spoons steamed pork with dried mango, curried eggplant, fried meatballs—all food she cooked the night before just for us—into flat plastic containers. The clear covers smush the contents into colorful swirls. I pass her a large museum tote bag and she wraps each container in Saran Wrap before shimmying them into plastic bags, and then closes the bags with slipknots. As if she forgot, she runs to the fridge for the frozen matter—a tub of lentil soup, loose Jimmy Dean breakfast sandwiches—a few Chobani yogurts, and the last bottle of kombucha. ("You're the only one who drinks it," she says.) The tote bag bulges, engorged, on the counter.

"I packed a lunch container separately for you," she adds, handing me a prewrapped bag.

I'm going back, like I have many times before, to try to make some event—a studio visit, an opening, a panel, some meeting. When I get to New York I'll stack the plastic into the fridge well past my apportioned freezer space and ration it over the course of the next few weeks before I can go home again. Later that night, I will probably meet Ekin or Jarron and Julio and Julie and Michelle at a bar, or if we're up for it, some club, and we'll sit on a couch all dressed up and pregame by watching music videos and we *will* resist the temptation to stay home and just watch music videos until we drop and eventually make it out (out!) where the bar will be too crowded, the drinks too expensive, the people too young, but once in a while a song will come on that we can't not dance to and we'll have a glimpse of Robyn's nirvana, and at some random point, I'm guessing 2:17 a.m., I'll worry that I forgot to put one of the curries in the fridge and think about it melting on the counter, sad to think about this materialized affection all alone and then

realize it's okay, it's okay, my mom can make more, even if she's not here now.

My dad says we should go. My mom's not coming; she has some calls to take for the meditation retreat she is organizing, and some things to take care of at home, but she'll see me soon, she says, and reminds me to separate the frozen food into meal-size portions so that they don't go bad when I defrost them. I thank her for the food and sling the weighted tote bag over my shoulder. I tell her I'll call her soon; she smiles, shaking her head, waving me away with her hand: I know, I know.

My dad and I pull out of the driveway and our house recedes from view. I imagine my mom inside, finding some frozen thing she forgot to pack for me, locking the front door, maybe putting some words down on her Notes app, or going back to wash the dishes in the kitchen, without gloves.

ACKNOWLEDGMENTS

I love my family and I love my friends and I am so grateful to have had the opportunity to write a book about how much I love them. To everyone who enabled my love:

Clare, for your belief and your pragmatism and your mirth. The cuteness of our matching Pintrill phone keychains. To Jenny, whose immediate, exuberant enthusiasm for this book—and careful, foundational shaping—scared and invigorated me. To Ezra, my dearest comrade in disco and track changes, I owe you this book's heart. You three gave this book it's bassline and its rhythm; you made it bleed. May we glitter in the rain of gay fan fiction love. Thank you.

Alex Strada, for your strength, friendship, and guidance. Tony Tulatumitthe and CRIT, for gaslighting me into thinking I might be able to be a writer. Alberto, Rosa, and Wardah for being my anchors. Ben Denzer and Leon Xu for a beautiful cover.

Many of these essays began from the kind invitation of editors, curators, and artists to shape my thoughts into what they became here; thank you to Rebecca Panovka, Kiara Barrow, Sky Gooden, Catherine Wagley, Merray Gerges, Michael Famighetti, Jeppe Ugelvig, Oscar yi Hou, Terence Trouillot, Chris Lew, Stuart Comer, and Kelly Huang.

I am grateful to the artists who opened their studios, homes, and dance floors to me: Ken Okiishi, Maia Ruth Lee, Maggie Lee,

Sybao Cheng-Wilson, Muna Tseng, Viva Ruiz, Anicka Yi, Stewart Uoo, Ajay Kurian, Bob Lee, Micaela Durand, Lotus L. Kang, Mira Dayal, Daniel Chew, Tin Nguyen, Kirsten Kilponen, Cole Lu, Ten Izu, Nicholas Andersen, and Jarod Lew. I learn from you everyday. Thank you to Cat Zhang, Ekalan Hou, Isabel Flower, Kathy Chow, Izzy Kornblatt, and Jack Davis for reading early drafts.

Julie: Remember when we used to ride the FiDi ferry? I'm glad we didn't waste all that romance on boyfriends. I'm so happy we met. Thank you for letting me make you the mascot of this book. Ekin: I propose we add another definition to *yakamoz*, after bioluminescence and sea sparkle, for how we shimmer together. I can't wait to see you soon.

Julio, Jarron, Colleen, Michelle, and Rachel: my siblings. My life is so much gayer because you all are in it. May we be blessed with many more music video nights.

Gratitude to the curatorial team of the Racial Imaginary Institute for babysitting me. To Helena Anrather and Megan Yuan. To Geoff Mak. To my Yale PhD cohort. To Jayne Cole, Lisa Yin Zhang, Yin Kong, and Think!Chinatown. To Dean CrossFit and The LAB. To Talya, Derin, Mikkel, and Başak. To Danie and Lilia. To Lana del Rey and Charli XCX. To Robyn.

And to my family—Nick, Duke, Mommy, Papa, and Ahma—where it begins and it ends and it begins again. Thank you for always being home.

NOTES

1. Ken Okiishi and Maika Pollack, *Ken Okiishi: A Model Childhood* (Mano, HI: The Art Gallery, University of Hawai'i at Manoa, 2022).

2. Wendy Yao and Maggie Lee, "1000 Words: Maggie Lee," *Artforum International Magazine* (online edition), November 30, 2016, https://www.artforum.com/print/201604/1000-words-maggie-lee-58714.

3. Vanessa Friedman, "The Year of Telfar," *The New York Times*, December 21, 2020, https://www.nytimes.com/2020/12/21/style/telfar-clemens-designer.html.

4. Michael Bullock, "Telfar Clemens," *Apartamento*, no. 23 (2019): 75–94.

5. Avery Booker, "Q&A: Telfar Aims to 'Exit' the Fashion Industry," *Jing Daily*, May 17, 2021, https://jingdaily.com/qa-telfar-aims-to-exit-the-fashion-industry/#:~:text=Telfar%20Clemens%20and%20Babak%20Radboy,selling%20to%20a%20different%20customer.

6. Ann Bilot, "Telfar and a Whole Army of 3D Printed Models Turn the New Museum into an Interactive Runway," *Vice*, February 12, 2014, https://www.vice.com/en/article/78e9vg/telfar-and-a-whole-army-of-3d-printed-models-turn-the-new-museum-into-an-interactive-runway.

7. Emily Witt, "Telfar Clemens's Mass Appeal," *The New Yorker*, March 9, 2020, https://www.newyorker.com/magazine/2020/03/16/telfar-clemens-mass-appeal.

8. Elizabeth Currid-Halkett, *The Sum of Small Things: A Theory of the Aspirational Class* (Princeton, NJ: Princeton University Press, 2018).

9. Robert Storr, "Interview with Felix Gonzalez-Torres," *ArtPress*, January 1995, 24–32.

10. Threaducation, "The Rise of Telfar," YouTube, September 10, 2021, https://www.youtube.com/watch?v=ZppVwADiBEM.

11. Lynette Nylander, "First Telfar Took New York, Now It's Going Global," *British Vogue*, February 7, 2020, https://www.vogue.co.uk/fashion/article/telfar-interview.

12. Telfar Clemens and Babak Radboy, "Telfar Clemens vs Babak Radboy," *Dazed*, August 4, 2014, https://www.dazeddigital.com/fashion/article/21099/1/telfar-clemens-vs-babak-radboy.

13. Witt, "Telfar Clemens's Mass Appeal."

14. "Joice Group Ltd.—Hong Kong (China) Manufacturer," Tradeeasy.com, https://www.tradeeasy.com/supplier/689688/joice.html, accessed December 14, 2022.

15. E. P. Licursi, "Telfar and Babak Go to White Castle," *SSENSE*, https://www.ssense.com/en-us/editorial/culture/telfar-and-babak-go-to-white-castle, accessed December 14, 2022.

16. Laura Snapes, "How Robyn Transformed Pop," *The Guardian*, September 28, 2018, https://www.theguardian.com/music/2018/sep/28/how-robyn-transformed-pop-music-honey#:~:text=According%20to%20The%20Song%20Machine,had%20written%20with%20Max%20Martin.

17. El Hunt, "'She Breaks the Mould': How Robyn's Pop Classic 'Body Talk' Changed the Game," *NME*, November 25, 2020, https://www.nme.com/features/robyn-body-talk-10-year-anniversary-charli-xcx-kleerup-2821453#:~:text=%E2%80%9CShe%20has%20paved%20the%20way,a%20woman%2C%E2%80%9D%20Chris%20added.

18. Carsten Höller and Robyn M. Carlsson. "Robin Miriam Carlsson Är Här Igen." *Bon.Se*, 2010, bon.se/magazine/bon-52/robin-miriam-carlsson/.

19. CFGNY, "Info," 2016, http://www.cfgny.us/info/.

20. Ying Xiang, "A 'Vaguely Asian' Clothing Enterprise," *Ying Xiang*, May 30, 2021, https://ying-xiang.org/articles/vaguely-asian.

21. Ibid.

22. Jack Sunnucks, "The CFGNY Show Brought Together Generations of Asian Creatives," *i-D*, https://i-d.vice.com/en_uk/article/7xg3mb/see-cfgnys-show-in-a-chinatown-park, accessed December 14, 2022.

23. Monica Kim, "How a New Art-Fashion Label Is Exploring Asian-American Identity," *Vogue*, May 24, 2018, https://www.vogue.com/article/cfgny-new-york-art-fashion-label-tin-nguyen-daniel-chew.

24. Jack Moss, "CFGNY: The Art-Fashion Duo Creating Community with Clothes," *AnOther*, October 15, 2019, https://www.anothermag.com/fashion-beauty/12023/cfgny-new-york-duo-creating-community-with-clothes-daniel-chew-tin-nguyen.

25. Ying, "A 'Vaguely Asian' Clothing Enterprise."

26. Thuy Linh Nguyen Tu, *The Beautiful Generation: Asian Americans and the Cultural Economy of Fashion* (Durham, NC: Duke University Press, 2011), 105.

27. Ying, "A 'Vaguely Asian' Clothing Enterprise."

28. Daniel Chew and Tin Nguyen, "Synthetic Blend V," *Triple Canopy*, December 13, 2019.

29. Tu, *The Beautiful Generation*.

30. Wilfred Chan, "Why One Chinatown Mini-Mall Languishes While Another Thrives," *Curbed*, October 31, 2022, https://www.curbed.com/2022/10/chinatown-minimalls-east-broadway-88-palace-pilot-taxes.html.

31. Jamie Chan and Leah Pires, "Kai Althoff," *4Columns*, https://4columns.org/leah-pires-jamie-chan-and/kai-althoff, accessed September 14, 2023.

32. Shanzhai Lyric, "'To How Do You Go Deep in a Shallow World'" (MIT NOMAS lecture, Cambridge, MA, April 13, 2023).

33. Ryan Dombal, "Robyn," *Pitchfork*, June 28, 2010, https://pitchfork.com/features/interview/7817-robyn/.

34. Judy Soojin Park, "Searching for a Cultural Home: Asian American Youth in the EDM Festival Scene," *Dancecult*, https://dj.dancecult.net/index.php/dancecult/article/view/642, accessed September 14, 2023.

35. Michelle Hyun Kim, "Was Frank Ocean's PrEP+ Party the Inclusive Queer Utopia He Promised?" *Them*, October 18, 2019, https://www.them.us/story/frank-ocean-prep-party.

36. Simon Reynolds, *Energy Flash: A Journey Through Rave Music and Dance Culture*, updated ed. (Berkeley, CA: Soft Skull Press, 2012), 55.

37. Park, "Searching for a Cultural Home."

38. Jenny Schlenzka, "What Art Spaces Can Learn from Legendary Berlin Nightclub Berghain," *Frieze*, January 30, 2019, https://www.frieze.com/article/what-art-spaces-can-learn-legendary-berlin-nightclub-berghain.

39. Alex Billet, "Joe Biden Wants to Take Away Your Music," *Jacobin*, August 31, 2019, https://jacobin.com/2019/08/joe-biden-rave-act-2002-music-mdma.

40. Ching Ho Cheng, quoted in Jaakov Kohn, "Ching Ho Cheng: A Conversation," *SoHo Weekly News*, January 27, 1977.

41. Lee Pivnik, quoted in Landon Peoples, "At Last, an Entire Institute for Queer Ecology," *Atmos*, January 5, 2021.

42. Ching Ho Cheng, "Note from the Artist," *Everson Museum of Art Bulletin*, June 1980 (published on the occasion of *Ching Ho Cheng: Intimate Illuminations*, Everson Museum of Art, Syracuse, NY, 1980).

43. Brian Dillon, "Tseng Kwong Chi, an 'Ambiguous Ambassador' to Life in America," *The New Yorker*, June 23, 2019, https://www.newyorker.com/culture/photo-booth/tseng-kwong-chi-an-ambiguous-ambassador-to-life-in-america.

44. Roland Hagenberg, "Interview with Tseng Kwong Chi," *Artfinder*, 1987.

45. Oliver Giles, "The Short But Extraordinary Life of Tseng Kwong-Chi," *Zolima CityMag*, July 20, 2022, https://zolimacitymag.com/the-short-but-extraordinary-life-of-artist-tseng-kwong-chi/.

46. Ching Ho Cheng, quoted in Henry Geldzahler, "Studio Visit: Ching Ho Cheng," *Contemporanea* (November/December 1988).

47. Harley Wong, "Appreciating Tseng Kwong Chi's Radical Art, Beyond His Photos of Keith Haring," *Artsy*, April 30, 2020, https://www.artsy.net/article/artsy-editorial-appreciating-tseng-kwong-chis-radical-art-photos-keith-haring.

48. Howie Chen, *Godzilla: Asian American Arts Network* (Brooklyn: Primary Information, 2021).

49. Alina Cohen, "The New MoMA's 5 Biggest Changes," *Artsy*, October 11, 2019, https://www.artsy.net/article/artsy-editorial-5-changes-new-moma.

50. Homi K. Bhabha, "Homi K. Bhabha on Whiteness Studies," *Artforum* (online edition), May 1, 1998, https://www.artforum.com/print/199805/whiteness-studies-32587.

51. Howie Chen, "Godzilla 10 Members on Community, Collaboration, and Rupture," *Artforum International Magazine* (online edition), May 6, 2021, https://www.artforum.com/interviews/godzilla-10-members-on-community-collaboration-and-rupture-85619.

52. Caryn Ganz, "How Robyn, Pop's Glittery Rebel, Danced Her Way Back from Darkness," *The New York Times*, September 21, 2018, https://www.nytimes.com/2018/09/21/arts/music/robyn-honey-interview.html.

53. Jayson Greene, "Dancing on My Own, Together: Capturing That Robyn Feeling," *Pitchfork*, September 12, 2018, https://pitchfork.com/features/overtones/dancing-on-my-own-together-capturing-that-robyn-feeling/.

54. Claudia Roth Pierpont, "Another Country," *The New Yorker*, February 2, 2009, https://www.newyorker.com/magazine/2009/02/09/another-country.

55. Suzy Hansen, "James Baldwin's Istanbul," *Public Books*, August 10, 2017, https://www.publicbooks.org/james-baldwins-istanbul/, accessed March 22, 2023.

56. Magdalena J. Zaborowska, *James Baldwin's Turkish Decade: Erotics of Exile* (Durham, NC: Duke University Press, 2009).

57. Gürsoy Doğtaş, "James Baldwin in Istanbul: Art and Activism in Exile," *Contemporary And*, March 18, 2022, https://contemporaryand.com/magazines/james-baldwin-in-istanbul-art-and-activism-in-exile/.

ABOUT THE AUTHOR

Simon Wu is a curator and writer involved in collaborative art production and research. He has organized exhibitions and programs at the Brooklyn Museum, the Whitney Museum, The Kitchen, MoMA, and David Zwirner, among other venues. In 2021 he was awarded an Andy Warhol Foundation Arts Writers Grant and was featured in *Cultured* magazine's Young Curators series. He was a 2018 Helena Rubinstein Curatorial Fellow at the Whitney Museum Independent Study Program and is currently in the PhD program in history of art at Yale University. He has two brothers, Nick and Duke, and loves the ocean.